Frida Kahlo

D1603723

Titles in the series Critical Lives present the work of leading cultural figures of the modern period. Each book explores the life of the artist, writer, philosopher or architect in question and relates it to their major works.

In the same series

Frida Kahlo

Gannit Ankori

REAKTION BOOKS

For my father, Zvi, and my mother, Ora, who took me to Mexico when I was a little girl and taught me to passionately embrace love, life and art.

Published by Reaktion Books Ltd
Unit 32, Waterside
44–48 Wharf Road
London N1 7UX, UK

www.reaktionbooks.co.uk

First published 2013, reprinted 2018

Printed and bound in Great Britain by Bell & Bain, Glasgow

A catalogue record for this book is available from the British Library

ISBN 978 1 78023 198 3

Contents

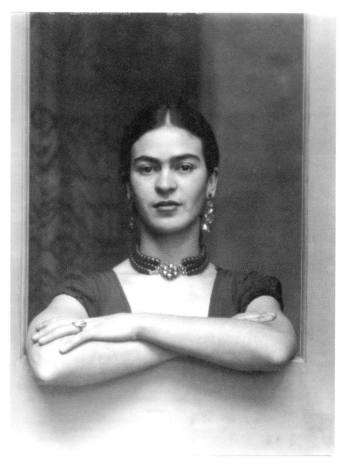

Frida Kahlo in San Francisco, photo by Peter Juley, 1931.

Introduction: The Artist as Mythmaker; Fissured Tales of Art and Life

Who knows anything of LIFE?
Frida Kahlo[1]

In a series of interviews that Frida Kahlo dictated to Olga Campos in the autumn of 1950, the tired and disillusioned artist professed:

> I do not like to influence others.
> I would not like to become famous.
> I have done nothing deserving of acknowledgment in my life.[2]

When Kahlo made this statement she had already produced virtually all the iconic paintings for which she is well known – indeed, venerated – today.

Ten years earlier, when still in her prime, Kahlo had expressed a comparable sense of worthlessness in a heart-rending letter to her then estranged husband, Diego Rivera. In a brutally self-critical epistle, she offered a succinct summary of her life as a series of personal and professional disappointments and utter failures:

> The conclusion I've drawn is that all I've done is fail. When I was a little girl I wanted to be a doctor and a bus squashed me. I live with you for ten years without doing anything in short but causing you problems and annoying you. I began

to paint and my painting is useless but for me and for you
to buy it, knowing that no one else will . . . [3]

Given Kahlo's immense posthumous influence, the cult-like adulation
and critical acclaim she inspires, and the current insatiable and
passionate demand for her (by now priceless) paintings, such
negative self-assessments regarding her own accomplishments
ring not merely incorrect, but also ironic and tragic.

The chasm that separates our contemporary admiration and
high regard for Kahlo and her achievements from the artist's own
scathing self-denigration is but one of numerous gaps and contra-
dictions that riddle the story – indeed stories – of Frida Kahlo.
This book is informed by the acute realization of the existence
and persistence of such discrepancies.

There is an important distinction, as well as a strong reciprocal
relationship, between Frida Kahlo's art and her life. For those who
are fascinated by the dramatic highlights of her biography – a
near-fatal bus accident at the age of eighteen; a stormy, on-again
off-again relationship with the celebrity artist Diego Rivera; and
her untimely death, after years of illness, at the age of 47 – her art
is merely one of many facets of this woman's extraordinary existence,
a useful key for understanding the story of her life. For those
who are driven by a desire to decipher the meaning of Kahlo's
paintings, her biography provides a crucial, though not exclusive,
iconographical key.

The proliferation of biographical (some would say hagiographical)
studies on Kahlo and the bellowing rise of 'Fridamania' prompted
the art historian Lynne Cooke to lament that, in the case of Kahlo
(like that of Van Gogh before her), a '(con)fusion between the art
and the life' is likely to continue to dominate both the research
literature and the popular imagination.[4] The relationship between
Kahlo's life and her paintings is much more complex, Cooke infers.
Beyond this, a long historical view of the entanglement of Kahlo's

art and life reveals that it is not a recent phenomenon, nor is it a result of the posthumous waves of 'Fridamania'. Rather, although exacerbated by Kahlo's recent popular appeal, it started during the artist's lifetime and was, at least partially, self-created.

Surprisingly, the fascination with Kahlo's life began even before she had produced, let alone exhibited, her mesmerising self-portraits. Kahlo attained her initial celebrity in 1929, after marrying the famous and infamous Diego Rivera. She was 22; he was 43. She was just barely beginning to paint; he was internationally renowned as an artist of genius, a peer and friend of Picasso, an outrageous personality and a reckless womanizer. Their 1929 marriage certificate identifies him as 'artist, painter' and her as 'housewife'.[5] Eventually, Kahlo's youthful beauty, exotic-looking appearance and unique persona and personality also captured the attention of journalists and fired the imagination of numerous outstanding photographers. She was brought into the limelight and hailed as 'Diego's beautiful young wife'.[6]

Helen Appleton Read's article published in the *Boston Evening Transcript* on 22 October 1930 is typical. The lengthy article introduces Diego Rivera as 'Mexico's most celebrated painter' and proceeds to discuss, as the verbose title promises, the 'Mexican Renaissance in Art: Diego Rivera Heads Group of Painters Who Are Rewriting Mexican History from the Revolutionary Standpoint'. Midway through the article, under the subheading 'Native Costume', Read devotes a brief yet telling paragraph to Kahlo:

Frida, Diego's beautiful young wife, is a part of the picture. She wears the native costume, a tight-bodied, full-skirted muslin dress, the classic *rebozo* draped about her shoulders and a massive string of Aztec beads about her slender brown throat. She, too, is an artist and has her studio next [to] her husband's. She has a charming, naïve talent and is only another example of the spontaneous artistic expression inherent in the Mexican temperament.[7]

This 'picture' of Diego's charming wife – native and naive, indigenous and spontaneous, colourful and 'brown' – came to dominate much of the writing about Kahlo throughout her life. Often, as in a short piece published in *Vanity Fair* in 1931, a photograph replaced the verbal description of Kahlo's 'persona'.[8]

The early photographs of Kahlo, taken by the leading photographers of the day – among them Peter Juley, Manuel Alvarez Bravo, Edward Weston, Imogen Cunningham, Ansel Adams, Carl Van Vechten – propelled her to fame, first and foremost as Rivera's young wife, but also as an exotic woman with a unique sense of style and indigenous Mexican flair. Edward Weston met Rivera and Kahlo in San Francisco in 1931 and noted in his journal:

> I photographed Diego again, his new wife – Frieda – too: she is in sharp contrast to Lupe [Rivera's ex-wife, Guadalupe Marín], petite, a little doll alongside Diego, but a doll in size only, for she is strong and quite beautiful, shows very little of her father's German blood. Dressed in native costume even to huaraches, she causes much excitement on the streets of San Francisco. People stop in their tracks to look in wonder.[9]

These photographs of Frida Kahlo – published in *Vogue, Vanity Fair* and *Time* magazine – helped construct her image as 'La Mexicana', a paradigmatic Mexican woman, and many of them pre-date her own self-portrayals in this role.

A long letter, written upon her arrival in the United States, reveals that Kahlo was well aware of this deliberate process of self-creation. On 21 November 1930 she wrote to her 'Mamacita linda' (dear Mummy) from San Francisco: 'The *gringas* really like me a lot and take notice of all the dresses and *rebozos* that I brought with me, their jaws drop at the sight of my jade necklaces and all the painters want me to pose for them.'[10]

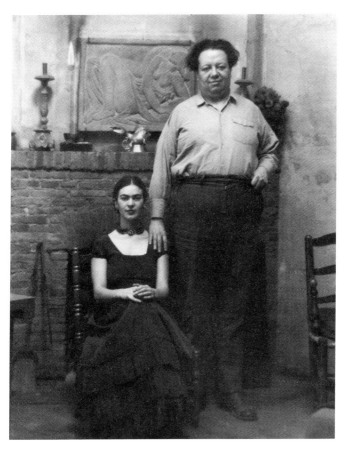

Frida Kahlo and Diego Rivera, photo by Peter Juley published in the September 1931 edition of *Vanity Fair*.

During the 1930s Kahlo began to paint more, and more seriously. By 1938 she had produced enough original work of superior quality to merit her first one-woman show at the prestigious Julien Levy Gallery on New York's elegant 57th Street. On 14 February 1938, as she was preparing for the show, she typed a single-spaced two-page letter to her friend Lucienne Bloch, which indicates that even at this stage she did not perceive herself as a significant painter:

> I have painted about twelve paintings, all small and unimportant, with the same personal subjects that only appeal to myself and nobody else . . . Four or five people told me they were swell, the rest think they are too crazy. To my surprise, Julian [*sic*] Levy wrote me a letter, saying that somebody talked to him about my paintings and that he was very much interested in having an exhibition in his gallery.[11]

The exhibition, which displayed 25 paintings, opened on 1 November 1938. A yellow fold-out sheet with a list of works and an essay by the Surrealist luminary André Breton accompanied the show. Breton's essay was published in the original French, much to Kahlo's dismay. However, everything else about the exhibition was very much to her liking, as she wrote to her childhood sweetheart and lifelong friend Alejandro Gómez Arias:

> Alex, on the very day of my exhibition I want to talk to you even just this little bit. Everything has been arranged absolutely marvelously and I really do have the luck of a scoundrel. The whole gang here is very fond of me and all of them are exceedingly kind. Levy didn't want to translate the preface by A. Breton and that's the only thing that seems iffy to me, since it looks rather pretentious, but there's no help for it now! What do you think about it? The gallery is swell and they arranged the paintings very well.[12]

On the occasion of her artistic debut, a smattering of articles on Kahlo as an artist began to appear for the first time. It is telling that she received more attention from fashion magazines (for example, *Vanity Fair* and *Vogue*) and from gossip columns (as in *Time* magazine) than from art journals. Moreover, even texts that purported to focus on her paintings were preoccupied with her status as 'wife of the weighty and mighty Diego, the master painter of Mexico',[13] and – as before – with her colourful personality and exotic Mexican costumes:

> From the bright, fuzzy, woolen strings that she plaits into her black hair and the color she puts into her cheeks and lips, to her heavy antique Mexican necklaces and her gaily colored Tehuana blouses and skirts, Madame Rivera seems herself a product of her art, and, like all her work, one that is instinctively and calculatingly well composed. It is also expressive – expressive of a gay, passionate, witty, and tender personality.[14]

From this point on, basic information began to appear and reappear repeatedly in subsequent texts regarding Kahlo. These reiterated statements further entangled her art and her life. Kahlo's supposed shyness and 'naive' childlike nature were attributed to both her personality and her artistic style. Her becoming a painter was heretofore explained simplistically as a direct result of her accident; the press release issued by the Julien Levy Gallery proclaimed: 'In 1926 [the correct date is 1925] she was the victim of a serious motor accident . . . Bedridden for some time, she started to paint with a primitive but meticulous technique.'[15] Bertram Wolfe confirmed: 'an automobile accident, made a painter out of her'.[16] Kahlo's paintings were viewed as direct depictions of her life; and, finally, her tumultuous and obsessive relationship with Rivera was seen as the main focus of both her life and her art.[17]

The review in *Time* magazine, accompanied by a beautiful photograph of Kahlo in native garb, captioned 'Frida Rivera and Picture', is a case in point. The photograph by Elinor Mayer shows the artist in front of her monumental oil painting *What the Water Gave Me* (1938). This innovative and extraordinary painting, however, which presents a revolutionary and original mode of representing a female bather, is neither named nor discussed.[18] Instead, the article is devoted solely to titillating and patronizing gossip:

> Flutter of the week in Manhattan was caused by the first exhibition of paintings by famed Muralist Diego Rivera's German-Mexican wife, Frida Kahlo. Too shy to show her work before, black-browed little Frida has been painting since 1926 [the correct date is 1925] when an automobile smashup put her in a plaster cast 'bored as hell' . . . Most charming piece: *Self-portrait with Heart*, Frida's record of a period of unhappiness with Diego . . .[19]

In hindsight, it can be unequivocally discerned that Kahlo herself deliberately encouraged – one could say, instigated – such a straightforward biographical approach to her art, constructing a paradigm whereby art and life seamlessly overlap in her paintings. Indeed, in the captivating and formative interviews that she granted to Bertram Wolfe and Julien Levy in 1938 and to Parker Lesley in 1939, Kahlo herself, with feigned *naïveté* and disarming, self-deprecating humour, described the paintings she produced as direct illustrations of specific episodes of her life.[20] 'I paint always whatever passes through my head, without any other considerations', she told Wolfe, convincing him (and those who followed in his footsteps) that somehow her life flowed onto her canvases without mediation or effort. She also provided the selective (and sometimes inaccurate) biographical milestones that would be cited and repeated without question in her subsequent biographies.

Oversimplified one-dimensional biographical readings of Kahlo's work continued as she produced new paintings and met new interlocutors and potential biographers. For example, when MacKinley Helm 'had tea with Frida Kahlo de Rivera in the house where she was born' in December 1939, he testified to her 'decidedly melancholy' mood upon receiving 'a set of papers announcing the final settlement of her divorce from Rivera'.[21] Linking this directly to the painting on her easel, he wrote what has since become the standard interpretation of Kahlo's monumental and complex masterpiece, *The Two Fridas*:

> There are two full-length self-portraits in it. One of them is the Frida that Diego had loved. This Frida derives her life's blood from a miniature portrait of Diego which she holds in her hand. The blood stream runs in an exposed purple artery to her heart, which is also laid out upon her bosom; winds thence around her neck and proceeds to the second Frida, the woman whom Diego no longer loves. There the artery is ruptured. The Frida scorned tries to stay the flow of blood, momentarily, with a pair of surgeon's forceps.[22]

Helm's next sentence is an illuminating example of how Kahlo's own words convinced even a most critical scholar that, in the case of Kahlo, the boundary between art and life was either fluid or non-existent: 'When the divorce papers arrived, while we were looking at the picture, I half expected her to seize the dripping instrument and fling it across the room.'[23] (Note the ambiguous use of the word 'her' that further conflates art and life – is Helm referring to the artist or to her painted portrait?)

Helm proceeds to reiterate all the familiar ingredients of the Kahlo story: her mixed Mexican-German/Catholic-Jewish ancestry; her accident in 1925, which 'made' her a painter; her

early infatuation with Rivera and their marriage in 1929. To this narrative he contributes the latest milestone: the divorce of 1939.[24]

By the time Kahlo produced her complete body of work, and this œuvre was displayed in a long-overdue solo exhibition in Mexico City in 1953, *Time* magazine summarized Kahlo's art as 'a painful autobiography set down with brush and paint'.[25] In this brief review all the well-known 'milestones' of Kahlo's mythical story (re)appear, particularly her near-fatal automobile accident, which 'transformed' her into an artist, and her childhood infatuation and subsequent stormy relationship with Diego Rivera. The Mexican reviewer of the exhibition, José Moreno Villa, presented an identical conclusion in *Novedades*: 'It is impossible to separate the life and work of this singular person. Her paintings are her biography.'[26]

Although Kahlo's posthumous biographers never had the benefit of direct interviews with her, they were all inevitably (and justifiably) strongly impacted by her previously recorded statements. Published in 1983, almost three decades after the artist's untimely death in 1954, Hayden Herrera's biographical volume *Frida* remains the most comprehensive and reliable study of Kahlo's life. Herrera echoes her predecessors and reasserts the premise that the artist's œuvre is an 'autobiography in paint'.[27] Her narration of Kahlo's life seems so intimate and fluid – virtually omniscient – that Salomon Grimberg commented that Herrera writes 'as if Kahlo herself had whispered . . . into her ear'.[28] In an interview she granted some two decades after the publication of her magisterial biography, Herrera confessed to a similar sensation: 'With Frida, I felt, for a time, that I was living inside her. I felt I was writing about her from the inside out.'[29]

Kahlo's own words – passed on like an oral tradition of yore through loyal friends, trusted interviewers and, by now, several generations of scholars – have powerfully inscribed her self-constructed life story. So much so that one of her most devoted biographers, Martha Zamora, wrote: 'In my quest for the truth,

I was even struggling against Frida herself, who seems to have wanted to invent her own biography, to plot her own myth and legend.'[30]

> Who was Frida Kahlo? It is not possible to find an exact answer. So contradictory and multiple was the personality of this woman, that it may be said that many Fridas existed. Perhaps none of them was the one she wanted to be.[31]

The public persona that Kahlo presented in interviews and in her meticulously staged photographic portraits is substantially different from 'the many Fridas' we encounter when reading her private letters, carefully studying her diary or analysing the profound and complex art she created. Contradictions abound. Crucial issues regarding Kahlo's life story are fraught with uncertainty or inconsistencies, including her date of birth and paternal genealogy, her attitude towards childbearing, her relationships (with Rivera and with others), her medical condition and, tellingly, even the ultimate cause of her death.

It must be emphasized that the gaps that characterize the Kahlo story are by no means a result of a paucity of source material. On the contrary, we possess an extraordinary array of verbal and visual sources related to almost every aspect of Kahlo's life. Moreover, in the last decade, there has been an astounding influx of new evidence, which will be referenced throughout this book.[32] Particularly dramatic was the opening of locked rooms and closets in Kahlo's home in Coyoacán, La Casa Azul, which brought to light thousands of fascinating items – drawings, medical contraptions, X-rays, original documents, photographs, garments and accessories – that are gradually becoming accessible to the public.

Books that reproduce and reflect upon new source material are now also available. Notable examples of this surge of publications

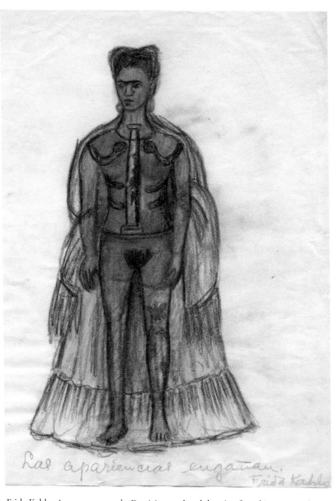

Frida Kahlo, *Appearances can be Deceiving*, undated drawing found in 2004 at the Frida Kahlo Museum, La Casa Azul, Coyaocán.

are: the memoirs of the artist's beloved niece, Isolda P. Kahlo, entitled *Intimate Frida* (2005), which include excerpts from the diary of Frida's sister, Cristina, along with other family documents and testimonies; Salomon Grimberg's *Frida Kahlo: Song of Herself* (2008), based on hitherto unknown interviews and psychological tests conducted with Kahlo during the last years of her life; the sumptuous book that displays and analyses 'Frida's Wardrobe' (2007); and a compilation of hundreds of previously unknown photographs from the artist's private archives (2010).[33]

Although every scrap of new information delights Kahlo aficionados – experts and lay fans alike – this expanding depository of material has not resolved most of the discrepancies that punctuate the artist's tale. Ironically, the uncovered information actually highlights and further accentuates the contradictions embedded in her biographical narrative.

As will be apparent in the pages that follow, any attempt simply to (re)construct a linear biography of this fascinating and innovative artist inevitably encounters a complex maze of conflicting information, documents and memories – a weave of overlapping objective and subjective facts and fabrications.

This book, then, presents a concerted effort to sift through a plethora of primary and secondary sources and distil verifiable facts. But it also reflects the realization that this information, along with the images that Kahlo created, the mythic tales she herself spun and the identities she constructed for herself – *as her selves* – coalesce into an elusive, multifaceted and fissured tale.

In the autumn of 1950 – echoing one of her favourite poets, Walt Whitman, who professed 'Do I contradict myself? Very well then I contradict myself (I am large, I contain multitudes)' – Frida Kahlo affirmed: 'I have enjoyed being contradictory.'[34]

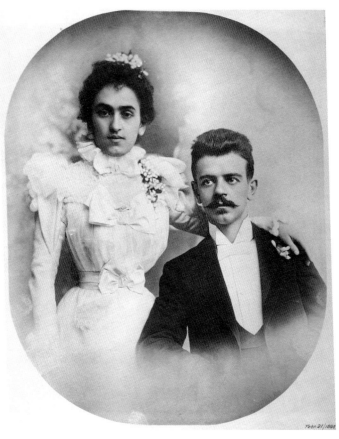

Guillermo Kahlo and Matilde Calderón, wedding photograph, 1898.

1

Family Tree: 'My Grandparents, My Parents and I'

I am a mixture

Frida Kahlo[1]

Frida Kahlo's birth certificate conjures up a vivid picture: on 4 August 1907 her maternal grandmother, 'la señora Isabel González Viuda de Calderón' (Mrs Isabel González, widow of Calderón), presented her infant granddaughter to the civil registrar in Coyoacán.

At 11 a.m. the newborn baby's name was typed onto her birth certificate in capital letters: 'MAGDALENA FRIDA CARMEN KAHLO'. She is reported to have been born four weeks and one day earlier, on 6 July 1907 at 8.30 a.m., the 'legitimate daughter' of Guillermo Kahlo, a 36-year-old photographer from Baden Baden, Germany, and Matilde Calderón, a 30-year-old woman 'without profession' from Mexico City. The somewhat modified, Mexicanized names of the infant's deceased paternal grandparents, 'Jacobo Enriquez Kahlo and Enriqueta Kaufmann', and of her maternal grandfather, 'Antonio Calderón', Isabel González's late husband, also appear in the document.[2]

Kahlo's 'mixed' genealogy, laconically inscribed on her birth certificate, was to become a significant component of the artist's identity. Throughout her life, in words and in images, she further elaborated on the diverse and multicultural origins of her progenitors, deliberately emphasizing the hybrid nature of her family tree. Moreover, Kahlo's personal genealogy parallels the mosaic-like

composition of modern Mexico, with its complex fusion of ethnicities, religions, races and origins, visualized in extraordinary paintings of the offspring of miscegenation, titled *Las Castas* (the castes).[3] Kahlo, of course, was well aware of these parallels and consistently highlighted her manifest *mestizaje*.

The artist's demonstrative identification with Mexico may have also been the reason why in all the interviews she granted, in subsequent documents, notarized certificates she filled out – and even in her diary – she consistently changed the year of her birth to 1910. Kahlo's posthumous biographers explained this discrepancy not as a case of trivial deceit, someone lying about their age, but rather as a sincere ideological proclamation:

> Claiming perhaps a greater truth than strict fact would allow, she chose as her birth date not the true year, but 1910 the year of the outbreak of the Mexican Revolution. Since she was a child of the revolutionary decade, when the streets of Mexico City were full of chaos and bloodshed, she decided that she and modern Mexico had been born together.[4]

There are additional inconsistencies and gaps between the information typed on the official birth certificate and the information that later became part of the Kahlo family tradition and history (perhaps the most glaring being the fact that Frida celebrated her birthday on 7 July and not on 6 July as written in the document).[5] Such discrepancies are commonly found in countless documents and they are rarely significant. In the case of Kahlo, however, every piece of information is scrutinized for possible meaning and instigates both sound and unsubstantiated conjectures.

The birth certificate reveals – but also omits – vital information about the Kahlo-Calderón household. Matilde Calderón was not Guillermo Kahlo's first wife, and at the time of her birth Frida already had four siblings. In 1894 Guillermo Kahlo had married

Maria Cardeña, who bore him two daughters: Maria Luisa and Margarita. While giving birth to Margarita in 1897, Maria Cardeña had died.[6] Guillermo married Matilde Calderón the following year in a church wedding, and their marriage was registered by the civilian authorities six years later, on 29 September 1904.[7] In the course of their marriage Guillermo and Matilde had five children, four surviving daughters, Matilde (*c.* 1898–1951), Adriana (*c.* 1902–1968), Frida (1907–1954) and Cristina (1908–1964), and a male infant (named Wilhelm after his father), who died shortly after birth. Immediately after her marriage to Guillermo, Matilde banished her two young stepdaughters – a toddler and an infant – from her

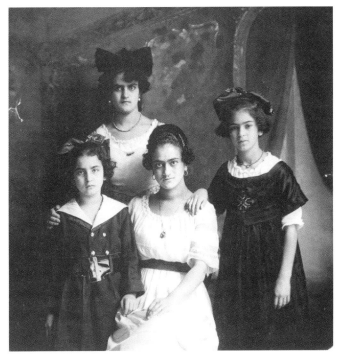

Guillermo Kahlo, photograph of his daughters (from left to right: Cristina, Adriana, Matilde and Frida Kahlo), 1919.

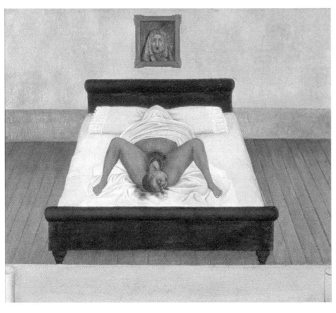

Frida Kahlo, *My Birth*, 1932, oil on metal.

household and sent them to a convent. Margarita later became a
nun, adding the name of her deceased mother and the Virgin Mary
to her own, and signing consequent letters 'Maria Margarita'.[8]

This complicated family history, with its dramatic overlapping
experiences of birth and death, seems to have cast a shadow over
Frida's childhood, shaping her understanding of life and eventually
finding salient expression in her art. In an unprecedented body of
work, Kahlo created penetrating images of her genealogy, inception
and birth that also reveal aspects of the complex family dynamics.
Her paintings shed light on formative experiences of her early years
that determined her identity and which cannot be gleaned from
official documents.[9]

In 1932 Kahlo composed a startling image, which she titled
My Birth and explained as a depiction of 'how I imagined that I

was born'.[10] At the centre of this nearly symmetrical composition, she painted a double bed in an otherwise stark and somewhat claustrophobic room. Upon the bed, part of a large female body may be seen. The woman's head and body from the waist up are shrouded with a white sheet. Her body from the waist down is emphatically exposed. Her brown legs are bent at the knees and spread wide apart, revealing her pubic hair and vaginal area. This taboo sight, framed by the bizarre zigzag formed by the woman's legs, occupies the focal point of the composition. The head and neck of Frida as a newborn baby emerge from the vagina onto a bloodstained sheet. Her eyes are closed; her eyebrows connect above the nose; and her neck seems to be slashed and bleeding. Both the mother and the baby appear to be dead. Above the bed, at the top centre of the composition, hangs a framed picture of the weeping head of Our Lady of Sorrows. The Virgin's blue mantle covers her head; two daggers pierce her neck, creating bleeding wounds. At the bottom of the painting there is an unfurled blank scroll.

Kahlo painted her birth as an agonizing event in which the beginning of life is conflated with death. This has been convincingly linked to Matilde Calderón's death on 15 September 1932, just before Kahlo began work on the painting. A few months earlier – in July 1932 – the artist herself had suffered a nearly fatal miscarriage. In early September Frida's maternal grandmother also died. Such intense consecutive experiences that link motherhood and death clearly impacted Kahlo's imagery in this painting. It is also possible that this cluster of events triggered earlier memories of family traumas, the death of Guillermo Kahlo's first wife during childbirth and the death of Frida's infant brother.

In addition to this, the stark barrenness of the room, the blank scroll and the fact that the mother's head is dramatically covered all convey a profound sense of loneliness, alienation and maternal absence, perhaps even abandonment.[11]

That Frida chose to portray her mother in this manner reflects a troubled mother–daughter relationship. Kahlo's close friends (among them Alejandro Gómez Arias and Juan O'Gorman), who were frequent visitors to her family home in Coyoacán during the artist's adolescence, witnessed her tense interactions with her mother and gave detailed accounts of what they viewed as a 'very cold and negative' relationship. 'Señora Calderón never understood Frida', Gómez Arias recalled. 'Her mother was a nonentity', O'Gorman stated, echoing Kahlo's visualization of Matilde Calderón as a headless, 'unavailable' and anonymous body fragment.[12]

In contrast to this evidence, which Frida reiterated in several interviews during the 1950s, dozens of newly uncovered letters from Frida to her mother sketch a more nuanced and ambivalent portrait of the mother–daughter relationship.

In the autumn of 1930 Frida left Mexico and was separated from her family for the first time in her life. The 23-year-old newly wed embarked on a life-altering journey to the United States, documented in her copious epistolary exchanges with numerous family members. Virtually every letter begins with a list of letters received or anticipated and contains many endearments and declarations of love and longing. The artist saved the letters for two decades until shortly before her death, when she transferred this voluminous correspondence to a close friend for safekeeping. It is interesting that whereas Frida kept dozens of letters from her sisters Adriana, Matilde and Cristina; long, beautifully scribed letters and poems from her father; and a substantial group of letters from her cousins, Carmen and Carlos Veraza, most of her mother's letters are not to be found in this trove. More than 50 missives from Frida to her mother, however, apparently retrieved by the artist after Matilde Calderón's death in 1932, were among the papers that Frida saved and, apparently, valued. Affectionately addressed to 'Mamacita linda' or 'Mamacita de mi corazón', these letters (from the late autumn of 1930 to the spring of 1932) teach us a great deal

about Frida's experiences in San Francisco and New York, as will be discussed elsewhere in this book. They also reveal that she missed her family and was eager to report to 'Mummy' all her adventures, impressions and success in the big world. The letters suggest that the 'very cold and negative' mother–daughter dynamics that reportedly characterized Frida's childhood and teenage years was beginning to shift after the artist left home. This positive (and not uncommon) process, however, came to an abrupt halt before the relationship was fully resolved.

In fact, Matilde's inability to be available when her daughter needed her repeated itself when Frida was hospitalized in Detroit on 4 July 1932, after her miscarriage. A telegram from Mexico indicates that all the family were worried and ready to come to Frida's bedside immediately, except for her mother, who was ill herself and not even notified of her daughter's condition. Conversely, when it was apparent that Matilde Calderón was gravely ill, it seems that Frida was reluctant to rush to Mexico to be at her mother's side and preferred to stay with Diego Rivera in Detroit.

By the time that Frida decided to travel back to Mexico, her mother was already on her deathbed. Upon her arrival, just five days before Matilde Calderón's death, Frida wrote a five-page letter to Rivera, describing her mother's hopeless situation. The letter details the mother's physical condition in vividly graphic terms: she was as 'yellow as the yolk of an egg' from her liver disease; sedated with morphine; suffering from a huge lump in her breast diagnosed as cancer; ready to undergo surgery to remove 'hundreds' of stones in her gall bladder.

Although she was in Mexico, Frida refrained from being at her mother's side when she passed away and refused to view her body after death.[13] It seems that even though the relationship was beginning to improve while Frida was travelling in the U.S., by the time she returned to Mexico only her mother's ailing body remained. Her spirit had 'departed' and was no longer there to

greet the 'abandoned' daughter. This turn of events may explain why Frida portrayed her mother as a grotesque maternal body, an entity that is emotionally unavailable. It may also elucidate the reason why the painting is imbued with a feeling of loneliness and alienation.

In lieu of the absent mother, *My Birth* presents a painting within a painting of the Virgin, positioning Mary as a surrogate mother. The icon also relates to Matilde Calderón's devout Catholicism. Isolda P. Kahlo, Frida's niece, the daughter of her sister Cristina, recalled:

> My grandmother, Matilde Calderón y González, who was Frida's mother, was born in Oaxaca in 1876 and came from a profoundly religious family . . . The women in that family were devout Catholics, so much so, that my grandmother and my aunts had an exclusive bench reserved in the Church of San Juan Bautista in Coyoacán.[14]

That both Our Lady of Sorrows and the infant Frida have similar bleeding neck wounds suggests a Catholic maternal legacy of suffering, blood and pain passed on to Frida by her mother, even before she was born.[15]

Kahlo further accentuated the Catholic legacy of her mother by painting *My Birth* in the format and using the medium characteristic of a religious *retablo*. *Retablos* are popular votive images, usually painted on tin, that include three main components: a visualization of a calamity or misfortune that was overcome; an image of a saint, often the Virgin Mary, who is credited with saving the protagonist from this calamity; and a scroll at the bottom of the composition that narrates the tale of miraculous intervention.[16] In *My Birth*, Kahlo emulates the tripart *retablo* format by including an image of the near-fatal event (childbirth), the interceding saint (the Virgin Mary) and a scroll. But she leaves the unfurled scroll blank. Salomon Grimberg has convincingly argued that by doing so Kahlo

presents her birth and her primal relationship with her mother as a calamity from which not even Our Lady of Sorrows could save her.[17]

Kahlo did not base *My Birth* on artistic representations of birth, such as the ubiquitous scenes of the Nativity of Christ and pre-Columbian images of the Aztec goddess of birth.[18] Her depiction of her mother is also radically different from the traditional genre of portraiture. In sharp contrast to such visual models, Kahlo deliberately chose to portray her mother – and hence to express her formative relationship with Matilde Calderón – by combining a devotional image related to a calamitous event (the *retablo*) with a gynaecological model.[19] By using a gynaecological illustration to portray her mother, Kahlo reduces Matilde Calderón to a faceless body fragment composed of physical elements that enable her to fulfil a single biological function: parturition. This mode of depiction – which shows the mother as 'indecently exposed' and links her to a double taboo, vaginal blood and sexually charged body parts (her vagina, clitoris and pubic hair) – seems to reflect Kahlo's ambivalence (or even outright hostility) towards her mother.

———————

Frida portrayed her father, his contribution to her conception and birth and the father–daughter relationship in a way that is diametrically opposed to her visualization of her mother. In *Portrait of my Father* (1951), a work marking the tenth anniversary of Guillermo Kahlo's death, a bust-size portrait dominates the canvas. Her father is portrayed as a young man with piercing green eyes. Behind his right shoulder is a large camera. The background is filled with dashes and circles of various sizes that appear to be based on microscopic images of ova and spermatozoa. At the bottom of the composition an unfurled scroll is inscribed with a caption that is carefully hand-written twice: once in pencil and a second time deliberately traced over in red paint, simulating blood. It reads:

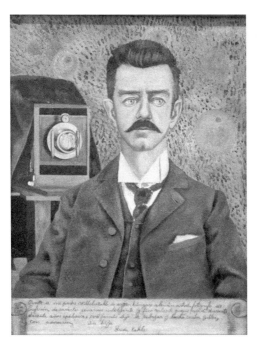

Frida Kahlo, *Portrait of my Father*, 1951, oil on masonite.

I painted my father, Wilhelm Kahlo, of Hungarian German origin, an artist photographer by profession, in character generous, intelligent and fine, valiant because he suffered for sixty years from epilepsy, but never stopped working and fought against Hitler. With adoration, His daughter, Frida Kahlo.

The figurative portions of the painting are based on photographs taken by Wilhelm Kahlo of himself and of his camera in 1907, the year that Frida was born.[20]

Frida portrays her father with great tenderness and affection. Their loving relationship is reflected in the image itself, in the warm tonality that pervades the work and in the caption that accompanies the portrait. At the onset of the inscription, Wilhelm Kahlo is identified as 'my father'. It ends: 'With adoration, His

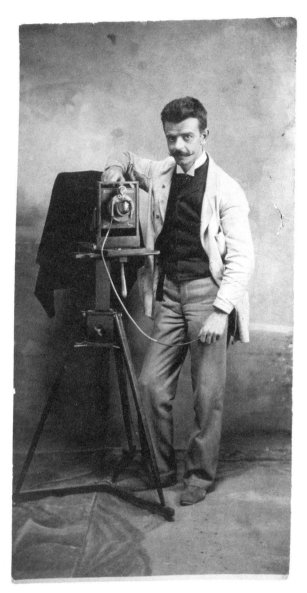

Guillermo Kahlo, *Self-portrait with Camera*, 1907.

daughter, Frida Kahlo'. The verbal testimony echoes the genetic ties symbolized by the cellular background of the portrait. Frida's correspondence with her father – replete with endearments and declarations of love and longing – similarly reflects their unconditional love for each other: he addresses his letters to 'My dearest Frieducha'; calls her 'the one he loves most'; longs to 'hug and kiss her'; and signs them 'your loving papa, Guille Kahlo'.[21]

When Frida's father emigrated to Mexico, he changed his name to Guillermo, the Spanish equivalent of Wilhelm. Yet when his daughter painted his portrait a decade after his death, she still identified him by his German name. More specifically, his Hungarian-German origins are not merely indicated by his name, but are also noted in the brief caption. Another point that Frida mentions is her father's active anti-Nazi position. This may seem strange within a Mexican context, but becomes understandable if Frida's own communist and anti-Nazi position is taken into account. She may have wanted to stress the fact that her German-born father was not to be identified in any way with Germany's dark past. Rather, his activism against Nazism is presented as part of the legacy he left his daughter.[22] Frida also emphasizes her father's vocation as an artist both in the caption and by portraying him with a large camera, his attribute as a photographer. The fact that Wilhelm was an artist formed an important, lifelong bond between father and daughter.[23]

The positive qualities that Frida attributed to her father – generosity, intelligence, gentleness and valour – are specifically the qualities that she often stated her mother lacked. Even during the last years of her life, Frida retold stories that reflected her mother's cold and cruel nature, ranging from descriptions of how Matilde Calderón drowned puppies in a basin, to the repeated accounts of how, as an unfeeling stepmother, she ruthlessly banished Frida's half-sisters to a convent after she had married their father. Within the primary family triangle, Frida constructed a subjective

polarized view of the 'good parent' and the 'bad parent', the loving solicitous father, whom she adored and with whom she identified, and the tough mother, whom she called 'my chief' and portrayed as emotionally unavailable.

Finally, the short text written on her father's portrait mentions his malady as an essential component of his personality. According to Frida's testimony, when Wilhelm was an eighteen-year-old student at Nuremberg University he began to suffer from epileptic seizures. These attacks continued to afflict him until his death. Being ill herself, it seems that she regarded her father's sickness as a link between them and that she considered his capacity to overcome his disabilities a reflection of his bravery, perseverance and fine character. In much the same way, her own ability to overcome pain and physical hardship became a defining aspect of her self-image. Tellingly, although her mother was also frequently sick, Frida did not identify with her in the same way.[24]

Portrait of my Father presents Frida's subjective view of her father. She depicts him as her progenitor, the source of her life; she visualizes him as a handsome young man, an artist and an idealized role model. But most of all she emphasizes his eyes. In an oft-quoted statement Frida is reported to have said: 'I have my father's eyes and my mother's body.'[25] Taken as a straightforward description of her physical features, this statement is incorrect. Kahlo had large brown eyes like her mother's. Her father's eyes, as the portrait displays, were green. A metaphorical rather than literal reading of this statement may shed light on its true meaning. Wilhelm Kahlo's prominent eyes are the all-seeing eyes of the visual artist. They are also symbolic windows to his soul.

Frida's portrayal of her father is deliberately and diametrically opposed to her view of her mother as presented in *My Birth*. The mother is shown from the waist down, the father from the waist up. The mother is an anonymous, headless, unseeing body; the father is all eyes and soul. The mother offers her child only a

picture of the *Mater Dolorosa*, who symbolizes a legacy of pain and death. The father's attribute is his camera, providing a legacy of art and creativity. The blank scroll and the empty room of *My Birth* reflect the emotional vacuum that memories of the mother evoke. In contrast, the vital background of *Portrait of my Father* and the carefully written caption tell a story of love, moral courage, artistic creativity, political activism and perseverance. Finally, even the visual antecedents that Frida associates with her mother and her father respectively underline the polarized views she projected onto each parent. Her visualization of her mother is based on an obstetrical image of the fragmented body of an anonymous woman. Her father's portrayal is a variation on his own art, a self-portrait in which he photographed himself as a dashing young man in 1907, the very year he became Frida's father.[26]

Some of the information that was visually conveyed in *Portrait of my Father* finds corroboration from other sources, often without Frida's positive spin. Wilhelm Kahlo's chronic illness, his foreign demeanour within the Mexican milieu, his professional excellence as a photographer and his tender devotion to Frida were recounted by eye witnesses who had met him in the 1920s and '30s. Diverse testimonies also attest to his peculiar, introverted personality, eccentric behaviour, financial and psychological hardships, and to the tense relations between Frida's parents.

Alejandro Gómez Arias shared vivid recollections of the Kahlo-Calderón household during Frida's teenage years: 'Señora [Matilde] Calderón was a lower middle-class woman from Oaxaca, with huge brown eyes, like Frida's. Given her extreme Catholic religiosity and totally conventional middle class values, she never understood Frida's art or her great talent and intellect.' In sharp contrast, Gómez Arias remembered Frida's father as a highly unconventional man and an intellectual:

Herr Kahlo, Don Guillermo Kahlo, was a German, probably a German Jew from Romania. The family's origins from way back were Hungarian. Unlike Frida's mother, Guillermo Kahlo was very well-educated; his fine library contained the German classics, Goethe, Schiller . . . and he had a most beautiful portrait of Schopenhauer.

Gómez Arias reflected on the difficult economic situation that plagued the Kahlo household and affected Frida's father:

He was an excellent photographer of architectural themes, but his commissions were from the Porfirio Díaz government. By the time I met Guillermo Kahlo he was out of favor with the new post-Revolution administration and his professional and economic status had greatly deteriorated. Her father declined. He didn't have a fixed job. By the time I met Herr Kahlo, Don Guillermo Kahlo was already a man who felt himself a 'loser'. He was a strange man . . . Very introverted.[27]

In spite of mounting difficulties, Guillermo was always tender and loving towards his 'querida Frieducha', by all accounts his favourite daughter: 'he had a great love for Frida, but not for the rest of his daughters . . . she loved him, backing him up, going to his studio . . . bringing him lunch . . . Frida was always looking after him because of the cycle of [epileptic] attacks.' Gómez Arias stressed that Frida learned how to take the most meticulous photographs and was, in a sense, a 'disciple' of her father. She later chose a different artistic path, but the lessons gleaned from her father's photography studio stayed with her.

Photographs by Frida published in 2010, and the many letters exchanged between father and daughter in the years 1930–33, confirm Gómez Arias's testimony.[28] The paucity of commissions and lack of money are referenced frequently in the correspondence.

Frida often sends money to her parents and consistently expresses deep concern for her father's physical and mental well-being. Wilhelm sends his daughter numerous photographs and describes his photographic practice in great technical detail, indicating the lenses, angles and lighting that he uses in each composition. She urges him to paint and he responds by confiding to her about the limitations of his talent as a painter:

> I'm going to confess to something: since nowadays I am painting a little bit more, I suddenly feel like slapping myself, because you know: it is not the same thing to have the colors, brushes, etc., and the capacity to *copy* a good painting that you have in front of your eyes, than to have in the first place the talent to invent the model and then to send it from the brain to your hands, to maneuver the brushes and transport it to the canvas, like your husband! I am very slow and that's why I have these sudden bile leaks and a big sadness.

Juan O'Gorman, who had come to know Wilhelm Kahlo well over a period of some twenty years, observed his introverted personality and socially awkward behaviour and believed them to be a result of his 'outsider' position in Mexico. In a lengthy interview, he explained:

> [Frida's father] was a person who did not find himself at ease in Mexico. He wasn't born here. Being an immigrant and a Jew made his life not an easy life, not because of discrimination against Jews, but because he had what all the Jews after the Diaspora had, which is the feeling of being a persecuted race. This was part of the make up of that man's character.[29]

Isolda Kahlo recalled the eccentricities of her grandfather, but also remembered him 'playing the piano magnificently', her visits

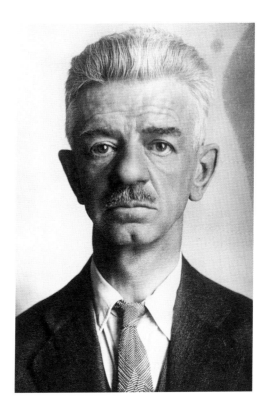

Guillermo Kahlo,
Self-portrait, late
1930s.

to his photography studio, his failed attempts to teach her German, and his quiet and quirky demeanour. She interpreted his 'melancholy' as a composite result of his nature, the onset of deafness and an immigrant's 'nostalgia' for the country and family he had left behind.[30]

As Wilhelm Kahlo grew older, he became almost completely deaf and increasingly withdrawn. In a moving letter to Frida, who was in Detroit at the time, he describes how, when a telephone was installed at the Kahlo family home in Coyoacán and the first call was placed to Frida on 8 August 1932, he cried because he couldn't hear her voice. Elsewhere, he writes about his 'bad moods' and

with wry humour and great familiarity presents himself to his daughter as a misanthrope:

> My advice to you is to always get involved as little as possible with humankind. Always get along with your husband and everything else treat with a little bit of laughter, but other than that, with indifference. That way you won't have either friends or enemies, and you will have tranquility. I still have the hope that this hideous nervousness will go away, and that's how I will attain that peace of mind.

After his wife's death in 1932, Wilhelm became more and more dependent on his daughters. He lived with Frida and her sisters, who loved him unconditionally, until his death on 14 April 1941,

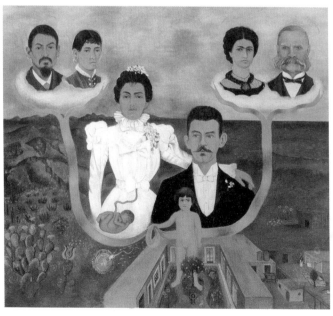

Frida Kahlo, *My Grandparents, My Parents and I*, 1936, oil and tempera on metal.

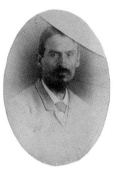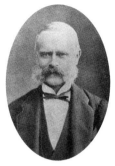

Antonio Calderón, Henriette Kaufmann, Jakob Kahlo, undated photographs.

apparently from a heart attack. After he died, Frida painted herself in black garb, shrouded by sorrow and mourning for her beloved father. She spoke of her 'papacito lindo' with love and immense affection until the day she died.[31]

Frida's identity as the daughter of an immigrant father and her hybrid genealogy are emphasized in an idealized family tree that she painted in 1936. Titled *My Grandparents, My Parents and I*, the work shows the artist's paternal grandparents located above the sea – indicating their European origin – and her maternal forebears hovering above the Mexican soil. The portraits of her grandparents are based on oval photographs, which were found in La Casa Azul among Frida's personal papers. On the back of Henriette Kaufmann's photo Frida wrote: 'My father's mother (a German Jew)'; on the back of Jakob Kahlo's photo: 'My father's father (Hungarian)'; on the back of Antonio Calderón's photograph: 'My grandfather José Calderón de la Barca'; and on the verso of Isabel González's photograph: 'My Spanish grandmother from Old Castile Isabel González y González'.[32]

Frida's parents – their portrayal based on their wedding photograph – are at the very centre of this family tree. Her father is positioned with his head set against a divided background of land and sea, split between two countries, the old and the new,

indicating his experience as an immigrant. It is his daughter Frida who completes the process of acculturation, presenting herself in this painting in multiple symbolic forms, as a cactus flower and a tree, rooted in the native Mexican soil, specifically in the patio of La Casa Azul in Coyoacán.[33]

Kahlo portrays her physical and psychological process of becoming, in relationship to both parents. She depicts herself as an ovum being fertilized by a sperm and as a developing foetus atop her mother's white wedding dress. Once again, she uses a medical illustration from a gynaecological book in her library to visualize her mother's role in giving her life.[34] In contrast, she situates herself as an alert child, who stands up on her own two feet at her father's side. The patio of La Casa Azul forms a protective womb-like shelter for the little girl, who is literally and figuratively close to her father's heart. This depiction reflects Kahlo's articulation of her different relationship with each parent and reinforces the polar views vis-à-vis her mother and father expressed in *My Birth* and *Portrait of my Father* respectively.

The preparatory sketch for this work, which (like the final painting) traces the hybrid roots of the Kahlo-Calderón family back three generations, deliberately emulates the schematic genealogical charts that became popular in 1936 in Germany and among Mexico's German expatriate community following the Nuremberg Laws. Genealogical charts of this kind were used in Nazi Germany to enforce racial laws that opposed inter-marriage or miscegenation as a way of promoting 'purity of blood'. Kahlo undermined this racist tool by using the Nazi diagram in a composition that affirms her interracial and interfaith identity as the offspring of a 'mixed' – hence 'impure' – family tree.[35]

Kahlo's family tree of 1936 sheds light on the artist's imaginative understanding of her formative process of becoming from zygote to foetus to toddler. But it also camouflages difficult aspects of her family life, masking certain hardships and conflicts and presenting

in their stead a wished-for, idealized portrayal of balance and harmony. The Kahlo-Calderón family – unlike the painting – included Frida's sisters and half-sisters. In interviews Frida described her pivotal relationships with her siblings, indicating that they played very significant roles in her life. Letters from her older sisters, Matilde and Adriana, suggest that they were solicitous and loving without reservation. Her relationship with her younger sister, Cristina, was much more complex. Born just eleven months after Frida, she 'displaced' her from her mother's breast, instigating a rivalry that was to outlast their childhood: 'My mother couldn't breast-feed me, because when I was eleven months old my sister Cristina was born', Frida told Raquel Tibol in 1953. 'I was very ugly and Cristi was very pretty, and I was very envious of her. I was eight . . . I was really ugly, and I had an admiration complex for Cristi', the 43-year-old artist told Olga Campos repeatedly in a series of interviews in the autumn of 1950. The relationship would continue to be complicated during their adulthood. The worst crisis between the sisters occurred in the mid-1930s, when Rivera had an affair with Cristina. 'Here began the most awful suffering', Frida told Campos, confessing that this double betrayal made her contemplate suicide.[36] Despite the ups and downs of their relationship, ultimately the two sisters resumed a close bond. Cristina cared for Frida during her illnesses and numerous hospitalizations. Frida loved Cristina's children, Isolda and Antonio, as if they were her own. They supported each other through difficult emotional and physical crises, remaining devoted to each other until Frida's death.[37]

Kahlo's idealized portrayal of her parents' marriage in the 1936 painting contrasts with information provided by the artist on other occasions. She frequently described her parents' marriage as 'troubled', causing her childhood home to be 'very very sad'. Her mother's religious fervour and lack of education were at odds with her father's atheism and immersion in European philosophy and

Frida Kahlo, unfinished family tree, *c.* 1950, oil on masonite.

culture. Both her parents were often ill and money was scarce.
Kahlo also revealed a dark family secret: that her mother did not
truly love her father, but was 'in love with another German, named
Luis Bauer' who had committed suicide in her presence.[38] In a
letter from Guillermo to Frida from 1932, responding to her marital
problems with Rivera, he writes knowingly about 'jealousy' that
rears its ugly head, confiding in his daughter: 'it shows up suddenly
with your mother, even after 34 years!'[39]

In 1950 Frida began to paint another family tree, which remained
unfinished at her death. In this painting, Matilde Calderón and
Guillermo Kahlo are aggressively separated, reflecting Frida's critical
understanding of the acrimonious marriage that engendered her.
The unhappy union clearly affects the fate of its offspring. Frida
depicts her sisters, her nephew and her niece isolated from each
other and from the artist herself. Replacing the well-articulated
landscape of land and sea and the protective architecture of
La Casa Azul, which in 1936 embraced Frida's growth and identity
formation – a chaotic space forms the ambiguous backdrop for

Kahlo's disillusioned family portrait.[40] At the end of her life, Frida reflected once again on her beginning, from a critical, sombre and pain-filled perspective.

2

Childhood Traumas: The Broken Body, the Doubled Self

Kahlo's life was shaped by two life-threatening traumas that framed her formative years: her bout of polio at the age of six, and the near-fatal traffic accident that devastated her body when she was eighteen years old. Both traumas, with their far-reaching physical and psychological consequences, had a decisive, profound and ongoing impact on Kahlo's life, self-image and world view, and they found poignant expression in her art.

In May 1953, just one year before her death, Kahlo laconically recalled her first serious illness:

> At the age of six I had poliomyelitis. From then on I remember everything clearly. I spent nine months in bed. It all started with a terrible pain in my right leg, from the thigh downward. They washed my little leg in a small tub with walnut water and hot compresses. The little 'paw' stayed very skinny.[1]

Throughout her life Kahlo's polio-stricken leg remained deformed. Its condition further deteriorated as the limb became infected with tumours, ulcers and ultimately gangrene. This necessitated numerous medical treatments and surgical operations until finally, in July 1953, Kahlo's right leg was amputated below the knee. Ironically, polio vaccine was developed in 1954 – the year of her untimely death.

Kahlo's initial childhood experience of her changing self-image began when she sensed her body as a source of pain. Subsequently,

she also felt her body's capacity for motion diminish. First, she was confined to bed for nine months. Later, she had to relearn to use her atrophied limb, and the normal gait she had taken for granted before her sickness became a limp. The external change in Kahlo's body image was also apparent from the start: the once-symmetrical two-legged body became lopsided; the healthy little girl turned into a disabled child with a noticeable deformity and a limp. The emotional impact of these radical internal and external physical transformations was immeasurable. Many studies have shown that when children experience strong physical pain over a long period of time, they lose confidence in their bodies and develop both a negative body image and, subsequently, a problematic self-image.[2] Kahlo also recalled the intensity of her emotional suffering when she was taunted by her classmates and nicknamed 'Frida pata de palo' (Frida peg leg).[3]

To counter her physical handicap Kahlo exercised vigorously, played 'like a boy' and, with the unfailing support of her father, was determined to regain her health, strength and mobility. To overcome the emotional hardships of being ridiculed for being

The young Frida, photos by Guillermo Kahlo.

Frida Kahlo, diary drawings, 1953.

different, she turned difference into specialness and transformed her disability into a defining quality of her identity. First she became Daddy's favourite, a little girl who needed special attention and won approval for her ability to overcome hardship. Ultimately, she transformed herself into a flamboyant and unique character. She also tried to recreate or mend the defective image of her body. As a child, she wore several pairs of socks to hide and reshape the thin leg; as an adult she wore trousers and later long native skirts to camouflage her deformity.[4]

Many of Kahlo's paintings, drawings and diary entries include direct and indirect references to her polio-stricken limb: in straightforward depictions she shows her foot bleeding, bandaged or cut off. Metaphorically, she frequently presents herself with broken wings or as a being who is unable to fly. In several drawings she presents autonomous, dismembered limbs, and in a number of major paintings she projects her own disability onto inanimate

objects, painting clay idols, tables and various other artefacts with broken feet or wounded legs.[5]

Kahlo's repeated visual allusions to her atrophied leg refer not only to her childhood bout with polio, but also to subsequent orthopaedic problems. The persistence of direct and oblique images of the maimed limb indicates that she never completely recovered from this formative trauma, and that the pain associated with it was triggered and reactivated time and again. Kahlo titled one of her paintings *Remembrance of an Open Wound*. The Greek word *trauma* literally means 'wound' – and is thus evoked by Kahlo's imagery, which reflects her recurring sense of pain, unhealed and always remembered. Her layered images, then, relate to a dominant characteristic of trauma: the traumatized individual cannot relegate the original 'event' to the past. Symptoms or traces of traumata are forever part and parcel of her present tense, consistently disrupting the forward motion of time and with it the ability to move beyond the pain, to move on with her life. The unhealed traumatic wound, with its physical and emotional residue and visible and invisible scars, found potent expression and a meaningful outlet in Kahlo's visual articulations of her broken body.

In order to help her cope with the debilitating emotional impact of her disease, six-year-old Frida invented an imaginary companion. The artist recorded this childhood experience in her diary, in a four-page memory text dated 1950 and entitled 'The Origin of the two Fridas = Memory':

I must have been six years old when I intensely experienced an imaginary friendship with a little girl . . . who was my age more or less. On the glass window of what at the time was my room, and which faced Allende street, upon one of the first glass panes of the window I let out vapor. And with one finger I drew a 'door' . . . Through the 'door' I went out in my imagination, with great joy and urgency. I crossed an entire field that I saw until I

arrived at a dairy shop called PINZÓN . . . Through the O of
PINZÓN I entered, and descended . . . to the interior of the earth
where my 'imaginary friend' was always waiting for me. I don't
remember her image or her color. But I do know that she was
happy – and laughed a lot. Without making a sound. She was
agile and danced as if she weighed nothing at all. I followed her
every move and while she danced I told her all my secret prob-
lems. Which ones? I don't remember. But she knew everything
about me from my voice . . . When I returned to the window,
entering through the same door I drew on the glass. How long?
How much time was I with 'her'? I don't know. It could have
been a second or a million years. I was happy. I erased the 'door'
with my hand and it 'disappeared'. I ran with my secret and my
joy until the far corner of the patio of my house, and always in
the same place, under the cedar tree, I yelled and cried, surprised
at being alone with my great happiness and the memory, so
vivid, of the girl. 34 years have passed since I experienced this
magic friendship and each time I remember it, it lives anew and
becomes greater and greater inside my world. PINZÓN. 1950.
Frida Kahlo.[6]

Children often invent imaginary companions in times of stress,
loneliness or crisis. Imaginary companions are often endowed with
'all the attributes the child lacks' and, as such, are ideal alter egos.
They are also much-needed friends at a time when a child feels
'loneliness, neglect, and rejection'.[7] The appearance of Kahlo's
imaginary companion – a much-needed friend and an ideal alter
ego – during her childhood illness is quite typical.

The name that Kahlo gave to the dairy shop, Pinzón, cannot be
arbitrary. 'Pinzón' is the name of a bird, specifically a finch. Kahlo's
use of bird symbolism was profuse. In one of her diary entries she
wrote: 'I am a bird.'[8] The artist – first as a crippled child, later as a
bedridden adult – clearly craved the ultimate freedom of motion

epitomized by flight. Kahlo's imaginary companion – an alternate Self – could dance in a way that defied gravity, like a weightless entity. In her fantasy, Kahlo, too, was able to enter through the 'o' of 'Pinzón' and symbolically merge with the magical bird. Thus, she, too, was able to fly.

Visually, throughout the text, Kahlo illustrates the letter 'o' of Pinzón as a perfect circle, suggesting an archetypal symbol of wholeness and unity. Kahlo, maimed and deformed by her illness, aspired to be whole, as she entered the perfect circle.[9] The circle is also a magical portal that leads into a liminal space of the imagination. As an adult, Kahlo would access this space through her art. She culminated the diary entry with a visual illustration of her childhood memory. The illustration reveals aspects of the experience that the narrative text does not. For example, Kahlo shows her child-self situated in a room full of threatening amorphic forms and scribbles. The abstract quality of these aggressive shapes alludes to the child's inability to define clearly or articulate what she senses as disturbing and unpleasant. What is clear is that she turns her back to these encroaching negative forms and faces the window, seeking relief. The entire episode is thus contextualized, and the fact that Kahlo had a reason for inventing her imaginary companion is inferred. The function and capacity of visual art to articulate what cannot be uttered in words is lucidly expressed here.

Kahlo depicts the window in a way that conveys its dual function. Two images appear on the windowpane: a door and an eye. On the one hand, the window functions as a transparent threshold between inside and outside; symbolically, the artist creates a door on the glass pane through which she attempts to escape and find refuge in a realm beyond the confines of her painful reality. The fact that the door she drew is barred may indicate that such refuge is difficult to attain. But, simultaneously, as the child looks at the glass pane, an image of her own eye gazes back at her. The window becomes a looking glass that reflects the child's 'double', her secret friend.

Hence, as Kahlo turned her back to the chaotic and troubled reality and faced the glass, her double appeared. Looking back at her – eye to eye – she offers release into a fantasy world of flight, laughter and order. Kahlo's memory, then, was of a metaphoric inward voyage, through which she found an alternative self.

Kahlo titled her memory text 'The Origin of the Two Fridas'. In doing so, she identified the imaginary friendship as the source of her doubled self. Scholars have linked this text to a specific painting of 1939, *The Two Fridas*, but I think the artist was referring to a broader and deeper phenomenon. In 1950, when she chose to commit this memory to writing, she had already completed most of her self-portraits and all her explicit doubled self-portraits. Thus, the text reflects the artist's hindsight understanding that her self-image and its manifestation in her art evolved (originated) from the seed of her childhood experience. Kahlo associated this

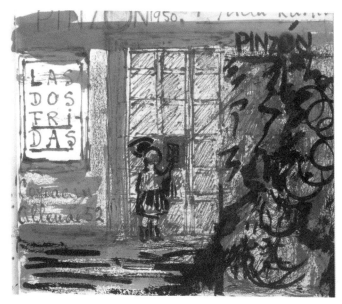

Frida Kahlo, diary entry, 'Origin of the Two Fridas', detail, 1950.

formative experience of seeing her 'second self' on the window-pane of her bedroom with her adult activity as an artist, whose self-portraits also functioned as metaphoric windows, mirrors and liminal spaces of the imagination.

On 17 September 1925, at the end of an uneventful school day, the eighteen-year-old Frida Kahlo and her boyfriend Alejandro Gómez Arias got on a bus in Mexico City en route to Coyoacán. A short time after they embarked, an electric tram crashed into the bus, killing several people. Kahlo suffered multiple injuries: her spinal column was broken in three places; her collarbone and two ribs were broken; her right leg had eleven fractures and the right foot was crushed; her left shoulder was out of joint and her pelvis was broken in three places.[10] Most horrifying of all, as the medical records document in chillingly laconic terms, she suffered a 'penetrating abdominal wound caused by iron handrail entering left hip, exiting through the vagina and tearing left lip'.[11]

Emergency medics at the scene originally left Kahlo for dead. Against all odds, she survived.[12] She spent several months at the Red Cross hospital before going home for a longer period of con-valescence. The accident devastated Kahlo's body and changed her life radically. Though at times she seemed to lead a semi-normal existence, the damage done – particularly to her reproductive system and spinal column, and the injuries that exacerbated the state of her polio-stricken limb – continued to torment the artist until her death. A friend, the writer Andrés Henestrosa, wrote that Kahlo survived the accident but 'lived dying'.[13]

In addition to her grave physical condition, Kahlo endured immense emotional hardship. Her letters from this period and her later accounts of the events reveal that following the accident she felt virtually abandoned. Her father, Frida said, reacted so strongly and was so overcome by grief that he became extremely ill and could come to the hospital only after twenty days.[14] Although there is evidence to the contrary, she claimed that her mother did not

come to see her at all, reiterating her strong ongoing sense of maternal abandonment. To her great dismay, Gómez Arias did not visit either. In fact, he apparently broke off their relationship when she was still in hospital, and before she recovered he left for Europe without saying goodbye.[15] Years later she recalled: 'I was already in a cast, after the accident, and Gómez Arias told me that an uncle was going to take him to Europe and that he would not leave me, but he lied to me. I received a letter from him from Veracruz saying he was leaving. It hurt me very much.'[16] It is not difficult to imagine that, particularly in this vulnerable state, Kahlo suffered greatly from these 'abandonments' and neglect. 'Nobody paid any attention to me', she recalled towards the end of her life.[17]

Kahlo's life changed dramatically in other ways as well. Before the accident, she was enrolled in the National Preparatory School, one of Mexico's finest educational institutions, and was planning to pursue a medical career. She was at the hub of a group of youthful intellectuals and political activists, immersed in Mexican modernism, communist politics and avant-garde literature, art and culture. After the accident, she gave up her plans to become a doctor. In fact, she never even went back to school. In 1945 she wrote: 'I was . . . enthusiastic about studying to become a doctor. All that was thwarted by the collision of a Coyoacán bus with a Tlalpan tram.'[18]

The family's already strained finances deteriorated rapidly, with every medical bill further aggravating the situation. Kahlo confided to her friends that she had to find a job as soon as she could stand on her feet again. Gómez Arias recalled that she found a temporary job at a pharmacy and later tried to work a cash register at a local store, but failed at both miserably.[19] At one point she planned to make microscopic medical illustrations as a way of earning a living, combining her interest in science with her aptitude for drawing, but this too came to naught.

Eventually, as is well known, Frida Kahlo became a painter, though she was never able to support herself by selling art. More

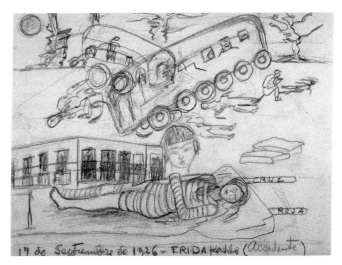

Frida Kahlo, *Accident Drawing*, 1926, pencil on paper.

than six decades after the fact, with tears in his eyes, Gómez Arias described the impact of the accident, which he dubbed 'our tragedy', on Kahlo's life:

> What happened eventually determined her fate . . . She was in the old Red Cross hospital for weeks, later they took her home, in bed paralysed and unable to move . . . she began to paint her own image as reflected in a mirror that was suspended from the ceiling . . . She always had the inclination to draw but was an autodidact. She went to painting school in Coyoacán but left, she was self-taught . . . During the long period of recuperation, Frida discovered that her real career would be painting. A new life.[20]

On 17 September 1926, the first anniversary of the accident, Kahlo drew an illustration of the event. It is a pencil drawing that is pervaded by duality. In terms of composition, it is divided into two horizontal sections; in terms of imagery, it depicts 'two

Fridas'; finally, it is even signed twice, once 'Frieda' and a second time 'Frida'.

The horizontal division of the drawing creates two separate sections, each of which uses a different scale and a different mode of representation. The top half sketchily illustrates the objective, external events of the day: the collision between the bus and the tram. A tree on the top right-hand corner and a sun at the upper left mark the time and place of the accident. Around the colliding vehicles, bodies and blotches that seem to indicate blood may be discerned. A despondent human figure sits near one of the stick-figure bodies.

The bottom section of the drawing conveys aspects of Kahlo's subjective, internal experiences at the time of the accident. Proportionately larger than the narrative scene on top, the figure of a young girl, wrapped in bandages and lying on top of a stretcher that is labelled 'Roja Cruz' (Red Cross), is seen. She is the wounded Kahlo, the protagonist of both objective and subjective tales. Kahlo looks younger than her eighteen years, for, as she told Tibol, 'I was eighteen then but I looked much younger, even younger than Cristi who was eleven months younger than me.'[21] Almost her entire body is covered with bandages. Her right leg is hidden from view completely, while her left leg seems to be the only undamaged part of her body.

A large, decapitated head hovers above the body of the wounded, shrouded Kahlo. The face bears Kahlo's features and is the artist's first known visualization of her second self. The drawing may present a visualization of 'splitting', a common defence mechanism used to cope with traumatic events. At the time of the accident Kahlo's situation was so grave and life-threatening that she felt compelled to disassociate herself from her own bodily sensations and death fears in order to survive. Only through the separation of the physical self from the conscious, 'thinking' self could she cope with such overwhelming sensations of pain, grief, anxiety and fear.[22]

Kahlo's visualization of splitting is related in an important way to her childhood experience of an imaginary friendship. Both were distinct coping devices developed by the artist in order to counter physical and emotional trauma and to combat her sense of incompleteness, damage and rejection. She eventually expressed the experiences as multiple self-portraits, or self-created 'doubles'.[23] Thereafter, she painted her 'selves' again and again. 'I paint myself because I am so often alone', Kahlo said.[24] This statement is usually interpreted as the artist's explanation for using her own face as the model for her paintings. The statement, however, may be read in a different way, implying that, for Kahlo, painting was a way of coping with being alone. That is, she painted herself as a second self, or 'imaginary companion', *because* she was so often emotionally alone.

Kahlo was plagued with serious medical problems throughout her life, most of them related to her accident wounds and perhaps also to the polio. The condition of her spinal column and polio-stricken limb deteriorated throughout her life, curtailing her mobility. She was often forced to wear corsets and a variety of medical contraptions. Although she could often walk on her own, she was at times bedridden or in need of a wheelchair. In addition to these physical restrictions, the accident may have contributed to the fact that Kahlo would never bear children.

Gómez Arias suggested that her constant pain and the desire to overcome it became a defining aspect of her identity: 'The essential in Frida is a sick woman, intelligent, with a great passion for life beyond her sickness.'[25] Many of Kahlo's paintings present her broken body as the site of physical and psychic struggles. In her paintings, drawings and diary entries she used a variety of visual idioms derived from medical, religious, artistic and symbolic sources to express the emotional, spiritual and physical experience of the body in pain.

In an insightful essay, Carlos Fuentes linked Kahlo's paintings with Elaine Scarry's magisterial study titled *The Body in Pain* (1985).[26]

Scarry claims that physical pain is rarely expressed in literature and never adequately verbalized. Fuentes asserts poignantly that, in contrast, Kahlo's paintings are able to convey pain. Pain is not merely something that cannot be put into words, Scarry argues. It is an emotion that actively obliterates language. A person who feels pain reverts to inaudible sighs or inarticulate utterances: 'Physical pain does not simply resist language but actively destroys it, bringing about an immediate reversion to a state anterior to language, to the sounds and cries a human being makes before language is learned.'[27] The inability to verbalize pain adequately creates a deep chasm – an epistemic crisis – that separates the individual who feels pain from the rest of the world:

> For the person in pain . . . 'having pain' may come to be thought of as the most vibrant example of what it is to 'have certainty', while for the other person it is so elusive that 'hearing about pain' may exist as the primary model of what it is 'to have doubt'. Thus pain comes unsharably into our midst as at once that which cannot be denied and that which cannot be confirmed.[28]

The 'unsharable' nature of pain, Scarry goes on to argue, triggers a chain reaction that isolates the bearer of pain and frequently leads to a lack of compassion, alienation and often even cruelty on the part of those who are not afflicted and lack the capacity to acknowledge, let alone comprehend its existence.

Trauma – defined as a wounding event but also as the symptoms and complex responses instigated by the event – causes a specific type of psychological and physical pain, not discussed by Scarry but relevant to this discussion of Kahlo's art. The pain induced by trauma is particularly resistant to verbal articulation since trauma victims often repress, seemingly forget or otherwise blur the contours of the 'open' traumatic wound. Yet the pain of trauma – by definition – can never be truly forgotten. It is, in fact, always

present, even though it is usually irretrievable as a direct verbal articulation. Significantly, that which cannot be defined with words or is deemed too painful or dangerous to enunciate verbally may be alluded to or visually expressed in art.

Kahlo's paintings offer a visual vocabulary with which trauma and pain can be transmitted or communicated with dignity and compassion. Through the language of her innovative art Kahlo gives voice to silenced, unresolved traumata. She thus obliterates the barrier between the individual experiencing pain and the viewer, and evokes empathy for our shared human fragility.

3

On the Cusp of Womanhood

A little while ago, not much more than a few days ago, I was a child
who went about in a world of colors, of hard and tangible forms . . .
Now I live in a painful planet, transparent as ice; but it is as if I had
learned everything at once in seconds. My friends, my companions
became women slowly, I became old in instants and everything today
is bland and lucid.

Frida Kahlo[1]

At the time of the accident in 1925 – the major fault line that
shattered Kahlo's youthful promise – the eighteen-year-old was
engaged in an intensive process of intellectual, emotional and
political growth. Alejandro Gómez Arias described Frida's
adolescence as a 'complete metamorphosis . . . [from a] parochial,
middle-class *muchacha* from Coyoacán to a brilliant young woman'.[2]
It began in 1922 when Kahlo transferred to the prestigious National
Preparatory School in Mexico City. Before that her schooling was,
to use her own words, 'mediocre but secular'. Whereas her older
sisters were sent to convent schools, Frida and Cristina attended
the neighbourhood kindergarten and public primary school in
Coyoacán. Apparently, they were home-schooled for two years
when Frida was in the fifth and sixth grades. Later, Frida alone
attended the German school, from which she was expelled after
less than a year for being disobedient. Prompted by her mother,
who urged her to follow a traditional track and become a teacher,

Frida Kahlo, *Memory*, 1937, oil on metal.

Frida was enrolled in a vocational teachers' school at the Mascarones building in Mexico City. Her parents took her out abruptly when they discovered that she was in love and had an affair with her gym teacher, Sara Zenil.[3]

Gómez Arias vividly remembered the first time he laid eyes on the young Frida: 'She was wearing the German school uniform: a dark skirt, white blouse, and a straw hat.' Numerous images echo Alejandro's recollections: Kahlo's first Preparatoria student card displays a 1922 photograph of the impish Frida. A couple of her pencil sketches show her wearing the beribboned straw hat that Gómez Arias described with words accompanied by expansive hand gestures.[4]

Kahlo's painting *Memory* of 1937 displays an empty school uniform, composed of the white shirt and dark skirt, as a stand-in for the artist as a child. The painting is multivalent and highly symbolic, but on one level it may be viewed as a visualization of Kahlo's 'metamorphosis' from childhood to adulthood, witnessed by Gómez Arias. That this transformation was challenging, wounding and painful may be gauged from the imagery itself, as well as from additional sources noted below.[5]

The National Preparatory School, according to Gómez Arias, changed the introverted little girl into a voracious reader, an out-spoken personality with 'a touch of genius', a sophisticated young woman who was deeply immersed and seriously committed to Mexican culture, political activism and issues of social justice.[6] In the 1920s the school was one of the best educational institutions in the country and Kahlo was one of 35 female students among a select student body of approximately 2,000.[7] In addition to being highly competitive, the Preparatoria was a nexus where some of the best young minds of Mexico were cultivated and encouraged to engage in critical and creative thinking. The challenging course of studies Kahlo was pursuing was intended to prepare her for medical school. During her teenage years, then, she not only

received an outstanding and broad education, but was also exposed to diverse traditions and innovative ideas, absorbing Mexican nationalism, communist ideology, the philosophy of Vasconcelos, world literature, history, culture and cutting-edge scientific discoveries both inside and outside the classroom. According to the testimony of her friends, Kahlo spent more time in the library than at home and she was never without several books under her arm. Her letters – spanning from youth to the end of her life – are replete with references to books from several genres, which she read in Spanish and English (the level of her German is unclear). A close analysis of her library offers a fascinating glimpse into her mental and intellectual worlds, the seeds of which were planted during her three years at the National Preparatory School.[8]

Kahlo and her classmates developed an intense interest in Mexico, exploring its layered histories, archaeology, customs, languages, literature, folk art, songs, film and peoples. Her budding interest in culture from other regions grew into an unquenchable thirst for art-history books that explored the cultures of Europe, the Americas, Oceania, Eastern Asia and Africa. Her interest in literature both popular and canonical, prose as well as poetry, was also reflected in the books she read. Her eclectic taste included the classics, but also contemporary works by North American, Russian, Spanish, Mexican, Latin American, French and German writers. In her youth she read Oscar Wilde over and over again. In the final years of her life, she kept Walt Whitman's *Leaves of Grass* at her bedside. Her predilection for poetry found expression in a poem she published in 1922 and in the rhyming verses she periodically composed for friends.[9] Eventually, she would meet and befriend many of the literary luminaries of her time: André Breton, Gabriela Mistral, Octavio Paz and Pablo Neruda. Other writers who were successful during Kahlo's lifetime, but whose fame has since waned, were also among her friends (for example, the poet Mary Channing Wister wrote Kahlo long confidential letters in 1932).[10]

Kahlo's interest in people prompted her to read biographies with relish. The lives of political leaders, artists, feminist activists and scientists fascinated her. Nine out of the 25 biographies that remained in her library when she died were devoted to women, among them Catherine of Aragon, Catherine the Great, George Sand and the women's rights activist Margaret Sanger. An unpublished note from Margaret Sanger to Diego Rivera reveals that Kahlo and Sanger met during the latter's visit to Mexico, and that the reproduction rights advocate was totally charmed by Kahlo and tried to schedule additional meetings with her. Sanger wrote to Rivera thanking him for introducing 'your lovely Frieda' and explaining that she was writing to him because 'it was stupid of me not to get Frieda's address, but the place, atmosphere, her works and personality were all so enchanting that the future eluded me entirely'.[11] In addition, Kahlo amassed a huge collection of books about communism and socialism as well as science. Books about Jewish history and culture in Mexico and Europe are also found in Kahlo's library.

Carlos Fuentes has observed that Kahlo's personal development was linked with the intersecting revolutions that dominated the early twentieth century: the Mexican Revolution, the Russian Revolution and the Freudian Revolution.[12] Her deep and lifelong study of history and politics, science and psychology, literature and culture began soon after she crossed the threshold of the elite school as an inquisitive and intellectually curious teenager on the cusp of womanhood.

Kahlo's social transformation was intertwined with her intellectual growth. She became part of a group of nine nicknamed the *Cachuchas*, many of whom were to become prominent members of Mexico's elite. 'Until then', Kahlo recalled, 'I had really not read anything. I owe [the *Cachuchas*] for getting me interested in literature of all types, about everything.'[13] The group's much-admired leader was Alejandro Gómez Arias, and soon after her arrival at school Kahlo became his girlfriend. Their amorous relationship lasted

Unknown photographer, Alejandro Gómez Arias, c. 1925.

off and on from around 1922 until the accident. Despite her disappointment at their subsequent break-up, their deep friendship continued until the artist's death.

Contrary to prevailing notions regarding the trajectory of Kahlo's biography, her life had its share of complications and drama long before she met Rivera and even before the fateful accident. In an interview of 1950, Kahlo confided that during their time together Gómez Arias was simultaneously involved in a homosexual relationship with Jesús Ríos Ibúñez y Valles, one of their classmates nicknamed Chucho Paisajes:

> I fell in love with Gómez Arias and he with me . . . Gómez Arias and I were sweethearts. But Alejandro was in love at the same time with Chucho Paisajes, whom he screwed. Chucho Paisajes and I would talk of our mutual infatuation with Gómez Arias, and we would give each other advice. Chucho Paisajes, to this day, continues to be in love with him . . . I never had anyone who loved only me. I have always shared love with another.[14]

Kahlo recalled this experience and the emotions it evoked in conjunction with earlier instances of 'shared love' and the pain they inflicted. One was her deep sibling rivalry with Cristina. The other was the aforementioned crush and apparent sexual liaison with her teacher, Sara Zenil, which she reluctantly 'shared' with two classmates: 'I fell in love with [Sara Zenil]. She was very affectionate. She would sit me on her lap . . . the three of us [the others were Ana Carmen del Moral and Lucha Rondero] were in love with her, and we were jealous of one another.'[15] It seems plausible that Kahlo's adult relationship with Rivera, with its intricate mutual infidelities and homoerotic accents, continued a pattern that was set during her early years.

After the accident, while she was recovering, the bedridden Kahlo began to paint portraits of her friends, as well as self-portraits that she gave as gifts to the people she loved. In hindsight, it seems that this was her way of keeping connected with her social circle, since she never went back to school and, as her letters express, felt lonely and isolated in Coyoacán.

Two significant images that she produced in 1926, the previously discussed *Accident Drawing* and her first self-portrait oil painting, painted for Gómez Arias, reveal recurring patterns that would persist throughout the artist's life. One work exposed her inner turmoil, while the other presented a facade. Whereas *Accident Drawing* displays Frida as a fragmented little girl, who is in the process of 'splitting' in response to trauma, the oil painting portrays her as a seductive young woman, who plays the role of a beautiful Venus-like beloved. Kahlo dubbed this first self-portrait 'Your Botticelli' when she gave it to Gómez Arias and it came with explicit written instructions: 'I implore you to put it somewhere low, where you can look at it as if you were looking at me.'[16] From 1926 until her death she would continue to paint and draw numerous self-portraits, bestowing them as binding gifts to her husband, Diego Rivera, and to friends, lovers and admirers, beseeching them to remember her, always.

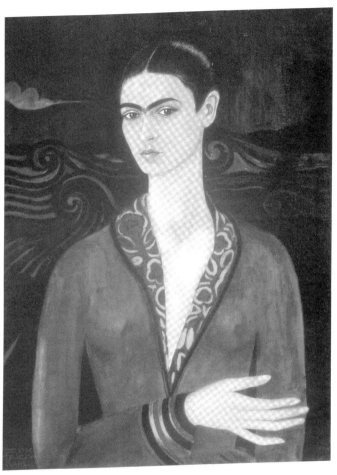

Frida Kahlo, *Self-portrait*, 1926, oil on canvas.

Kahlo's *Self-portrait* of 1926 presents the nineteen-year-old Kahlo as a beautiful young woman. The ocean waves behind her, the emphasized hand that approximates the *venus pudica* gesture, the dimpled chin and long neck, are all tell-tale signs of Kahlo's attempt (albeit as a beginner) to mould herself in the image of

Botticelli's *Venus*. Her deliberately Germanized signature (Frieda) and the German caption inscribed on the back of the canvas ('Heute ist immer noch') align her with European art and with her German heritage in particular. The fact that Alejandro was travelling in Germany at the time was probably also an incentive to affiliate herself with German culture. The inner schism and contradictions reflected in Kahlo's simultaneous self-portrayal as a broken 'splitting' child on the one hand and as a seductive love goddess on the other would henceforth dominate her art.

Kahlo's voluminous correspondence from this period exposes additional gaps that pervaded her conflict-ridden adolescence and painful transition into womanhood. In a few letters she expresses an overt desire to be Gómez Arias's 'little woman', whom he might 'carry in [his] pocket [like] a little tiny thing'.[17] After an argument, Kahlo assumes a virtually selfless position as she promises to become 'good' for her man, 'made to order' according to his very wishes.[18] Elsewhere, she expresses her desire to become his wife and a willingness to remake herself for his sake.[19] In certain sections of these letters, Kahlo reveals profound self-deprecation and a form of internalized misogyny: 'don't believe a dog's limp and a woman's tears', she wrote less than a month after the accident,[20] expressing the sexist idea that all women are both uncontrollably emotional and manipulative. Kahlo's use of an idiom that equates women with dogs and labels both liars, combined with the fact that she herself both limped and wept inconsolably after the accident, is a particularly painful example of a woman who has embraced the very social conventions that denigrate and oppress her.

Kahlo's letters from 1925 to 1927 reveal a deep ambivalence: she clearly espoused many of the social conventions and sexist biases of Mexican society, yet her writing also exposes an undercurrent of critical thinking and rebelliousness. A budding proto-feminist realization that something is wrong with prevailing macho attitudes towards women may be discerned in her correspondence.

A major issue that apparently gave rise to Kahlo's questioning of accepted norms and social codes was her struggle with her own sexuality. Rejecting her mother's Catholic upbringing, which viewed sexually active unmarried women as inherently immoral, the teenager attempted to assert her right to sexual freedom. Her affair with Sara Zenil and an alleged sexual liaison with Fernando Fernández, one of her father's friends who taught her drawing for a brief period, attest to the fact that even at a young age she attempted to break conventions and follow her own desires.[21] Yet, at this early stage, she could not free herself entirely from stereotypical views about 'loose' women. For example, in a desperate attempt to salvage her 'sullied' reputation, she wrote to Gómez Arias: 'I will never forget that you, whom I have loved as I love myself or more, saw me as a Nahui Olin or even worse than she, who is an example of all of those women.'[22] (Nahui Olin was a liberated artist, poet and model who had posed for Rivera's Preparatory School mural as the allegory for Erotic Poetry. She was also reputed to be one of Rivera's mistresses.[23]) In this letter, then, eighteen-year-old Kahlo confusedly tried to distance herself from Nahui Olin – the paradigmatic 'loose' woman – rather than stand up for her right to be sexually free. Kahlo's friends, interviewed after the sexual revolution of the 1960s, defined the artist as an independent woman, liberated before her time.[24] Raquel Tibol, who met the artist less than a year before her death, also stressed Kahlo's liberation from hypocritical bourgeois morality.[25] Kahlo's early writings and her paintings reveal a much more conflicted attitude. Although as an adult she rationally rejected standard moral codes and the misogynist attitudes of Mexican society, it seems that in the early years she never completely forgot the strict teachings and harsh upbringing of her devoutly Catholic mother and could not easily and fully disengage from the social conventions of her time.

4

Coming of Age

Shortly after her romantic involvement with Gómez Arias ended, Kahlo's lifelong partnership with Diego Rivera began. It was an unusual relationship that spanned almost three decades and has been variously understood and misunderstood. Both Kahlo and Rivera provided a plethora of textual and visual testimonies – factual, fabricated or fictitious – regarding their relationship. Diego Rivera was a notorious mythmaker and his propensity for tall tales became almost as famous as his frescos. It frustrated his biographers, but delighted the public and the press. One can only speculate that Kahlo learned from him when she began to invent her own mythic persona. Rivera's most prolific biographer, Bertram Wolfe, described Rivera's 'endless labyrinth of fables' in poetic terms:

> The tall tales for which Diego was famous, improvised effortlessly as a spider spins his web, their pattern changing with each retelling, were fables wrapped in fables, woven so skillfully out of truth and fantasy that one thread could not be distinguished from the other, told with such artistry that they compelled the momentary suspension of disbelief.[1]

Additional sources, ranging from newspaper reports, official documents and eyewitness accounts, intersect with the couple's own multiple narratives. Together they expose rather than resolve many

questions and contradictions regarding this volatile tale of love and cruelty; marriage, divorce and remarriage; devotion and betrayal.

Colourful accounts of Kahlo's youthful encounter with Rivera abound. While she was a student at the National Preparatory School, Rivera painted a mural there, and legend has it that the 15-year-old Frida taunted the great maestro, played tricks on him and became infatuated.[2] Their adult relationship, however, began only in July 1928, about one month after Rivera had returned to Mexico from the Soviet Union.[3] One version reports that the couple met at the home of the Italian-born photographer and political activist Tina Modotti.[4] Modotti is credited with encouraging Kahlo to join the Mexican Communist Party as a teenager. It seems likely that Kahlo's youthful immersion in photography, gained through her father, also drew her to Modotti and her circle. Another, more

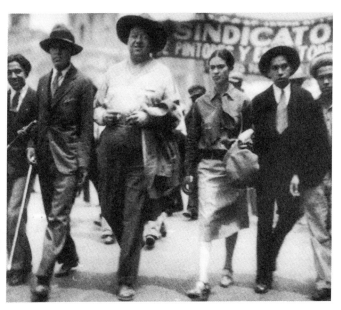

Frida Kahlo and Diego Rivera at a demonstration, 1 May 1929 (unknown photographer).

colourful account describes Kahlo boldly interrupting Rivera as he was painting a mural, commanding him to come down from the scaffold, and asking him to look at her paintings and tell her candidly whether she had the talent to become a professional painter.[5]

The Kahlo–Rivera courtship lasted a little over a year and must have been highly unconventional. Bertram Wolfe reported in Rivera's biography that 'at no time in his life did Diego have so many affairs as during this year that elapsed from the time of his return from Russia in the summer of 1928 to the summer of 1929'.[6] Although she was not the only woman in his life, however, Kahlo undoubtedly played a major and significant role. Wolfe recalled that when a friend, Rafael Carrillo, showed him a reproduction of Rivera's mural of 1928–9 in which a portrait of Kahlo appears, Wolfe immediately remarked: 'Diego has a new girl.' Carillo reportedly replied: 'You're right, I guess. She's a nice kid. Bright as an eagle. A member of the Young Communist League. Only eighteen. Her name's Carmen Frida Kahlo.'[7] Rivera's portrait of Kahlo appears in a panel titled *Distributing Arms* at the Secretaría de Educación Público in Mexico City and speaks volumes about his perception of his future wife. Kahlo stands at the centre of this panel wearing what appears to be a man's red shirt with a red star fastened above the left pocket and a plain (Wolfe wrote 'severe') black skirt that is partially hidden behind a large wooden crate. Her cropped black hair, boyish facial features and loose attire hide any trace of femininity. Wolfe correctly observed that, rather than being womanly, Kahlo in this portrait possesses 'the aspect of an adolescent boy'.[8] This image contrasts sharply with Rivera's vision of his former wife, Lupe Marín, whom he portrayed time and again as a voluptuous nude, the epitome of female sexuality.

Kahlo's *Self-portrait* (erroneously titled *Time Flies*) of 1929, painted a few months after Rivera had completed his fresco, displays an entirely different image. Certainly not boyish, Kahlo portrays herself looking straight ahead. Her elongated, beautiful

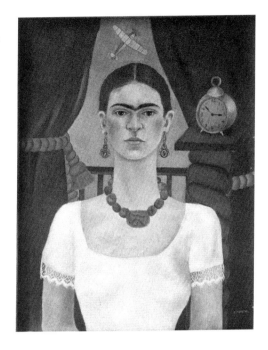

Frida Kahlo,
Self-portrait, 1929,
oil on masonite.

neck is decorated with a jade bead necklace; a white, lace-trimmed shirt emphasizes her firm round breasts; long and elaborate earrings further accentuate her femininity. Although this work differs from her aforementioned 'Botticelli' self-portrait of 1926, it is also similar to it in that once again she displays herself in the role of the beloved. She is no longer Gómez Arias's 'Botticelli Venus' with her European demeanour and Germanized signature 'Frieda'. Here, Kahlo presents herself as Rivera's *mestiza* young woman.[9] This *Self-portrait* emphasizes *mexicanidad* both in content and in style. Kahlo's popular Mexican attire and Aztec necklace indicate her identification with native culture. The pictorial formula, which places a figure between open curtains, is derived from Mexican colonial portraiture. This combination stresses the artist's demonstrative affiliation with the multi-layered cultures of Mexico.

Kahlo's specific jade Aztec necklace functions as a signifier of her sexual identity as well. In the painting, the artist faithfully copied a necklace that she owned and often wore, as many photographs from this period clearly show.[10] The art historian Janice Helland correctly identified one of the glyphs incised on the large jade stone: the circle from which four lines emanate is the sign for 'movement'.[11] The Nahuatl name for this glyph is 'Olin'. Four notches are incised on the top rim of the central stone. The Nahuatl word for the number four is 'Nahui'.[12] Thus, the Nahuatl term 'Nahui Olin' is incised upon the central stone of Kahlo's necklace. The term is generally associated with the four corners of the earth. For Kahlo, however, Nahui Olin was first and foremost the name of the artist and model that she had known by reputation since she was a student at the Preparatory School. By 1929 Kahlo knew her personally as well through Modotti and Rivera.[13] Whereas the Frida of 1926 attempted to distance herself from that type of 'loose' woman, the Kahlo of 1929 tried to identify with Nahui Olin, whom Rivera had once painted as the personification of Erotic Poetry. Like Nahui Olin, who adopted a Nahuatl name as an act of identification with native Mexican culture, Kahlo painted herself with emblems of her Mexican heritage. Also, by wearing the 'Nahui Olin' stone, she may have been signalling her transformation into a sexually liberated woman and specifically Rivera's lover. In this context, the clock in the painting could indicate that her time has come. The aeroplane seen in the sky behind her could be a symbol of modernity. In this work, Kahlo painted herself as she wanted Rivera to see her: a sexually ripe, modern and beloved woman with whom he might share his future. Significantly, already at this early stage of their relationship, a great gap existed between Kahlo's self-image and Rivera's vision of her. For him, as the mural portrait reveals, she was no voluptuous Nahui Olin, but rather a boyish, asexual Communist comrade.

The 22-year-old Kahlo and 43-year-old Rivera were married on 21 August 1929, at Coyoacán town hall. Kahlo was Rivera's third wife.[14]

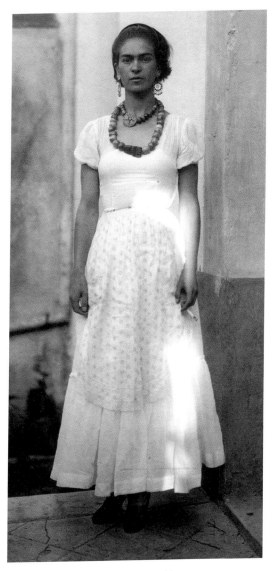

Frida Kahlo wearing the 'Nahui Olin' necklace, 1929,
photo by Guillermo Davila.

During his fourteen-year stay in Europe (1907–21), Rivera had lived with Angelina Beloff, who became his common-law wife. In 1916 she bore him a son, who died two years later. During this time, Rivera had an affair with Marievna Vorobiev-Stebelska, and their daughter, Marika, was born in 1919. Back in Mexico, Rivera married Guadalupe Marín in 1922. They had two daughters, Lupe (b. 1924) and Ruth (b. 1927). In 1927 Rivera and Marín were divorced. Decades later, exactly one year after Kahlo died, in July 1955, Rivera married Emma Hurtado.[15] Unlike his first wives, Kahlo did not have any children. Her childlessness eventually became a major component of her self-image.

Rivera was a huge man with endless energy; Kahlo was petite and physically fragile. Kahlo said that her parents described their union as a marriage between 'an elephant and a dove'.[16] Apparently Kahlo tried to play the role of the devoted wife during the first years of their marriage. She accompanied Rivera, who was a greatly sought-after muralist, and tried to 'take care of him' wherever he went: from Mexico City to Cuernavaca in 1929, then to San Francisco in November 1930, back to Mexico in mid-1931, followed by a sea voyage on the 'Turbo Electric Liner Morro Castle' that sailed from Veracruz through Havana to New York, where Rivera had a one-man exhibition at the newly opened Museum of Modern Art.[17] Kahlo and Rivera resided in New York from mid-November 1931 until the early spring of 1932, when they travelled to Detroit, since Rivera was commissioned to paint a cycle of murals there, inspired by the Ford Motor Company. They were back in New York in March 1933, and returned to Mexico at the end of that year.

But the Rivera–Kahlo union was not always characterized by 'care' or devotion. Though they seem to have loved each other profoundly, they were sometimes extremely cruel to one another. Rivera's numerous and flagrant affairs with other women were a major source of pain for Kahlo. She also engaged in extramarital relationships with both men and women, although these were more

discreet. Sadly, Rivera's cruelty often seemed deliberate, as he wrote in a most disturbing passage in his autobiography: 'If I loved a woman, the more I loved her, the more I wanted to hurt her. Frida was only the most obvious victim of this disgusting trait.'[18]

The extreme highs and lows of the Rivera–Kahlo relationship may be partially fathomed from Kahlo's correspondence and various other sources. During the first years of their marriage, Kahlo struggled to assert her place as Rivera's wife and companion. She managed to overcome attempts by Rivera's ex-wife Lupe Marín to humiliate her by mocking her deformed legs.[19] She even came to terms with Rivera's infidelities, though there is ample evidence that they continued to cause her much sorrow.

Both Kahlo and her relationship with Rivera flourished when the newly weds took their first trip outside Mexico. When they arrived in San Francisco in November 1930, they resided on 716 Montgomery Street, near the artists William Gerstle and Ralph Stackpole, who helped secure Rivera's commission to paint a mural at the San Francisco Stock Exchange. Rivera eventually painted two additional murals surrounded by a close-knit circle of admiring artists, benefactors and friends. Both he and Kahlo fell in love with the city and, once again, with each other.

On her arrival Kahlo sent her mother two postcards and wrote an exuberant letter to her 'papacito lindo':

San Francisco is very beautiful. Our way here was also very beautiful. For the first time I got to see the Ocean, and I loved it! The city is in a beautiful location, from everywhere you can see the sea. The bay is beautiful and ships arrive from China and from everywhere in the Orient.

Kahlo reported to her mother that Rivera was 'good to me (so far)' and much less busy than in Mexico, so they spent more time together, to her delight. They explored Stanford University,

Berkeley, Fairfax and travelled to Los Angeles as well.[20] There they met the art dealer Galka Scheyer, who maintained an intimate correspondence with Kahlo. Scheyer's letters and photographs, kept by Kahlo among her personal papers, attest to a close and supportive relationship.[21]

Kahlo was fascinated by the multiple ethnic neighbourhoods that comprised San Francisco and its vicinity and wrote to her family about this with great enthusiasm. She and Rivera lived a few blocks from Chinatown and she was mesmerized by what she saw there, as she wrote to her father: 'imagine, there are 10,000 Chinese here, in their shops they sell beautiful things, clothing and handmade fabrics of very fine silk. When I return I'll tell you all about it in detail.'[22]

The letters reveal that Kahlo was becoming aware of the power of distinct ethnic costumes. This may have prompted her to cultivate further her exotic Mexican persona. Abroad, her indigenous Mexican costumes and sartorial flair were a unique and much-admired phenomenon. 'The gringas love me', she wrote to her family, describing their admiration for her Mexican dresses, shawls and jewellery.[23] She thrived in the limelight and relished her new-found freedom, as she posed for the best photographers, befriended a host of fascinating people from all walks of life, and explored a new world with joy and curiosity. Many of the people she met maintained a lively correspondence with her after she left San Francisco, later visiting her in Detroit and Mexico, and continuing to care about her very deeply.[24] A few friendships she forged – like her deep relationship with the artist Emmy Lou Packard and with the thoracic surgeon and medical scholar Dr Leo Eloesser – were sustained until her death. Eloesser in particular played a pivotal role in Kahlo's life at significant medical and marital junctions. They met on 9 November 1930 and the next day Frida wrote to her mother raving about the doctor. His fluency in Spanish, the way he took care of her and her complete confidence in him – as medical

adviser and as a trusted friend – were transformed into a friendship of 24 years.[25] Kahlo expressed her gratitude by painting a loving portrait of her friend (*Portrait of Leo Eloesser*, 1931) that contains the inscription: 'I painted my portrait for Dr Leo Eloesser, my doctor and best friend, with all my love, Frida Kahlo'. In 1940 she gave him the stunning *Self-portrait Dedicated to Leo Eloesser* (p. 135) and in the 1950s painted a still-life for him.

While Rivera was painting his grand murals in San Francisco, Kahlo devoted time to painting. In addition to portraits of her friends, composed in the pseudo-naive style she had developed in Mexico, she produced an original and imaginative posthumous portrait of Luther Burbank (1849–1926), a botanist and scientist from Massachusetts, who had settled in California and became internationally famous for cross-breeding, grafting and hybridizing plants, including fruits and vegetables.[26] Based on a photograph, which she obtained after visiting his farm in Santa Rosa, Kahlo painted Burbank as a hybrid creature: a man, a tree-trunk, a philodendron plant and a cadaver all in one.[27]

In order fully to understand the sophisticated ideological implications of Kahlo's tribute to the late Burbank, a brief reconstruction of several pertinent issues that relate to his life and times is in order. In July 1925, less than a year before his death, Burbank (along with Kahlo and other intellectuals) was shocked by the so-called monkey trials in which John Scopes – a biology teacher from Tennessee – was put on trial and convicted for teaching Darwin's theory of evolution.[28] In reaction to this, Burbank – a great admirer of Darwin since his youth and an avid believer in evolutionary science – publicly proclaimed 'I am an Infidel', voicing his opposition to religious tenets and his utter disbelief in life after death. Burbank declared that the only thing that may remain after the body decays is the 'immortal influence' of one's good work. His proclamations made the front page of the *San Francisco Bulletin* (22 January 1926), creating what his biographer described as 'shock

Luther Burbank (unknown photographer) and Kahlo's painting *Luther Burbank*, 1931, oil on masonite.

waves around the world'. Although Kahlo arrived in California several years after Burbank's death, she met his young widow during her visit to Santa Rosa, as well as a number of his friends, and was well acquainted with his legacy. Moreover, the controversies surrounding his work, his conflicts with religious doctrines and his blasphemous public proclamations were still very much the talk of the town. As both Burbank and Kahlo would have known, hybridization and cross-breeding were strictly forbidden in Scripture (for example, Leviticus 19:19). In 1931 Kahlo chose to portray Luther Burbank – who had then been dead for five years – as a decomposing cadaver planted in the earth. Espousing his views, she relates his symbolic immortality to 'the influence of his good work' as she memorializes the creator of hybrids as a hybrid. Within the dichotomy inscribed by the Bible between purity of 'kind' – of seed and of species on the one hand and cross-breeding, mixing and hybridization, on the other – Kahlo clearly chose to embrace hybridity, which is associated here with science, but also with freedom and unbridled creativity.

Kahlo's extraordinary intellectual, artistic and personal growth in San Francisco was captured by one of her new friends, the writer John M. Weatherwax.[29] Weatherwax was working with Sergei Eisenstein (to whom he was introduced by Upton Sinclair) on the film project *Viva Mexico* and was asked to approach Rivera to help facilitate one of the scenes to be shot on location in Mexico. The two men became friends, collaborated on a project to translate and illustrate the Mesoamerican manuscript Popol Vuh, and shared an infatuation with the exuberant Kahlo. In 1931 Weatherwax completed a dozen versions of an unpublished play and short story, both titled *The Queen of Montgomery Street.* In these manuscripts, the much-adored 'Queen Frieda' comes to life: her unique persona and dramatic appearance captivate all who come under her spell. Kahlo's childlike exuberance, playfulness and humour were among her most enduring characteristics, noted by friends, even as her

life force waned. Her love of dolls, toys, games and puppets can be sensed as one reads her letters, listens to her friends reminiscing or observes the photographs and objects she left behind.

> The Queen has been laughing and clapping her hands . . .
> Everyone has been looking at her. She is bewitching in her long,
> high-waisted grass-green dress. Over her shoulders is a bronze
> open-work shawl. About her neck is a heavy jade-green *chalchi-*
> *huitl* necklace. Her black hair is parted in the middle and drawn
> into a little knot at the back of her neck. Her cheeks and lips
> have just the right amount of rouge. Her feet are still in
> guaraches. Glowing, she returns to her seat.

Kahlo's amorous relationship with her husband is also vividly described throughout Weatherwax's texts. He wrote of them:

> they seem to be completely happy. She in her twenties, he in his
> forties. She a German-Mexican, he ever so typically Mexican.
> He gets up . . . putting an arm around the Queen. He bends
> down to her. His lips move out, making a delicate little noise.
> The Queen laughs, hugs him, and kisses him on the neck.
> Don Diego straightens up, slowly. The Queen is still clinging to
> him, her feet now twelve inches from the floor. She bites his ear,
> laughs, and lets go. Arm in arm they turn the end of the corridor,
> unlock another door, and enter the Royal Studio.

Weatherwax also provides details about Kahlo's portrait painting:

> The Queen is already hard at work. The poser doesn't crack a
> smile, doesn't even look up when the door opens. Frieda works
> like lightning. She has done many oils. If she wished, she could
> have a one-man exhibit in New York at any time . . . At last Don
> Diego comes home . . . The Queen throws her arms around his

neck, laughing gleefully. Astonishment, fear and joy struggle in Don Diego's face. The poser bows good-bye. The King and the Queen go to Frieda's gigantic easel. Don Diego looks long and soberly at his wife's work. 'Bueno', he says. After a while he adds in Spanish, 'A pure and strong woman's spirit is as precious as the light of the stars.'

Later accounts of Kahlo's studio practice suggest that until the last years of her life, and with the exception of periods when her health was failing, she continued to work with focus, precision and speed. Her student Fanny Rabel, her nurse Judith Ferreto and her friend Natasha Gelman noted how neatly she painted, in an organized manner that depended on her 'strict order' of laying out her meticulously clean sable brushes and well-chosen paints.[30] Another friend, the artist Lucienne Bloch, described how after sketching an outline for a composition, Kahlo 'worked like a muralist', systematically covering the canvas from the top left corner to the bottom right corner, without wavering or pausing.[31] People who posed for Kahlo described the experience as pleasurable. Even children (such as Mariana Morillo Safa, whose portrait Kahlo painted in 1944 when Mariana was a little girl) remembered looking forward to seeing Kahlo and how quickly the sessions went by. The stunning portraits seemed to materialize magically and effortlessly.[32]

Whereas Rivera liked to paint in front of an audience – who inevitably congregated to admire the virtuosity of the prolific maestro – Kahlo usually painted in her studio, in solitude, revealing her work to Rivera and friends only after completion or near completion. She did often have a sketchbook with her, however, and made drawings whenever the spirit moved her.

Kahlo and Rivera sometimes painted similar themes. They both painted portraits of Luther Burbank and Natasha Gelman; both painted Mexican symbols, artefacts and flora; both referenced medical images in their work. But their approach was always distinct.

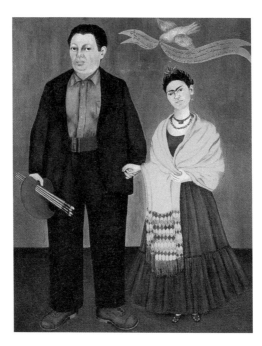

Frida Kahlo, *Frieda Kahlo and Diego Rivera*, 1931, oil on canvas.

Rivera aspired to capture clear ideological concepts objectively through broad historical narratives, while Kahlo used more complex, multi-layered and psychologically sophisticated symbolism.

While Weatherwax was composing his tender tale of Queen Frieda and King Diego, Kahlo painted a slightly more ambiguous version of her marriage. The inscription painted above the double portrait reads: 'Here you see us, myself Frieda Kahlo together with my beloved husband Diego Rivera. I painted these portraits in the beautiful city of San Francisco California for our friend Mr Albert Bender, and it was the month of April 1931.'[33] Kahlo herself, the artist who painted the image, is not presented as a painter at all. Rather, it is Rivera who is portrayed as the great artist, holding the attributes of the painter, palette and brushes, in his right hand. Kahlo, in contrast, holds onto her husband, defining herself not as

a painter but as 'the painter's little wife'. She displays herself in colourful native garb, adorned with a red *rebozo* and jade Aztec beads – the paradigmatic Mexican woman. Moreover, Kahlo's manner of painting this work – the stiff pose, awkward rendering of the feet and affinity with colonial portraiture – emulates the style of an amateur painter. She conceals her sophistication behind a mask of naivety and camouflages her position as a painter by espousing the subordinate

Kahlo and Rivera, San Francisco, 1931, photo by Peter Juley.

role of the doting wife. Ironically, Kahlo deliberately based this Mexican, pseudo-naive work on a well-known European precedent, Jan van Eyck's depiction of a marriage, his *Arnolfini Portrait* (London, National Gallery) of 1434. She kept a reproduction of this work in her studio, among numerous other books and documents that reflect her vast knowledge and erudition. Like van Eyck, she emphasized the importance of the marriage bond by placing the joined hands of husband and wife at the very centre of the composition. The exact positioning of Rivera's hand and head, however, subtly conveys his aloofness and less-than-active participation in this union.

Rivera and Kahlo travelled back to Mexico, where Rivera was committed to painting murals at the National Palace. In November 1931 they embarked on a ship that took them to New York, where Rivera's solo exhibition at the Museum of Modern Art was scheduled to open on 23 December 1931.[34] Kahlo's initial encounter with New York was just as exhilerating as her arrival in San Francisco. After the three-day boat ride, which left her dizzy, she recovered quickly and wrote to her mother on 14 November 1931: 'New York is simply *a marvel*! It is hard to believe it was build by humans, it appears like magic.' Climbing up the newly erected Empire State Building, she wrote that the city was 'so enormous that looking from the tallest building that's 110 stories high' one could hardly discern the far-away neighbourhoods. Kahlo was elated, exclaiming that New York's two rivers, the 'Hudson and East Rivers and the general view [are] magnificent!' She also raved about 'Central Park . . . that is also marvelous'.[35]

Kahlo explored the city and spent many hours at the Metropolitan Museum. Her letters reflect her excitement and an unquenchable desire to see more and more – the Egyptian collection, Etruscan art, El Greco's *View of Toledo*, 'Goya originals' and other masterpieces are described in detail in her letters home. She also attended concerts: some were to her liking – she called Stokowski 'Marvelous'; others ('Koussevitzky who is very famous') made her snooze. She was

thrilled with popular films, such as the early Marx Brothers' movies and the first Johnny Weissmuller as Tarzan film, *Tarzan the Ape Man*, released in 1932. On her return to New York in 1933, she rushed to see *King Kong*, viewing it several times with delight.

But in New York Kahlo also began to observe the ills of American society with a sharp eye and political criticality. In one of her first letters home (14 November 1931), she wrote about Fifth Avenue, where the 'filthy rich' reside:

> There is so much wealth and so much misery at the same time, that it seems incredible that people can endure such class differences, and accept such a form of life, since thousands and thousands of people are starving of hunger while on the other hand, the millionaires throw away millions on stupidities.[36]

As always, Kahlo made close friends, who were deeply devoted to her. Many remained loyal companions for years to come, among them, the muralist and artist Lucienne Bloch, who served as Rivera's assistant; her sister, the musician Suzanne Bloch; Ella and Bertram Wolfe; the art historian Meyer Schapiro and his sister Mary Sklar; and the photographer Nickolas Muray. Initially, Kahlo continued to play the role of 'Rivera's exotic young wife' and helpmate, attending dinners with his patrons and appearing at a variety of cultural events, at Columbia University, the New York Public Library and other venues.[37] The fact that she spoke English well and Rivera did not also made her role a practical one.

After a few months, however, Kahlo was homesick and sick of Rivera's infidelities, which took him away from her, sometimes for days at a time. By the time they left New York for Detroit, the San Franciscan honeymoon was clearly over. It was at this juncture that Kahlo discovered that she was pregnant.

5

'The Lost Desire':
Relinquishing Maternity

A rarely contested pillar of the Kahlo myth posits that since adolescence Frida's greatest desire was to have Diego's baby. Rivera himself perpetuated this tale and took care to emphasize it on every occasion.[1] In his autobiography he pronounced:

> Since the age of 12, as a wild and precocious schoolgirl, she had been obsessed with the idea of having my baby. When asked her greatest ambition, she would announce to her flustered teachers and schoolmates: 'To have a baby by Diego Rivera as soon as I can convince him to cooperate.'[2]

Regardless of what Frida the schoolgirl may have told her friends and teachers in 1922 (she was in fact fifteen at the time), the information that records her attitude towards childbearing a decade later reveals deep ambivalence and reluctance to become a mother, rather than great ambition or resolve.

In the dramatic saga of Kahlo's quest for motherhood, the year 1932 marks a crucial turning point. After Rivera's exhibition at the Museum of Modern Art and a few months' stay in New York, Rivera and Kahlo went to Detroit, arriving at the Wardell Hotel on 21 April 1932. Rivera was invited to paint a cycle of murals on the theme of modern industry at the Detroit Institute of Arts. By the end of May, Kahlo was already several weeks pregnant. On 4 July 1932 she had a miscarriage and nearly bled to death. This life-threatening

trauma had an indelible impact on Kahlo and transformed her art radically.

Two documentary sources illuminate the events of the spring and summer of 1932 and they undermine the myth conclusively. One is Kahlo's letters to her close friend Dr Leo Eloesser, with whom she had kept in close touch since they had met in San Francisco. Particularly important is a handwritten ten-page letter, dated 26 May 1932. In this dispatch Kahlo consults Eloesser on the course she should take concerning her pregnancy. To him, she confides her serious doubts and tenuous hopes concerning the possibility of motherhood.[3] The second source is Lucienne Bloch's diary. Bloch, who worked as Rivera's assistant, became one of Kahlo's closest friends after the two met in New York. Bloch had shared the Wardell Hotel apartment with Rivera and Kahlo in Detroit since June 1932 and her diary provides an important eyewitness account of Kahlo's pregnancy, miscarriage and their aftermath.

In Kahlo's letter to Eloesser, she bluntly reveals that her initial reaction once she found out she was pregnant was to abort the foetus. Having had an abortion under 'more or less the same conditions' two years earlier, Kahlo seems to have had no moral qualms about terminating this pregnancy as well. According to her own testimony, Kahlo asked her Detroit physician, Dr Pratt, to terminate the pregnancy, and was immediately given medicine to induce an abortion. 'Considering the state of health I'm in, I thought it would be best to abort, and I told him so, and he gave me a dose of "quinine" and a strong purge of castor oil.' After drinking the abortion-inducing substances, Kahlo haemorrhaged lightly, and thought that she had aborted successfully: 'The day after I took [the substances] I had a light hemorrhage, almost nothing. For five or six days I have had some blood but very little. In any case I thought I had aborted and I went to see Dr Pratt once again.'

But Dr Pratt examined her and told her that she was still pregnant. Kahlo's letter makes it clear that she herself did not even

consider keeping the baby. It was Dr Pratt who tried to convince her: 'He told me that in his opinion it would be much better if instead of having an operation to abort, I will keep the baby and in spite of all the bad conditions of my organism, taking into account the small fracture of the pelvis, spine etc etc I would be able to have a [baby] by Caesarean section without great difficulties.'

In spite of Dr Pratt's assurances that he would look after her personally with the utmost care, Kahlo lists many reasons against having a baby at all. She voices concern about her heredity, perhaps referring to her father's epilepsy ('In the first place with this heredity in the blood I don't think the child could come out very healthy'). Her own physical condition was also of concern, and she wrote: 'Secondly, I am not strong and a pregnancy would weaken me more.' Practical problems relating to Rivera's schedule occupy much more space:

> Moreover, at this moment the situation for me is difficult enough since I do not know exactly how much time Diego needs to finish the fresco, and if as I calculate it, it will be in September, the child will be born in December and I would have to go to Mexico three months before the birth. If Diego finishes later, the best thing would be for me to wait here until the baby was born, and in any case there would be terrible difficulties traveling with a baby a few days old.

Kahlo seems even more perturbed by Rivera's unwillingness to have a child: 'I don't think that Diego is very interested in having a child since he is very busy with his work and he's absolutely right. Kids would come in the third or fourth place.' Finally, she reveals that her own ambivalence concerning the option of motherhood is significantly related to her primary commitment to remain by Rivera's side: 'As for me, I do not know if it would be good or not to have a child, as Diego continually travels and for no reason

would I want to leave him alone and to remain in Mexico, that would only mean difficulties and "troubles" for the two of us, don't you think?'

The 'troubles' that Kahlo was referring to, according to her closest friends, were Rivera's numerous affairs with other women. Her reluctance to leave him even for a short period of time reveals an insecurity that seems to have been grounded on her past experiences and the knowledge that Rivera never remained without the company of women for long. In any case, Kahlo's desire to be with Rivera 'at any cost' and her fear of losing him probably contributed to her decision to abort her child.[4]

Kahlo writes of the pregnancy as a total nuisance and persistently urges Dr Eloesser to convince Dr Pratt to perform an abortion, since (she speculates) the illegality of the operation may be deterring him:

> But now all the time I want to vomit with this bothersome pregnancy and I'm a mess! . . . I request that you write Dr Pratt, as he probably did not take into account all the circumstances, and as it is against the law he may be frightened or something and later it will be impossible for me to have the abortion.

Kahlo seems to be willing to have a baby only if Eloesser thinks an abortion may endanger her health: 'But, if you really think, like Dr Pratt, that for my health it is much better not to abort and to have the baby, all these difficulties may be solved somehow.'

A letter from Lucienne's sister, Suzanne Bloch, dated 6 June 1932 indicates that Kahlo was still deliberating if she wanted to have the baby at all:

> Well, what are you going to do – I am much concerned over this – I'd like you to have a baby – what a baby it would be! And yet it is a big decision to take – and a responsibility – But no one

can decide that for you and I hope the doctor is a good one you can trust.[5]

The fact that Rivera did not want a child and that he had left the mothers of all his other children to fend for themselves must have had an impact on Kahlo's attitude. Angelina Beloff's testimony concerning this matter is particularly revealing. With unswerving frankness she wrote:

> When I became pregnant, Diego began to broach the subject of having our marriage legalized. Yet he would also shout and threaten that if the child cried and disturbed him, he would toss it right out the window. He would say that if the child grew up to be anything like me, he would really cry with grief and disappointment. All in all, Diego was very annoyed at having to play the role of a father.

Soon after the birth of his son, Rivera abandoned Beloff and the baby:

> After our son was born, Diego had an adventure with the Russian painter, Marievna. He left our apartment and went to live with her for five months . . . But the one thing I have always held against Diego is the way he acted when our one and a half-year-old baby lay sick and dying. From the beginning of the child's illness, Diego would stay away from the house for days at a time, cavorting with his friends in the cafés. He kept up this infantile routine even during the last three days and nights of our baby's life. Diego knew that I was keeping a constant vigil over the baby in a last desperate effort to save its life; still he didn't come home at all.[6]

Rivera's attitude towards his daughter Marika and her mother was also less than supportive. Apparently, he abandoned Marievna

soon after she became pregnant. Even a sympathetic biographer like Wolfe found it difficult to soften Rivera's rough indifference to Marievna's child.[7] Rivera was a better father to the daughters of Guadalupe Marín, though she too had her complaints: 'After our girls were born, he gave me very little money to support them; otherwise, he was a good papa.'[8] It is probably no coincidence that immediately after their second daughter, Ruth, was born, Rivera 'carried on so flagrantly with the model, Tina Modotti', according to Marín, that their marriage came to an end.[9]

Taking Rivera's well-known behaviour towards the mothers of his children into consideration, it is likely that Kahlo's decision to abort rather than to have Rivera's child was on some level motivated by her fear of being abandoned by him. In her situation, the roles of wife and mother seemed not only incompatible, but also mutually exclusive. As Beloff unequivocally stated, Rivera himself was 'infantile'; there was no room in his home for another child. Wolfe recalled a conversation he witnessed in which Marín, Beloff and Kahlo participated. After the women 'joined dispassionately dissecting the painter as husband, friend and lover', Beloff knowingly summed up the discussion: 'He's just a child, a great big child.'[10]

Lucienne Bloch's eyewitness account of the events of 1932 reflects Kahlo's persistent ambivalence concerning her pregnancy.[11] In her diary as well as in later interviews, Bloch describes Kahlo's situation during the month of June 1932. Although she was bleeding constantly and experiencing abnormal pain, she refused to consult her doctor, in spite of Bloch's repeated prodding. Moreover, she did not follow the doctor's advice to rest, but rather did many things she was explicitly told to avoid.[12] Yet, when Kahlo wrote to Eloesser just 25 days after her miscarriage, she told a completely different tale. In a letter dated 29 July 1932, she claims to have been feeling well and to have abided by the doctor's advice: 'About two months passed and I did not feel any discomfort, having rested

continuously and taking care of myself the best I could.'[13] In the same letter she reveals that in spite of her initial annoyance with the pregnancy, she later began to feel some kind of 'biological' desire for a child:

> In those days I was enthusiastic about having the child after having thought of all the difficulties that it would occasion, but sure that it was rather a biological thing that I felt the need to give myself over to the baby. When your letter arrived, it encouraged me more, since you thought it possible for me to have the baby and I did not deliver the letter you sent Dr Pratt, being so sure that I would be able to sustain the pregnancy, go to Mexico in time to have the baby there.[14]

Even in this letter, Kahlo's motivation for having a child seems somewhat strange and accompanied by ambivalence, since she views it as 'a biological thing' to which she must surrender. One may speculate that this approach is possibly related to Kahlo's view of her own mother. As discussed above, the artist painted her mother based on gynaecological illustrations that focus solely on the maternal body's 'biological' functions. Furthermore, the fact that Kahlo had decided to go to Mexico to have the baby rather than remain in Detroit, as Dr Pratt recommended, suggests a persistent pattern of disobeying doctors' orders.

Echoing Lucienne Bloch's eyewitness testimony, Kahlo's close friend Ella Wolfe also asserted that Kahlo would have been able to have a baby had she followed doctors' orders and taken care of herself properly. A telegram from Frida's sister, Matilde, dispatched on 6 July 1932, expresses her distress and grave concern about Frida's condition, her willingness to drop everything and come to her sister's side, but also hints at Frida's tendency to disobey doctors' orders. The telegram curtly beseeches Frida: 'Obey Doctors orders. Don't deceive in any way.'[15]

In any event, Kahlo's behaviour, the letters cited above and the fact that she decided to have several deliberate abortions both before and after 1932 indicate that her attitude towards having children was deeply ambivalent.[16] It was certainly not her 'greatest ambition', as the Kahlo myth posits. This cluster of complex emotions is reflected most poignantly in the innovative artwork that Kahlo produced after the miscarriage.

As soon as she could hold pencil in hand, Kahlo began to draw. Barely sitting up in the hospital bed, just five days after her miscarriage, she composed a small self-portrait. Dated 9 July, this pencil sketch depicts the artist's unusually puffy face, framed by a hospital hairnet. Kahlo's eyes seem unfocused and glazed. In contrast, a separate and oversized eye is clearly delineated at the bottom left-hand corner of the drawing. As she had done in the *Accident Drawing* of 1926, Kahlo once again visualized herself ' splitting', this time as a way of coping with the trauma of the miscarriage. She produced and dated a second pencil drawing the next day, on 10 July 1932. This became the basis for her first *retablo*-like oil on metal painting titled *Henry Ford Hospital*. This work marks Kahlo's transformation from a talented portrait painter to a radically original, innovative and taboo-breaking artist.

On a manifest level, *Henry Ford Hospital* displays Kahlo's physical and emotional experiences at the time of her miscarriage. She is alone, lying on a hospital bed, crying, twisted and bleeding. The Ford River Rouge Factory depicted in the background locates the scene in the city of Detroit, where Rivera was absorbed in painting his monumental murals glorifying the Ford factory. The scene is ambiguous in that it confounds the indoor hospital setting with the outdoor industrial landscape, merges realistic elements with surreal features and amalgamates imagery derived from mechanical drawings, medical illustrations and a variety of art historical sources. The ambiguity that permeates the composition echoes Kahlo's own ambivalence during this period.

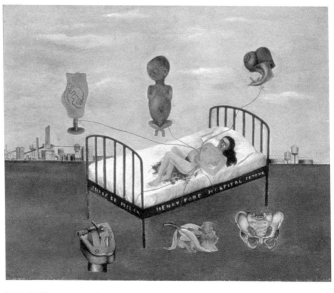

Frida Kahlo, *Henry Ford Hospital*, 1932, oil on metal.

Miscarriages – both as objective medical procedures and as subjective physical and psychological experiences – were rarely (if ever) depicted in art. Kahlo, therefore, invented a totally unprecedented visual vocabulary to present her unique female perspective. In addition to appropriating medical illustrations (for example, of the foetus and the pelvis) and carefully chosen art historical references (for example, the work of Charles Sheeler, Raoul Hausmann and Francis Picabia), she deliberately subverted conventional genres related to birth (such as Christian Nativity scenes) and representations of the traditional reclining female nude (for example, the *odalisque*).[17] Finally, in presenting herself with dishevelled black hair and in tears, Kahlo intentionally endowed herself with the attributes of La Llorona, the Weeping Woman, an archetypal evil woman, antithetical to the normative wife and mother. Like them she is sexual and maternal, but hers

is a deviant sexual energy and a moribund motherhood that threaten the very foundations of the patriarchal order. There are several versions of the Mexican story of La Llorona, but two elements dominate all the tales. She is first and foremost a woman abandoned by her lover; second, loss of love leads her to the brutal act of killing her own children in a rage of frenzy. A Mexican Medea, she becomes the epitome of unrequited love, uncontrolled sexuality, childlessness and madness, associated with women who are relegated to the margins of society.

Henry Ford Hospital is a powerful record of Kahlo's miscarriage. But it also evokes broader cultural and social ramifications, through its revolutionary art historical reversals and rupturing of taboos. It is constructed deliberately as an anti-Nativity scene. Indeed, Kahlo's naked body is decidedly not immaculate and unlike the chaste and virginal Mary, Kahlo does not produce a child but rather the taboo uterine blood of La Llorona. *Henry Ford Hospital* is also original in its bold rejection of traditional female roles as it oscillates between biographical and ontological references. Kahlo's painting reflects her personal understanding that she cannot fit into the roles of wife and mother. The fact that the work was originally exhibited in 1938 with the title *The Lost Desire* may suggest that she no longer wanted to fit into these limited roles. But her attempt to explore other options of being – through the espousal of the identity of the outcast Llorona – engages in a broader, proto-feminist discourse pertaining to the oppressive nature of gender roles in Mexican society.[18] Long before feminist thinkers came up with the slogan 'the personal is political', this concept had found poignant expression in Kahlo's path-breaking art.

Although it is possible that Kahlo never fully recovered from the trauma of her miscarriage, a lithograph she completed on 11 August 1932 exhibits the beginning of a healing process and a transformation. No longer passively lying in an alienated hospital bed, Kahlo literally and figuratively stands on her own two feet. No longer

Frida Kahlo, *Frida Kahlo and the Miscarriage*, 1932, lithograph.

grieving with the wild hair of the tearful Llorona, Kahlo's tresses are carefully gathered in a hairnet, as in her first post-miscarriage drawing. Even her blood flows in an orderly, controlled fashion. In fact, the blood drops and the tears become a stylized visual pattern – no longer unruly, abject and taboo body fluids – just as the artist's experiences are sublimated and contained within the frame of the artwork.

Both the composition and Kahlo, its protagonist, are split in half. The left side of the work shows the fertile promise that did not materialize: from a foetus in Kahlo's uterus a delicate line, evoking an umbilical cord, encircles her right leg and is attached to the navel of a three-month-old male foetus.[19] Above this foetus, two images of ovular cell division are depicted in detail. On the right side of the composition, an alternative scene of productivity is presented. Blood drops fall from Kahlo's vagina and fertilize the soil. They coagulate into strange phallic-looking subterranean forms. Plants that resemble the human organs of the foetus, particularly his eyes, hands and genitals, sprout from this source. The plants with their visible roots relate to Aztec depictions of medicinal herbs; hence, they symbolize both fertility and healing. Sperm-like worms wriggle as Kahlo's blood contributes to the regeneration of the earth.

Above the realm of nature's fecundity, a third arm grows from Kahlo's left shoulder. In this newly acquired limb (reminiscent of Hindu and Buddhist imagery) she holds a painter's palette. This is the very same palette that Rivera had held in his hand in Kahlo's marriage portrait of 1931 (see p. 82). In that double portrait, Kahlo was the doting wife of the great artist. Just one year later – a failed mother – Kahlo becomes an artist in her own right. In the top right corner of the work a weeping moon appears. The moon, a symbol of female menses and fertility, weeps for Kahlo's infertility. Kahlo too is weeping. But the two large symmetrical teardrops on her cheeks are stylized in such a way as to express a moderate sadness, no longer the frenzied grief of La Llorona. Kahlo is on her way to

recovery as she dons the bead necklaces. Acknowledging that part of her has failed, the part that could not produce a human offspring, she structures the other aspects of her being as a productive entity. Her other side is divided into two realms of creativity in which she participates: the fertility of nature and the fertility of art.

Kahlo's lithograph is based on a genre of anatomical cosmologies that insert medical illustrations of the male and female bodies within cosmological settings. These elaborate compositions often include the sun and the moon, botanical illustrations and numerous additional images derived from scientific and mythic realms of human knowledge.[20] In this lithograph, Kahlo meticulously reconfigures an alternative cosmology in which the male partner and the sun that is his symbol are conspicuously absent.

From this point on, Kahlo probably began to understand that she would never fill the traditional roles of wife and mother. Empowered by her art, she continued to challenge gender norms, construct and reconstruct her identity, and explore new modes of representation. Her art and her life would never be the same.

6

'Double Sorrow':
Losing and Finding Love

Kahlo was still in the hospital when a telegram from her sister Mati informed her that her mother was sick.[1] A few weeks later, Frida thought her sisters were exaggerating when they wrote to inform her that Matilde Calderón's condition was grave. Her relationship with Rivera was strained and she decided to stay in Detroit rather than rush to her mother's bedside. Guillermo Kahlo supported his daughter's decision, urging her to work through her 'jealousy' and stay with her husband.[2]

About two months after the miscarriage, accompanied by Lucienne Bloch, Frida embarked on an arduous train journey from Detroit to Mexico, arriving at Mati's Mexico City home the night of Saturday, 10 September 1932. By the time she went to see her mother on Sunday morning, Matilde Calderón was on her deathbed. Frida's telegrams and letters to Rivera indicate that she was feeling desperate and overwhelmed because of her mother's critical condition. Although the family solicited medical advice from numerous doctors and scheduled surgery for Monday, 12 September, the situation was clearly hopeless. On 15 September 1932, less than three days after undergoing surgery, Matilde Calderón died. By mid-October the exhausted Kahlo rushed back to Detroit.

As noted earlier, the death of her mother was the last in a string of devastating losses that Kahlo experienced in close proximity in the summer and autumn of 1932. To this may be added her gradual but inescapable realization that she was also losing Rivera.

Kahlo's private letters and the testimony of her friends reveal that even before the miscarriage her relationship with Rivera was deteriorating rapidly.[3] Lucienne Bloch's harrowing recollections of the night Kahlo was hospitalized are particularly disturbing:

> [The noise] in the other room sounded like fighting. I didn't want to walk in. I knew that one of them would call me. Diego walked in and said Frida is very sick. I rushed in to see her. He said call a doctor. She was in this blood. In my mind was the idea that Diego had stabbed her. That they had fought and he had stabbed her and now he's saying she's sick. That was my first impression.[4]

In Detroit, Rivera was totally immersed in his work and fascinated by the city's industrial landscape and factories. He had very little time for Kahlo and often treated her with evident impatience. Kahlo was miserable and lonely. She made very few friends, and given her communist sensibilities, socializing with Rivera's wealthy patrons, Mr and Mrs Henry Ford, was anathema to her. Henry Ford's reported anti-Semitic views disturbed her, as Lucienne Bloch recalled, and she found a way of addressing them humorously. During a formal dinner party at the Ford residence, Kahlo waited for a lull in the conversation and then asked the host with feigned innocence: 'Mr Ford, are you Jewish?'[5] During her visits to San Francisco and New York, she had explored the cities with delight, gone to the movies, to museums, to shows, painted sporadically and forged lifelong friendships. But Detroit was a different story: 'This city gives me the impression of an ancient and impoverished hamlet, it struck me as a village, I don't like it at all', she wrote to Leo Eloesser on 2 May 1932.[6] Although her many devoted friends wrote to her regularly and even travelled all the way from San Francisco or New York to visit her in Detroit, she found the city oppressive. Henry Ford put Rivera and Kahlo up at the Wardell

Hotel, but as soon as they had checked in they discovered that the hotel barred Jews from its premises. Appalled at such racism, both Frida and Diego declared that they had Jewish ancestry, forcing the hotel to rescind its discriminatory policies.[7]

Kahlo, Rivera and Bloch found another way to challenge the Wardell's xenophobia. Lucienne deliberately sent Kahlo a picture postcard of an early American interior, but drew an African American man lying in bed in the 'all-American' bedroom. On another postcard, she wrote a Jewish prayer in Hebrew and mock Chinese characters. Some four years after they left the city, Bloch wrote to Kahlo with biting irony:

> Isn't Detroit lovely, I'm sure you'll have a perfectly lovely time there, with the intelligentsia and the high society. We of Detroit are quite advanced in cultural things. We have a museum and library which cost $10000000 and an average of 200 people go there by week at an average of 120 pounds each, an average of 89% female species, 5% male, and the rest undefined.[8]

As Rivera was about to finish his Detroit project, Kahlo reconnected with her New York friends, anticipating her return to the city. On 1 March 1933 she posted a letter to Georgia O'Keeffe, with whom she had developed a brief and intimate friendship when she was in New York earlier:

> I'll be in Detroit two more weeks. I would like to tell you every thing that happened to me since the last time we saw each other, but most of them are sad and you musn't [sic] know sad things now. After all I shouldn't complain because I have been happy in many ways though. Diego is good to me, and you can't imagine how happy he has been working on the frescoes here. I have been painting a little too and that helped. I thought of you a lot and never forget your wonderful hands and the color of

your eyes. I will see you soon. I am sure that in New York I will be much happier. If you [are] still in the hospital when I come back I will bring you flowers, but it is so difficult to find the ones I would like for you. I would be so happy if you could write me even two words. I like you very much Georgia. Frieda[9]

In mid-March Kahlo and Rivera left Detroit and arrived in New York City. Rivera was commissioned to paint a large mural in the lobby of the newly erected Rockefeller Center building on Fifth Avenue and, once again, Kahlo was expected to play the role of the devoted wife of the celebrity artist. She was called upon to be particularly supportive while this painting commission was under way, given the vicious attacks levelled against her husband. Rivera's prominent inclusion of a portrait of Lenin in the mural caused a much-publicized uproar and stirred great controversy. The episode culminated with the climactic and brutal destruction of the mural.[10]

Both politically and artistically, Kahlo was Rivera's most loyal ally and steadfast companion. But by the time the couple reached New York their marriage was unravelling. Rivera reportedly had an affair with Louise Nevelson and Kahlo felt angry and betrayed.[11] Apparently, she also engaged in extramarital relationships. It seems that her love story with the Hungarian-American photographer and fencer Nickolas Muray began at this time and that she also tried to rekindle an amorous relationship with Georgia O'Keeffe.[12]

Another major source of friction, which began in Detroit, was Kahlo's longing to return to Mexico. In the autumn she wrote to her friend Isabel Campos: 'Here in Gringolandia I spend my life dreaming of returning to Mexico . . . New York is very pretty and I'm much happier than in Detroit, but I still miss Mexico.'[13] Rivera, on the other hand, was eager to stay in the United States where he saw endless opportunities for painting, socializing and engaging with industrialization, which he identified as a path to the future. Although he embraced indigenous Mexican culture, he was wary

of what he perceived as contemporary Mexico's provincialism. He accused Kahlo of wallowing in nostalgia, idealizing Mexico and selfishly trying to drag him back to a place that would not allow him to grow.[14] She found it impossible to stay in 'Gringolandia' with its capitalist economy and multiple social problems, particularly during the Great Depression. These personal and ideological tensions exacerbated each other, making the relationship virtually unbearable.

Kahlo's painting *My Dress Hangs There* (1933) contains direct references to the stock market collapse and to the social unrest of the Great Depression era. It also expresses lucidly her political and psychological position at this time. Kahlo's empty Tehuana costume hangs at the centre of the composition, presenting the artist as both absent and present. She is there to witness the ills and injustices of

Frida Kahlo, *My Dress Hangs There*, 1933, oil and collage on masonite.

U.S. society, but positions herself as an alienated outsider who does not wish to belong. New York's identifiable landmarks are depicted in the background: the island of Manhattan, the Empire State building and the Statue of Liberty. The neo-classical U.S. Sub-Treasury building, with the statue of George Washington upon a pedestal gracing its facade, appears directly above the empty dress. It was in this building that Washington took the oath of office as first president and where Congress, the Supreme Court and the Executive Branch offices were initially situated. The building is located on Wall Street and in October 1929, as the stock market began to crash, crowds gathered in protest at this very site.

The American ideals of democracy, liberty and progress – suggested by the iconic edifices that Kahlo painted – are called into question by anonymous tenement buildings, piles of rubbish and numerous emblems of the harsh reality and ugly aspects of the capitalist system. Most poignant perhaps are the photographs and newspaper clippings that form the foundation of the composition (in Marxist terms, the base of the social pyramid designated for the lowest stratum of society). Using a collage technique, Kahlo pasted newspaper clippings that show the working-class masses protesting against the evils of an unequal society: hunger, homelessness, racial discrimination and the growing gap between the rich and the poor. She cut and pasted dozens of small photographs showing bread lines and striking workers, with signs and captions that read: 'Free Rent', 'No Evictions', 'Negro and White Workers', 'Negro and White Dressmakers', 'Workers Join Hunger March' and 'On the Picket Lines'.[15]

Kahlo's letters from New York in the 1930s complement her visual critique:

> I don't like high society here at all and I feel . . . indignation at all these moneybags around here, as I've seen thousands of people in the most terrible poverty, without anything to eat or anywhere

to sleep, it's what has struck me most here, it's frightful to see the rich throwing parties day and night while thousands and thousands of people are dying of hunger.[16]

Of course, Kahlo knew what she was talking about, and even as she was writing this letter she was attending many such lavish parties. Although her closest friends in the USA were committed to left-wing politics, as Rivera's wife she was wined and dined by the Rockefellers, Fords and other 'moneybags'. Today, one may only speculate how she negotiated between her communist political views and moral values and the practical wisdom of socializing with Rivera's patrons.[17] Yet, given her close and intimate friendships with many Americans and the varied and positive experiences she had in the United States, her scathing verdict on 'Gringolandia' rings harsh and flat: 'I can't stand the gringos . . . I detest their ways, their hypocrisy and their disgusting Puritanism, their Protestant homilies, their boundless pretension, the fact that one has to be "very decent" and "very proper" for everything.'[18]

Kahlo's negative view of the United States was certainly influenced by her socialist outlook. But to an even greater extent, it was shaped by her identification with Mexico. She was particularly concerned about the negative impact of North American culture on Mexican society, as she wrote in a letter to Leo Eloesser: 'Mexico is as always, disorganized and gone to the devil, it has nothing left but the great beauty of the land and of the Indians. Everyday the ugliness of the United States steals a little piece of it. It's sad, but people have to eat and there's no help for the fact that the big fish eats up the little one.'[19]

Self-portrait on the Borderline Between the United States and Mexico explicitly juxtaposes the industrialized United States and the traditional culture of Mexico. Kahlo stands on a pedestal, posing as Rivera's Mexican wife-on-display: 'Carmen Rivera'. Although this was the role she had espoused since marrying Rivera in 1929, here she appears to be challenging it with self-irony.

Diego Rivera watching Frida Kahlo painting *Self-portrait on the Borderline Between the United States and Mexico* at the Detroit Art Institute, 1932 (unknown photographer).

Carmen was one of the names inscribed on Kahlo's birth certificate, but she always went by the name 'Frida' (sometimes spelt 'Frieda'). It was Rivera who introduced her to reporters on their arrival in the United States as 'Carmen Rivera', emphasizing her Mexican heritage on the one hand, and her subordinate role as his wife on the other. In the painting, Kahlo as 'Carmen Rivera' is

situated literally 'on the borderline' between the two distinct cultures within an emphatically binary composition. Sporting a cigarette in one hand and a small Mexican flag in the other, 'Carmen Rivera' masquerades as both the modern woman and the Mexican woman. Terry Smith's brilliant analysis of this work demonstrates that although Kahlo clearly identified with Mexico, she was extremely critical of both the mechanically developed north and the rural south. She neither ignored nor minimized Mexico's serious problems and articulated her country's shortcomings in letters and art. This painting includes signs of Mexico's death and destruction alongside its natural beauty and impressive archaeological past. As Smith argues, Kahlo displayed the contrasts as well as the parallels between Mexico and the USA with a keen irony that subverts Rivera's idealized Pan-American utopia.[20]

The couple returned to Mexico in December 1933. Rivera was deeply unhappy and, as Kahlo lamented in a letter to her close friend Ella Wolfe, he blamed her for 'everything that's happening to him for having made him come to Mexico'.[21] Shortly thereafter Rivera and Frida's younger sister, Cristina, began a clandestine affair. This double betrayal devastated Kahlo. In the autumn of 1934 she wrote to Ella and Bertram Wolfe: 'It's a double sorrow, if I may put it that way. You know better than anyone what Diego means to me in all senses, and then, on the other hand, she was the sister I most loved.'[22] The affair had a paralysing effect on Kahlo as an artist and in 1934 she did not paint at all.[23] The following year she painted only one stamp-sized self-portrait in which her tiny face is barely recognizable. She had cut and permed her hair in a poodle-like coiffure that seems to be a flagrant rejection of her former self, a virtual act of self-mutilation. She gave the painting, which is imprinted with her agony, to the Wolfes. It echoes the letters she wrote to them a few months earlier: 'I'm worthless, I don't know how to do anything, I'm not sufficient unto myself; my situation seems so ridiculous and so idiotic that you cannot imagine

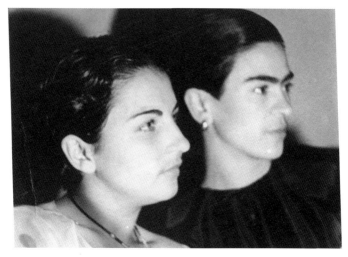

Frida and Cristina Kahlo, undated photo by Guillermo Kahlo.

how I dislike and hate myself.' Ella Wolfe zealously clung to this cherished gift from her friend and kept it in her home until her death in 2000 at the age of 103.[24]

The only other painting Kahlo produced that year is a bloody depiction of a man cold-heartedly butchering a woman, ironically titled *A Few Small Nips*. Although the work was probably based on a newspaper account of an actual crime, it has been convincingly interpreted as a reflection of Kahlo's feelings of being 'murdered by life' at the time of Rivera's affair with Cristina.[25] Several years later, Kahlo told her friend Olga Campos that she 'wanted to die out of desperation [and] . . . thought of committing suicide'.[26] According to another source, Rivera told Frida: 'Look the one I loved was your sister; you were just a doormat to my love.'[27] Bertram Wolfe, who maintained a close friendship with both Kahlo and Rivera, wrote a detailed account of the aftermath of this episode that came close to breaking up their marriage:

A lonely and miserable time followed for both. Frida moved into a room in another part of the city, raged and wept in secret, tried listlessly to knit to some other being or interest the raveled threads that had bound her life so completely to Diego's. Too restless to paint, she left suddenly for New York, told her bitter tale to my wife and me as her most intimate friends there, vainly tried to 'get even' by 'affairs' of her own.[28]

Kahlo left for New York in July 1935. Some time later the affair with Cristina apparently ended and she returned to Mexico and to Rivera. By the end of the year Kahlo and Rivera were reconciled and during 1936, according to Wolfe, who spent much of the year working on a book project with Rivera in Mexico, their relationship was closer than ever. A year later, another crisis ensued.

Though rarely discussed, Frida's relationship with Cristina was obviously also affected by this double betrayal. Kahlo wrote to Dr Eloesser: 'after months of veritable torture for me, I forgave my sister'.[29] The siblings eventually resumed their close bond, which developed into a lifelong interdependence. Sections from Cristina's handwritten diaries and letters published by her daughter, Isolda, in 2005 corroborate testimonies that describe how Cristina took care of the domestic chores of the Kahlo-Rivera household, served as Rivera's secretary and chauffeur and, most important, was always by Frida's side when her health deteriorated. Isolda Kahlo wrote:

mutual support and affection . . . prevailed between both sisters until the day Frida died. They showed great dedication to each other in every difficult moment they had to go through. They shared victories and defeats, happiness and grief. It goes far beyond [Cristina's] unconditional presence at the side of her sister whenever she felt ill. The first thing Frida would do whenever she had to undergo one of her many surgeries, or whenever she felt her life was in danger, was call Cristina.[30]

Cristina wrote that her sister Frida became 'her daughter' as she nursed her back to health and took care of all her needs with immense maternal love. In one of her diary entries, Frida painted a portrait of herself merging with Cristina, transforming the two sisters into a unified hybrid being, suggesting their closeness and interconnectedness.[31]

In contrast to the steady rapprochement between the sisters, Kahlo's relationship with Rivera zigzagged along a volatile trajectory, punctuated by explosive break-ups, leading to their divorce in 1939. As they drifted apart, Rivera had well-publicized affairs with the artist Irene Bohus and the actress Paulette Goddard. Kahlo also engaged in romantic liaisons, but since these were kept private, there is much speculation regarding the identity of her lovers. She had a brief affair with the artist Ignacio Aguirre, followed by a short relationship with the sculptor Isamu Noguchi, who was in Mexico in 1935 on a Guggenheim fellowship.[32] Kahlo kept a photograph of Noguchi and a note he wrote on 'Sunset Limited, Southern Pacific' stationery, apparently several years after their affair had ended. He wrote: 'Dear Frida, I happen to be passing this way – I think of you – the radio is playing songs from Mexico. I long to see you, Isamu.'[33]

In 1937 Kahlo had a brief romantic episode with the exiled Russian leader Leon Trotsky. Following the violent rift between Stalin and Trotsky, which resulted in Trotsky's forced exile and the threat to his life, Rivera petitioned the Mexican president Lázaro Cárdenas to provide Trotsky with political asylum in Mexico. Cárdenas agreed, and on 7 January Kahlo went to greet Trotsky and his wife Natalia in Tampico, Mexico. She escorted them to Coyoacán, where they resided at La Casa Azul for about two years. During this period, Kahlo and Rivera lived in San Ángel, in a newly constructed home planned by Kahlo's lifelong friend since childhood, the artist and architect Juan O'Gorman. Composed of two separate houses – a large light red house for Rivera and a smaller

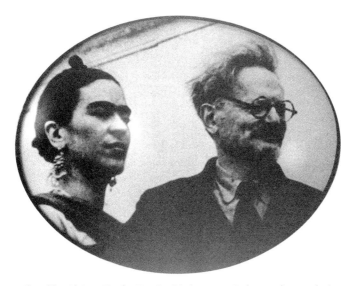

Frida Kahlo with Leon Trotsky, Tampico, Mexico, *c.* 1937 (unknown photographer).

light blue residence for Kahlo – linked by a single footbridge, this unique home enabled Kahlo and Rivera to live apart while remaining in close touch. It was clearly a vision of the independent marriage that Rivera desired. During this time, Frida's father lived with his daughter Mati. Isolda Kahlo remembered that she, her brother and her mother, Cristina, 'cohabited' with the Trotskys.[34]

La Casa Azul was also the site where the Dewey Commission, which exonerated Trotsky from the crimes of which he was accused by the Moscow trials, conducted its sessions in April 1937. Shortly after the commission completed its meetings, according to Trotsky's secretary, Jean van Heijenoort, a romantic relationship developed between Frida and the Russian leader. Van Heijenoort based his account on what Kahlo had told him after the relationship ended:

Frida was a person remarkable for her beauty, character, and intelligence. In her relations with Trotsky, she quickly adopted

a certain freedom of manner. Her French was poor, but she spoke English well . . . So she usually spoke with Trotsky in English, and Natalia, who could not speak English at all, found herself excluded from the conversation. Frida did not hesitate to use the word 'love' after the American fashion. 'All my love', she would say to Trotsky upon leaving. Trotsky, who was apparently taken by Frida, began writing letters to her. He would slip a letter into a book and give the book to her, often in the presence of others, including Natalia or Diego, with recommendation that Frida read it . . . All this took place a few weeks after the end of the sessions of the Dewey commission. Late in June the situation became such that those close to Trotsky began to get uneasy. Natalia was suffering. As for Diego, he had no inkling of what was going on. Since he was morbidly jealous, the least suspicion would have caused an explosion. There would have been a scandal, with grave politi-cal repercussions . . . At the beginning of July, in order to reduce the tension that was building between them, Trotsky and Natalia decided to live apart for a time. On July 7 Trotsky went to live in the hacienda of a landlord . . . some ninety miles northeast of Mexico City . . . On July 11 Frida went to see Trotsky at the hacienda. I am inclined to believe that it was at the close of this visit that Trotsky and Frida decided to put an end to their amorous relationship . . . [35]

Some time in early 1939 Rivera and Trotsky had a falling out that has been attributed to political disagreements or to the possibility that he found out about Kahlo's affair with Trotsky. Kahlo mentioned this in a letter from Paris addressed to Ella and Bertram Wolfe: 'Diego has quarreled with the IVth and seriously sent "Vandyke" Trotsky to hell.'[36] The term 'the IVth' refers to Trotsky's Fourth International, established in 1938 to counter the 'third International', which had been taken over by Stalin. The

name 'Vandyke' alludes to the painter Van Dyck, whose goatee was similar to Trotsky's beard.

The Russian exile and his wife left La Casa Azul for a nearby residence in Coyoacán, where, following a number of attempts on his life, Trotsky was assassinated in the summer of 1940. A dozen years later, Kahlo wrote in her diary: 'Since Trotsky's arrival in Mexico I recognized his mistake. I was never a Trotskyite. But in those days – 1940 – I was only an ally of Diego (personally).'[37] At the end of her life, Kahlo was a devoted Stalinist. This diary entry may be a hindsight justification of her relationship with Trotsky.

New information suggests that Kahlo had an affair with the French writer Pierre Combret de Lanux, an assistant to André Gide. His semi-nude photographs were found among Kahlo's private papers. One photograph of him reclining, published in 2010 by the Frida Kahlo Museum, served as a model for one of the figures that populate Kahlo's painting *What the Water Gave Me* (1938), suggesting that de Lanux may have played an important role in Kahlo's life.[38]

In 1938 Kahlo and Nickolas Muray apparently resumed what had been a casual liaison a few years earlier. Their relationship developed into an intensive love affair, which ended about a year later. Their deep friendship lasted for many years to come. Muray's numerous photographs of Kahlo have become iconic images of the stunningly beautiful mythic Frida. She herself dubbed one of her favourite photographs 'FW' 'fucking wonder' -- with intentional double entendre. Several series of lesser-known black and white photographs by Muray reveal other aspects of Kahlo's life, showing her in traction in a hospital bed, her eyes projecting pain rather than seductive beauty.[39]

Kahlo's paintings for Muray reveal the complexity and intimacy of their relationship. She nicknamed herself his 'Xochitl' – the Nahuatl word for flower – and painted a symbolic self-portrait as a sexualized red blossom, which may have been influenced by

113

O'Keeffe's sensual floral imagery (*Xochitl*, 1938). She also painted the stunning *Self-portrait with Dead Hummingbird* of 1940 for him, based on his photograph of her and on a varied array of literary and art historical allusions, which communicated to him her unrequited sexual longings.[40]

The intimate correspondence between Frida and Nick, thoroughly studied by Salomon Grimberg, reveals Muray's devoted friendship and ongoing emotional and financial support for Kahlo through thick and thin. It also exposes Kahlo's inexplicable insensitivity and troubling behaviour, particularly at a time when Muray needed her most. In the summer of 1941 Muray took his nineteen-year-old daughter, Arija, to visit Kahlo in Mexico. While in Mexico Arija travelled to Veracruz on her own and contracted an illness. Muray flew her back to New York where she was hospitalized. She died on 19 September 1941. The devastated Muray asked Kahlo to paint a portrait of his beloved daughter and he rushed two photographs of Arija to Kahlo. Kahlo cabled her condolences and agreed to paint the portrait. Muray wrote and cabled again and again. His pain and desperation ring loud from every syllable. Kahlo did not reply. Nor did she ever paint the promised portrait of Muray's daughter.[41]

Encouraged by Rivera, Kahlo travelled to New York and Paris alone in 1938 and 1939. There is speculation regarding Rivera's possible motives – did he want her out of the way so he could pursue his work and what apparently became a significant relationship with the American actress Paulette Goddard? Or was he sincerely attempting to advance her development as an independent painter? Regarding the latter, there is ample evidence that Rivera had immense respect for Kahlo's art and that he worked both publicly and behind the scenes to promote her paintings. A letter he wrote to Walter Pach on the eve of Kahlo's New York debut resulted in an excellent review of her show by Pach (signed W. P.) in *Art News*.[42] It was also Rivera who convinced André Breton to write an essay about Kahlo's work and to reproduce her painting *What the Water*

Gave Me in the 1938 issue of the Surrealist journal *Minotaure* and in Breton's book on Surrealism. Breton was also instrumental in bringing Kahlo to Paris, though eventually it was Marcel Duchamp who organized a display of her paintings (along with artefacts and photographs) at the Pierre et Colle gallery. Kahlo's letters from Paris reveal that she disliked Breton intensely, but she developed a close relationship with his wife, Jacqueline Lamba, and was extremely fond of Duchamp and his partner Mary Reynolds. Photographs of Breton, Lamba, Reynolds and Duchamp and a lively correspondence with Lamba were found among Kahlo's personal papers.[43] In addition to using his considerable connections to promote Kahlo and advance her art in New York and Paris, in 1943 Rivera wrote a laudatory and insightful essay titled 'Frida Kahlo and Mexican Art', which reveals his profound admiration of her work.[44]

In Paris, in addition to being promoted by Breton and Duchamp, Kahlo was embraced by leading artists, many of whom attended her exhibition, as she reported to friends with a mixture of under-stated pride, humour and typical self-deprecation: 'There were lots of people the day of the opening, great congratulations for the "chicua" including a big hug from Joan Miró and great praises from Kandinsky for my painting, congratulations from Picasso and Tanguy, from Paalen and from other "big shits" of the surrealist movement.' Picasso gave her a pair of earrings shaped like hands on that occasion, which she cherished and included in a painting and a drawing. The Louvre bought one of her self-portraits titled *The Frame*. In spite of the positive aspects of her trip, however, Kahlo's letters from Paris reflect a personal dislike for French intel-lectuals and their cultural milieu, as well as sharp political criticism of what was happening in Europe on the eve of the Second World War: 'These contemptible French have behaved like pigs with all the refugees; they're just bastards, of the worst sort I've ever known. I'm disgusted with all these rotten people in Europe, these goddamed "democracies" aren't worth a dime.'[45]

By the time Kahlo returned to Mexico some time before April 1939, the rift between her and Rivera had become unbridgeable. In mid-October 1939 she wrote to Nickolas Muray:

> My situation with Diego was worse and worse, till [*sic*] came to [an] end. Two weeks ago we began the divorce. I have no words to tell you how much I [have] been suffering and knowing how much I love Diego you must understand that this [*sic*] troubles will never end in my life, but after the last fight I had with him (by phone) because it is almost a month that I don't see him, I understood that for him it is much better to leave me. He told me the worst things you can imagine and the dirtiest insults I ever expected from him.[46]

By November 1939 Kahlo and Rivera were divorced.[47] The break-up was reported with cynicism in the press. For example an article titled 'Frida vs. Diego' in the November 1939 issue of the *Art Digest* reported:

> Reno Judges have heard practically all the grounds on which angered or bored parties build divorce cases. But something new in the way of grounds has just come out of Mexico. 'Artistic differences' the *New York Herald Tribune* reported last fortnight, are the basis of the present divorce proceedings between Mexico's famous and fiery muralist, Diego Rivera, and his pretty and charming painter-wife, Frida Kahlo de Rivera.

The report proceeded to describe Rivera playing with 'a pet monkey', noted his previous relationships and quoted him as saying: 'We are doing it in order to improve Frida's legal position. There are no sentimental, artistic or economic questions involved.' Kahlo's view – which rings much more truthful – was also quoted: 'We have been separated for five months. Our difficulties began after my

return to Mexico from Paris and New York. We were not getting along well.'

Although Kahlo was clearly unhappy during her estrangement from Rivera, she was determined to become financially independent and to work on her art more ambitiously than ever before. She was hoping to produce work for a second exhibition at the Julien Levy Gallery and to sell her paintings. She also applied for a Guggenheim Fellowship with the aid and at the suggestion of Carlos Chávez.[48] Among her supporters for the grant, she listed Breton, Picasso, Duchamp and Meyer Schapiro, the art historian from Columbia University who was a fan. She received great encouragement from her friends, among them Nickolas Muray, who wrote: 'Darling you must pull yourself together and lift yourself by your own bootstraps. You have at your fingertips a great gift . . . You must work work work paint paint paint work work. You must believe in yourself and in your own power.'[49] Her close friend Mary Sklar (Meyer Schapiro's sister) wrote to her ceaselessly during this difficult period, sent her money, encouraged her to come to New York and suggested ways of helping her to support herself, her father, Cristina and Cristina's children. One option that Kahlo was exploring, to which Sklar responded in a long letter, was renting out rooms in La Casa Azul.[50] Sklar and other friends offered their unbounded love and support and invited Kahlo to New York. When she learned about the divorce, Sklar began to renovate her Manhattan home and urged Kahlo to come and live with her:

We are going to have a room for you, very light, light enough to paint in, if you come to New York. Choose, my proud beauty, Diego or us!!!!! If I had crooked dice, I'd let on us, Frida Linda. How will it go? My dear, the past months getting used to living without Diego were so hard for you. What will you do now. You have suffered so to make the separation possible. Will you go

back and start over again or will you go on by yourself. I wish
you were strong enough in your body for it . . .

Upon hearing that Kahlo had renewed her relationship with Rivera,
a wary Sklar wrote:

> but I hope you let him know that you can stand alone, and
> where he gets off. Try not to need him too much, or you will
> go on suffering, on and on. Don't let yourself give in to him.
> I hope you can use all the energy you have building up your
> strength in yourself alone. It's a whopper of a job – but
> you'll have something when you're thru . . . I love you and
> wish I could help to make you strong.

Kahlo, however, did not attain either her personal or her professional
goals for a variety of reasons. To begin with, the Leon Trotsky assas-
sination attempt in May 1939 affected her plans dramatically. Rivera
was initially suspected of being involved in the plot and, with the
aid of Paulette Goddard, escaped to the United States.[51] He remained
in San Francisco for months. Kahlo was unaware of Rivera's where-
abouts for ten days.[52] Apparently, Rivera did not involve her for her
own protection, but she felt hurt and humiliated by the fact that
Goddard was 'trusted' while she was not. In a long letter she wrote
to Rivera on 11 June 1940, Kahlo begins by expressing relief that he
is safe and sound. However, the latter part of the letter reveals her
feelings of disillusionment, jealousy and palpable pain. She mentions
both Irene Bohus and Paulette Goddard by name and writes with
a mixture of sincerity and sarcasm: 'I would have given my life to
help you, it turns out other women are the real "saviors" . . . To
Mrs Goddard give my most repeated thanks for punctuality and
"coincidence" at the moment of taking the airplane.'
 She also expresses bitter disappointment because she failed
to attain financial independence: 'I was hoping the Guggenheim

thing would fix me up for this month, but not even the ghost of a response, not even the ghost of more hopes.'[53] Finally, the planned exhibition in New York never materialized, for unknown reasons.

When Leon Trotsky was stabbed with an ice pick by a Stalinist agent Ramon Mercader, on 20 August 1940, Rivera was still in San Francisco. When Trotsky died of his wounds the following day, Kahlo was interrogated by the police and her home was searched. She had met the assassin socially and this link was investigated. Her already frail condition became worse. Rivera was worried about her safety and deteriorating health. Kahlo did not allay his concerns but rather sent him a photograph in which she lay in bed with her eyes closed in pain and her body in traction. On the photo she added a handwritten inscription: 'To Diego with love from Frida.'[54]

In consultation with Dr Leo Eloesser, Rivera convinced Kahlo to fly to San Francisco for medical treatment. Her clinical records report that Dr Eloesser ordered 'absolute rest, very nutritious food, no alcoholic beverages, electrotherapy, calcium therapy', and that her condition improved.[55] Eloesser also attended to Frida's emotional needs and acted as a go-between, ultimately negotiating the remarriage of Kahlo and Rivera.

On 8 December 1940, Rivera's 54th birthday – after a thirteen-month divorce – Kahlo and Rivera were remarried in San Francisco. Unlike the first marriage certificate, in this document Kahlo is no longer listed as a 'housewife' but rather as a 'painter'. The terms and conditions of the second marriage were quite distinct from the first. Kahlo no longer expected to play the traditional role of wife and mother. The new partnership was understood to be a non-sexual, non-monogamous union. Rivera insisted that he was 'medically' incapable of being monogamous. Kahlo also said at the time that she could not bear to make love to Rivera because she could not help thinking of his other women. Kahlo also insisted that all expenses be divided equally between husband and wife,

reflecting her desire for financial independence. The latter condition was never fulfilled. Kahlo remained dependent on Rivera financially all her life.

Rivera's mural, painted in San Francisco at this time, depicts his view of the relationship. He portrays Kahlo as a Mexican painter, who holds a palette and brushes in her hand. Donning spectacular native Tehuana garb, she represents the beauty of Latin American culture. Rivera positions himself behind his wife, seated and with his back turned to her. He sits near the 'tree of love' holding hands with the beautiful Paulette Goddard, symbolizing the 'Pan-American' union, but also – blatantly – love between a man and a woman.[56]

The Rivera–Kahlo bond continued until Kahlo's death, and was peppered with frequent disruptions and numerous other players. Rivera continued to have affairs with famous women, among them the beautiful actress Maria Félix, whom he wanted to marry in 1949. Rivera wrote in his autobiography: 'While I was preparing for the [1949 retrospective] exhibition [in Mexico City], I gave Frida another bad time. I had fallen in love with the movie actress, Maria Félix, I not only planned to center my show around a life-size portrait I had painted of her, but I took steps toward a second divorce.'[57] Kahlo confided in Olga Campos a year later that in response to this she attempted to take her own life, but was unsuccessful.[58]

For her part, Kahlo forged many significant friendships and sexual liaisons with both men and women. While she was negotiating her remarriage to Rivera, she had a brief fling with Hans Berggruen, who was a young art collector at the time.[59] Some time in the mid-1940s she fell in love with the Spanish artist José Bartolí. Bartolí fought in the Spanish Civil War and was captured and imprisoned by Franco's forces. In 1942 he managed to escape first to South Africa, then to Mexico. He met Kahlo at that time because she was active in helping Spanish refugees find a safe haven in Mexico. In the mid-1940s he moved to New York, and when Kahlo was there

in 1946 for a spinal fusion operation the two became extremely close. They shared a love of Walt Whitman and Eastern philosophy and art. Kahlo wrote to her confidante Ella Wolfe around that time: 'To you I can say that I truly love him and that he makes me feel the desire to live again.' Until his death in 1995 Bartolí cherished a miniature oval self-portrait that Kahlo had painted and dedicated to him, and several other items, which he kept like relics in a special box. The intensity of their love is reflected in an undated letter that Kahlo wrote to her lover: 'The atoms of my body are yours and they vibrate together so that we can love each other.'[60]

There has been much speculation and controversy concerning Kahlo's lesbian affairs. Photographs and letters from countless women addressed to Kahlo reflect how deeply her friends loved her, but it is not always clear if the relationships were close friendships, intimate romantic involvements or sexual liaisons. Among the names that have been mentioned (but not confirmed) are several women who were also reputed to have been Rivera's lovers, including Maria Félix and the actress Dolores del Rio.

Another name that comes up is that of the African-American performer Josephine Baker. The Costa Rican singer Chavela Vargas, who had come to Mexico as a teenager and met Kahlo in the 1940s, claimed to have had a love affair with Kahlo.[61] Photographs and letters from the artist Sonja Sekula attest to a passionate liaison.[62] Traces of Kahlo's relationships have been sought (and found) in the photographs, letters and self-portraits that she left behind. James Oles, one of the first scholars who was granted full access to the archival material from La Casa Azul, published his findings in 2010, but offered a cautionary observation:

In the end, none of these pictures will really have much of a transformational impact on Kahlo scholarship: Even those of identified individuals, after all, are more like bits of gossip preserved in gelatin silver, as biased and subjective as any

whisper, hearsay more than history. Going through this material is more exhausting than exciting, more obfuscating than enlightening. Does it change how we imagine Kahlo or does it merely allow us to fill in a few more salacious (and not so salacious) details?[63]

The artist's niece Isolda P. Kahlo and Rivera's student Rina Lazo claim that malicious gossips falsely malign Kahlo and misrepresent her intimate friendships with women as torrid sexual affairs.[64] They blame specific individuals for spreading such rumours and vehemently deny that Kahlo had any homosexual tendencies. Kahlo's close, lifelong friends viewed her loving relationships in a different light. Gómez Arias opined that Kahlo's 'great passion for life . . . was manifested as love – for animals, plants, nature, her good friends, women or men . . . if there were tints of homosexuality – which I did not see or feel – it must have been a desperate search for life or to feel pleasure. One cannot judge Frida with the criteria of bourgeois morality.'[65]

Juan O'Gorman expanded this idea, claiming that Kahlo was not 'bi-sexual' but rather 'ambi-sexual' and that love – including sexual love – was the most prominent feature of her art, her life and her very being:

> The . . . characteristic of Frida's painting is her love for life, love for living, love for plants, love for the little animal, love for the little monkey, the tuna plant, love for her family, love for Rivera, love for her friends, love for her house, love for her ancestry. It is a very distinct characteristic that she was a person that loved everything around her. She put all that love into her painting and it shows.[66]

Kahlo's own words seem to affirm her friends' assessment. 'Love is the basis of all life', she told Olga Campos in 1950.[67] And Judith

Ferreto, Kahlo's nurse and long-time care-giver, recalled that the last time she saw the artist, just days before her death, the artist declared: 'Love is the only reason for living.'[68]

7

'Where is the "I"?':
Losing and Finding her Selves

I have broken many social norms.

Frida Kahlo[1]

Kahlo's marital drama, intimate friendships and emotional vicissitudes during the 1930s and '40s engendered insatiable speculations and gossip during her lifetime and continue to titillate audiences across the globe. Yet, even with the vast documentation that is available today – letters, photographs and eyewitness testimonies – Kahlo's personal experiences and emotions can never be fully known. Nor are they, to my mind, the most compelling aspect of her story. What is accessible, knowable and of utmost significance is Kahlo's remarkable artistic œuvre. Her ability to transpose personal experiences and profound insights concerning the human condition and the world at large into art is what makes Kahlo's life and legacy poignant, path-breaking and important.

Kahlo began her life with the conventional aspirations available to women of her time, particularly in Mexico. She wanted to become a wife and a mother, perhaps also a teacher and, later on, a doctor. Her physical and emotional experiences, which thwarted these ambitions, were powerful but not unique. Many people suffer from illness, accidents, a bad marriage and divorce. It was Kahlo's responses to the experiences of her life, rather than the experiences themselves, combined with her rare talent for articulating them visually and giving meaning to them that distinguish Kahlo as a towering cultural figure.

By the mid-1930s Kahlo seems to have realized that the normative gender roles of wife and mother were no longer viable options for her. Other aspects of her life were also crumbling or brought into question. The sudden death of her mother, her painful estrangement from both her husband and sister, and the ensuing social and familial rifts forced her to come to terms with the fact that she was on her own. She also began to think and rethink who she was and who she might become. As has been seen, at a critical juncture, Kahlo portrayed herself holding a palette in her hand, symbolically taking on the identity of an artist. This deliberate shift from identifying as the painter's wife (in 1931) to presenting herself as a painter in her own right (1932) marked a pivotal moment in her remarkable, though inconsistent, path as an artist.

In terms of exhibitions and sales, Kahlo was not very successful during her lifetime. Unlike Rivera, she was not part of the celebrated mural movement of Mexico. She had only two solo exhibitions in private galleries and sporadically participated in group shows over a period of decades.[2] Moreover, although she obtained a handful of commissions and sold a few paintings – mostly to friends – her ongoing efforts to support herself by selling her art were decidedly unsuccessful. Her brief attempt in 1943 to teach at La Esmeralda, the Ministry of Public Education's school of painting and sculpture, ended abruptly due to her ill health, although four students, nicknamed 'Los Fridos', continued to come to her home for informal instruction and remained loyal to their *maestra* and her memory long after her death.[3] Yet, much to her distress, throughout her life Kahlo was never self-sufficient and was financially dependent on Rivera until the day she died. 'All I've done is fail', she wrote in a sad epistle to her husband.[4]

In contrast to this perceived 'failure', it is clear today that in terms of quality and significance Kahlo's art is an astounding achievement. Against all odds, she created a revolutionary and innovative body of work. Impacted no doubt by her personal

experiences, but also firmly based on a staggering array of non-biographical historical, literary, artistic, scientific, philosophical and political sources, Kahlo's paintings coalesce into an unprecedented visual discourse on identity. Focusing on her particular search for self as a test case, but moving far beyond a singular biography, she produced more than 100 paintings and countless drawings that provide multiple perspectives on how human beings construct complex, multi-layered and shifting identities throughout their lives.

Informed by her erudition and an overarching philosophical understanding of ontological debates, evidenced by the books she read and a plethora of visual and textual documents, Kahlo critically examined her process of becoming from birth to death, taking into account physical, psychological, genealogical, social, national and religious/spiritual aspects of identity formation. She portrayed her physical self as it developed through time, from her conception and birth to her death and decomposition. She depicted herself as a zygote, a foetus, a child, an adult, a skull, a disintegrating mortal being. She visualized her own body or body parts (heart, feet, eyes) as objective, subjective, metonymic or symbolic signifiers.

Espousing Freudian tenets that view early childhood as the crucial period of identity formation, Kahlo painted a penetrating group of nine works that comprise her Childhood Series. Painted between 1932 and 1938, this series offers compounded visualizations of her childhood experiences, as well as accompanying clusters of emotional memories and sensations, which shaped the woman Kahlo would become.[5]

Concurrently, she examined her various social identities. Her first self-portraits displayed the youthful Frida in traditional female roles, for example as Gómez Arias's 'Botticelli' in 1926 or as Rivera's doting Mexican wife in 1931. Understanding that she could not conform to these normative gender roles, Kahlo presented herself

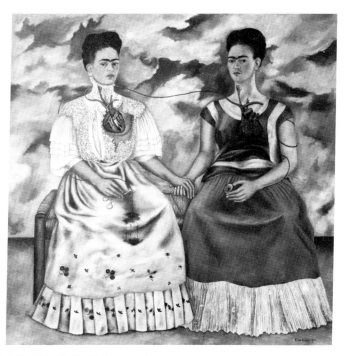

Frida Kahlo, *The Two Fridas*, 1939, oil on canvas.

as a failed wife and mother in her 'anti-Nativity' scene of 1932, *Henry Ford Hospital*, and again in *The Two Fridas* of 1939.

 The Two Fridas – an almost life-sized monumental painting – presents Kahlo in two distinct roles established by the costumes she dons and the props she holds in her hand. The left Kahlo is the bride whose white wedding dress is decorated by bleeding flowers, evoking her 'defloration'. The right Kahlo is a Tehuana mother, who holds an egg-shaped portrait of Rivera as a toddler near her loins. Both Fridas appear with exposed (broken) hearts, and their open arteries bleed incessantly. It seems that the failure to conform to confined gender roles, but also the very attempt to do so, can be oppressive, wounding and detrimental to the integrity of the self.

Kahlo's *Two Nudes in a Forest* from the very same year offers a radical alternative to the conventional roles presented in *The Two Fridas*. In *Two Nudes in a Forest*, Kahlo painted two naked women who embrace in a jungle-like, pre-social setting – an interracial, same-sex couple embracing and comforting each other. The entire composition, with its snake-like vines and monkey, is reminiscent of Henri Rousseau's *Eve*, known to Kahlo from reproductions. In Kahlo's reconfigured Garden of Eden, however, two loving women (perhaps Lillith and Eve) replace Adam and Eve and, by implication, the sorrow and grief that relationships between man and woman entail.[6]

Kahlo's espousal of a lesbian option is related to another bold subversion of conventional gender divisions and to her identification as an androgynous being. *Self-portrait with Cropped Hair* (1940) is often interpreted as her 'direct' response to Rivera's demand for a divorce, a reflection of her hurt feminine pride, and as masochistic self-punishment following the breakdown of her marriage. But the fact that in early photographs the nineteen-year-old Kahlo already sports male garb indicates that while the divorce may have instigated her recourse to this particular androgynous self-image, the work reflects a more profound understanding of aspects of her identity.

By cropping her hair and by displaying the evidence of her actions, Kahlo creates a multivalent symbolic image. *Self-portrait with Cropped Hair* includes three distinct references to hair. First, two remnants of her braids appear in the work. Kahlo's left hand holds one cut plait upon her lap; a second is discarded near the foot of the chair. Her braided hair – beribboned or decked with flowers – was a central feature of the exotic coiffures that helped construct her identity as 'La Mexicana'. By lopping off her locks, Kahlo, the artist-protagonist, rejects her former identity as the traditional Mexican wife.

Kahlo included a second reference to hair in her 1940 painting. At the top of the canvas – with brushstrokes that resemble her hair

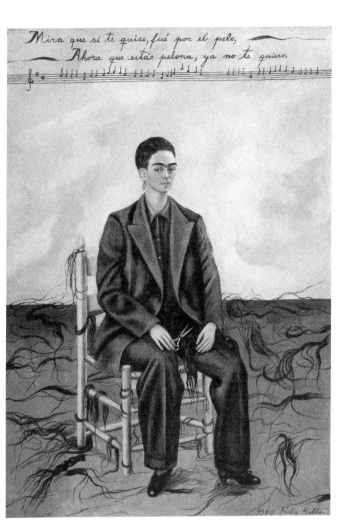

Frida Kahlo, *Self-portrait with Cropped Hair*, 1940, oil on canvas.

Family photograph showing Frida in man's suit, 1926, photo by Guillermo Kahlo.

in colour and texture – she inscribed the lyrics and music of a song. A distinctly male voice utters a cruel rejection: 'Look, if I loved you it was for your hair, now that you are hairless, I don't love you any more.' This verbal and musical statement, a product of culture, articulates the social convention that links female desirability with luxurious hair and gives men power over women's lives and hearts.

In addition to the braids and the hair-like music and lyrics, wild strands of loose hair fill the scene. As they float in the air, litter the ground and writhe around the chair, these dark, animated tresses recall the attributes of La Llorona, the Weeping Woman. As noted in chapter Five, Kahlo first portrayed herself as La Llorona in *Henry Ford Hospital* of 1932.[7] *Self-portrait with Cropped Hair*, then, expresses Kahlo's unwillingness to accept female roles that place her in subordination to men. Her cut hair and masculine attire define her self-creation as an alternative, androgynous being.

In addition to La Llorona, Kahlo portrayed herself in the role of another 'evil woman', La Malinche/La Chingada, a figure whose non-conjugal sexuality and maternity also threatened the patriarchal order, challenging and potentially destabilizing societal norms. La Malinche, the Indian translator and mistress of the Spanish conquistador Hernán Cortés, is one of the most notorious and contentious characters of Mexican lore. She is popularly viewed as a traitor, a sinful and sensuous Mexican Eve, who is responsible for 'the fall' (or the conquest of Mexico by the Spanish). In her role as the mother of Cortés's *mestizo* son, she is considered a primal maternal being, the mother of all Mexicans.[8]

In *The Dream* (1940), Kahlo painted herself as La Malinche, based on the Indian woman's portrayal in Antonio Ruíz's painting, *The Dream of the Malinche* (1932).[9] Like Ruíz's Malinche, she depicts herself in passive slumber upon a bed covered by a blanket that metamorphoses into a plant. Both painters evoke the archetypal link between woman and nature, but also suggest a more specific analogy between the conquest of the land and the invasion of the continent, and the sexual violation of the Indian woman. La Malinche's passivity is conceived as an inherent and defining trait. Whereas Ruíz's Malinche is transformed into a Mexican village, Kahlo's body is associated with a thorny vine. The thorns suggest pain, but they also conjure up specific Christian symbolism, alluding to Christ's crown of thorns and by inference to his

humiliation, suffering and sacrifice. The leaves that Kahlo painted – each composed of five elongated pointed segments – are based on a particular Mexican plant popularly called *Tripa de Judas* or 'Judas's entrails'.[10] The name relates to the story of Judas's suicide that caused his intestines to spill out in a repulsive display of corporal vulnerability, viewed as fitting punishment for his betrayal of Christ. Through this intentional botanical allusion, Kahlo links her Malinche self to the skeletal 'Judas' figure that lies above her, transforming her bed into a 'double decker' tomb. This particular Judas *calavera* (skeleton) was an actual papier mâché artefact that Kahlo placed on top of the canopy of her bed. In Mexico, Judas effigies were traditionally blown up with firecrackers on Holy Saturday.[11] Kahlo here identifies with a skeleton, with Judas and with La Malinche – all infamous characters popularly associated with betrayal, suffering and death.

Kahlo's *Roots* depicts the artist in a pose that emulates that of the passive Malinche from both *The Dream* and *The Dream of the Malinche.* In *Roots*, however, the connection of Kahlo-Malinche with nature is even more pronounced. Rather than being covered by a blanket that turns into a vine, Kahlo literally metamorphoses

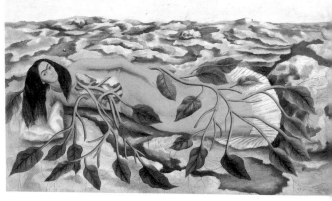

Frida Kahlo, *Roots*, 1943, oil on metal.

into a plant. The uneven hole that perforates her body, surrounded by the red fabric of her costume, resembles an open wound. This vivid image of an open wound relates to the vulgar Mexican term 'La Chingada' – an epithet that characterizes La Malinche as 'forced open', a 'screwed' or ravaged woman.[12]

The plant that sprouts from the violated body of Kahlo-as-Chingada has many leafless branches and bleeds profusely into the barren terrain. In this work the artist chose to link herself with a specific plant, *Calotropis procera*, popularly known as the Apple of Sodom. The prominent veins in the leaves of this plant contain a poisonous fluid that was used by the Indians of Latin America to kill or commit suicide.[13] The name of the plant evokes additional biblical connotations, linking its deadly botanical potential with Eve's transgression ('Original Sin'), as well as with the sexual deviations associated with Sodom. Kahlo's identification with the stony earth (the Mexican *pedregal*) and with the plant of death is further accentuated as she transforms the lethal serum that courses through the leaves into blood-red paint, with which she signs her own name upon the parched land.[14]

Kahlo's by now obsessive identification with La Malinche is expressed once again in *The Mask* of 1945. In this unusual self-portrait, rather than depicting her features, Kahlo conceals her face completely with a red mask. It is a typical Malinche mask, which was traditionally scarlet, symbolizing the 'sexuality and . . . lasciviousness that led [La Malinche] to become Cortes's mistress' on the one hand, and the 'violence and bloodshed that Malinche brought upon her own people with the Conquest' on the other.[15] But the masked Kahlo-Malinche appears neither sensuous nor treacherous. Both she and the mask are crying. At the bottom left-hand corner of the painting, a cactus plant sheds tears as well. The cactus and the leaves that serve as a backdrop for this image have a brownish-green colour that makes them look dry and lifeless. Behind these plants, dark shadows reinforce the sombre mood.

Kahlo's self-depictions as the Malinche may relate to her personal experiences of being caught in a web of deceit and multiple betrayals.[16] But they simultaneously recast La Malinche – a central character of Mexican history – and allow us to see her and empathize with her as the tragic victim she really was rather than the mythic traitor constructed by the popular imagination. In fact, Kahlo's revisionist view of the Indian woman seems to be more in keeping with the historical facts of La Malinche's life.

La Malinche was born to an Aztec family of chiefs. When she was a small child her father died. After her mother remarried and had a son she sold her daughter to a group of traders. The girl was repeatedly sold and resold from tribe to tribe until she was finally 'given' to the Spanish Cortés. She was fourteen years old at the time. Her fluency in several indigenous languages as well as in Spanish, her vast intelligence and her proficient knowledge of the native cultures were clearly great assets for the Spanish expedition. She was used and abused in other ways as well. After becoming Cortés's mistress and bearing him a son, he married her off to another Spanish man. She died at the age of 24. Kahlo signed several letters as 'La Malinche' and referenced her repeatedly through her imagery, thus cementing her identification with the Chingada-Malinche. In doing so she rehabilitated the most despised and misunderstood character of Mexican history and exposed the misogynist forces that maligned her and continued to oppress her daughters during Kahlo's lifetime.

Unlike La Llorona and La Malinche-Chingada, who are marked by what patriarchy perceives as a threatening and deviant sexuality, the nun's identity is defined by her celibacy. 'Respectable' Mexican women of the early part of the twentieth century (particularly those who were brought up in Catholic households like Matilde Calderón's) had very limited social options. They could become conventional wives and mothers and engage in what was considered 'legitimate' marital sex, or they could become nuns and take

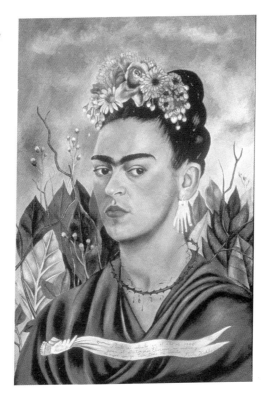

Frida Kahlo, *Self-portrait Dedicated to Leo Eloesser*, 1940, oil on masonite.

vows of chastity. All other options were considered immoral or transgressive, and could result in a tarnished reputation.

In several self-portraits from the 1940s (for example, *Self-portrait with Dead Hummingbird, Self-portrait as a Tehuana*), Kahlo explored the possibility of playing the role of a Mexican nun. For example, in *Self-portrait Dedicated to Dr Eloesser* of 1940 she wears the habit of a nun, its dull brown colour symbolizing mortification, mourning and humility. A crown of thorns encircles her neck and punctures her skin, making her bleed. Kahlo portrays herself from the neck down as an ascetic, engaged in *imitatio Christi* self-mortification. The artist's head is crowned with flowers whose voluptuousness

contrasts with the asceticism of her lower half. Emmanuel Pernoud has convincingly argued that this type of self-portrayal is modelled after portraits of 'Crowned Nuns', a Mexican genre that was famous in viceregal times.[17] The nun is characteristically portrayed bedecked with flowers on the day she takes the veil. The sensuousness of her apparel contrasts with her austere future life in the convent. By adopting the symbolism of this genre, Kahlo displays herself as a deeply divided being, split between sensuality and asceticism.[18]

Kahlo's espousal of Christian symbols, however, goes well beyond her interrogation of social roles. As the next chapter shows, it intertwines with her ongoing explorations of religion and spirituality and her search to understand the mystery of life.

8

'Everything is All and One': Losing and Finding Faith

Towards the end of her life, Kahlo wrote in her diary that as a communist she rejected all religions. She also told a friend: 'I do not like to be considered religious. I like people to know that I am not.'[1] Yet Kahlo's art reveals that she was immersed in religious traditions, and that various spiritual concepts and beliefs shaped and resonated with her world view.[2]

Given her strong maternal Catholic Mexican heritage, it is not surprising that Christian elements permeate Kahlo's art with frequency and force. Her appropriation of the *retablo* format, ubiquitous use of distinct symbols of suffering and martyrdom (for example, nails, thorns, blood, hearts), and her adoption of Christian motifs or entire scenes as essential components of her visual vocabulary, have been observed by virtually all Kahlo scholars.[3] Prominent examples are the *Virgin and Child* motif that served as a model for *My Nurse and I* (1937); Leonardo's *Last Supper*, on which Kahlo based her large painting *The Wounded Table* (1940), where the 33-year-old artist appears in the role of Jesus; and her overt allusion to both Christ and the martyrdom of St Sebastian in *The Broken Column* (1944).[4] Indeed, it is virtually impossible to understand Kahlo's paintings without taking into account the profound influence of Christianity and its visual manifestations on her psyche. Frequently, her manner of incorporating these religious emblems challenges and complicates her overt anti-religion declarations.[5]

Kahlo's interest in Judaism seems to be related to her father's lineage and to her political, rather than religious, views. Her repeated assertions – particularly during the Nazi era – that her father's forebears were Jewish may be interpreted as a political statement of protest against the rampant anti-Semitism and racism of her time. The books in Kahlo's library reveal that she was deeply interested in diverse aspects of Jewish history and culture and that this interest influenced her imagery.[6] A Yiddish book that deals with Jewish immigration, two volumes that recount and illustrate the torture of Jews by the Mexican Inquisition, and her previously noted use of Nazi genealogical charts are examples of this rather unusual predilection.[7] Photographs from La Casa Azul, published in 2010, that Kahlo collected and kept throughout her life expose her sustained interest in Jewish immigration to British Mandate Palestine and to the State of Israel. These include a photograph of 1943 of the ship *Exodus*; one of 1945 of Jews from concentration camps, still wearing striped uniforms, upon their arrival in Palestine; and one of 1949 by Zoltan Kluger documenting operation 'Magic Carpet' in which Yemenite Jews were airlifted to the newly established State of Israel.[8]

The artist's most overt engagement with Judaism may be found in a small, mural-like painting titled *Moses* (1945), which she based on Sigmund Freud's *Moses and Monotheism*.[9] Kahlo transformed Freud's dense tome on the birth of Judaism into a central scene depicting the birth of Moses, flanked by a crowded and idiosyncratic gallery of mythical deities, historical characters and symbolic self-portraits. Freud's complicated text advances a hypothesis that Moses was an Egyptian who transformed the religion of Ikhnaton into an ascetic and monotheistic religion. Rejected by his own people, the Egyptian Moses became the leader of the Jewish people, who took on the monotheistic faith that evolved into the Jewish creed.[10]

The gods that populate the top part of the painting have nothing to do with Freud's book and everything to do with Kahlo's hybrid

cosmological musings. Her pantheon of anthropomorphic gods –
most of them copied from books in her library and coloured in
vivid polychrome – includes deities from numerous cultures and
geographical regions. On the right, Kahlo painted gods that relate
to Western culture. Although she feigned ignorance as to their
origin and meaning, she chose them carefully, emphasizing deities
that are associated with the sun and with birth myths, thus linking
them to Freud's text. On the left Kahlo painted pre-Columbian and
Eastern deities.

Below the gods – in the realm dominated by death – Kahlo
portrayed historical figures. On the right Ikhnaton along with
Christ, Hammurabi, Alexander, Caesar, Muhammad, Luther,
Napoleon and Hitler appear. These are leaders and religious
reformers who, like Moses, led or in many cases misled their people.
On the left is a profile portrait of Nefertiti, based on the famous
statue of the Egyptian queen, whom Kahlo calls 'the marvellous
Nefertiti'.[11] Alongside Nefertiti she painted Marx, Paracelsus, Freud
himself, Epicurus, Stalin, Lenin, Gandhi, Genghis Khan and Buddha.
The bottom portion of the canvas depicts war, strife, national flags
and the masses. Kahlo explained that these represented

> humanity, composed of all kinds of – rare types, the warriors,
> the pacifists, the scientists, the ignorant, the makers of monu-
> ments, the rebels, the flag-bearers, the medal carriers, the
> loud mouths, the sane and the insane, the gay and the sad,
> the healthy and the sick, the poets and the fools and all the
> rest of the race that you may imagine exist among this
> f . . . ertile bunch.[12]

Among the crowd, on the left, Kahlo distinguished a symbolic
image of Man the Constructor composed of four colours to repre-
sent the four races. On the right she painted a symbolic image of
Woman, Creator of Life, with a child in her arms. Behind both are

monkeys, their simian ancestors according to Darwinian theories of evolution, with which Kahlo was well acquainted. Kahlo's image of Woman relates to her concept of self. The archetypal woman is painted as a hybrid creature, composed of diverse racial components, of human and plant elements, as she nurses an offspring who is part human, part animal. These factors, and her kinship with the apes behind her, situate her within a cosmological web of interconnectedness.

Kahlo's spectacular polytheistic pantheon of hybrid deities undermines Freud's strict iconoclastic monotheism. His emphasis on the spiritual, manifested in the prohibition to visualize God pronounced in the second commandment of the Mosaic law, is subverted by Kahlo's emphatic polychromatic visual splendour. Another way to interpret Kahlo's *Moses* is as a magnificent visualization of 'the return of the repressed' – not merely the victory of an anthropomorphic and zoomorphic imagination over an ascetic and anti-visual severity, but also the triumphant 'return' of the sensual, the return of the body, the return of the maternal womb.

Kahlo took from Freud's immense creative output that which resonated with her own concerns. As always, she oscillated between the personal and the ontological as she painted a creation myth that intersected with and corresponded to her own mythical self-creation. She presented Moses as she presented herself, as a hybrid, cross-cultural protagonist within a cosmic drama that embraces plants, animals and human beings; that balances Eros and Thanatos, male and female components, East and West, science and art. The hybrid cosmology and faith in the interconnectedness of all beings that may be observed in *Moses* draws more on pre-Columbian myths and Eastern philosophies than on Christianity or Judaism. Indeed, during the last decade of her life, Kahlo embraced her own variation of Hinduism, Buddhism and Taoism.

Kahlo's poetic texts, the books she read, and the overt Hindu, Buddhist and Taoist signs and symbols that she inscribed in her

diary and in her art – for example, the yin-yang emblem, the words Tao and Carma (Karma), the third eye – reflect her deliberately chosen spiritual inclinations. In several paintings from the 1940s (*Self-portrait as a Tehuana*, 1943; *Diego and I*, 1949) she included a miniature portrait of Rivera on her forehead, indicating that he is lodged in her thoughts, that he is an integral part of her very being, and that he has become her 'third eye' and source of insight.

In 1944 Kahlo painted two virtually identical paintings, one for herself and one for Rivera, to mark fifteen years of marriage. Both are titled *Diego and Frida, 1929–1944*, and link her marriage to Rivera with the conjugal bond between the Hindu deities Siva and Parvati. The two works depict a hybrid creature composed of the right half of Rivera's face and the left half of Kahlo's face. In each painting, a heart-shaped piece of wood fastens the two half portraits together at the neck. Branches, which resemble wooden veins or antlers, emerge from this wooden 'heart'. At the bottom of the work a conch and a shell, emblems of fertility, appear. On the right side of the composition the sun and moon, symbols of the male and female elements, are painted.

The two halved portraits are riddled with ambiguity and tension. On one level, each work shows Kahlo and Rivera split in half; both are therefore, by definition, not whole. On the other hand, the images portray an effort to seek completeness through unity with the beloved. The basic concept inherent in this image, of physical and metaphysical union with the beloved as a means of achieving wholeness, was not Kahlo's invention. The Surrealists enthusiastically embraced this notion. Acknowledging cabalistic, alchemical, Hindu and other precedents concerned with this theme, they proclaimed that the path to self-knowledge was carnal and spiritual knowledge of the beloved 'other'.[13] The issue of *Minotaure* of 15 May 1938 that Kahlo kept in her studio devoted several articles to these themes, specifically referring to the androgyne as a complete being who unites the two sexes and to the Hindu concept of

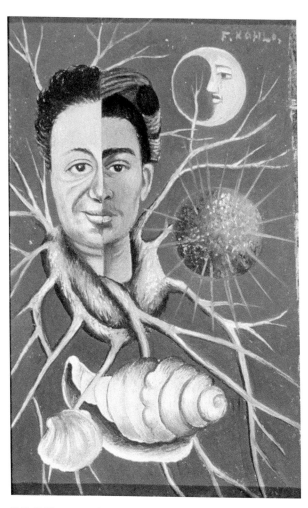

Frida Kahlo, *Diego and Frida 1929–1944*, 1944, oil on wood.

sakti, the female element that is an integral, activating part of the male god.[14] Kahlo's interest in Hindu manifestations of the androgynous union between husband and wife, as expressed in the image of the god Siva and his wife Parvati merged into a single being known as Siva Ardhanarisvara, seem particularly relevant to these portraits of 1944.

Kahlo's library contained books and articles on Hindu and Indian philosophy, and during the last decade of her life oriental thought influenced her writing as well.[15] For example, specific passages from the artist's journal refer to her relationship with Rivera in terms that echo both the visual imagery of the 1944 composite portraits and their Hindu antecedents. Her complicated relationship with Rivera during the last decade of her life – her obsessive love for him, her desire to merge with him, but also her knowledge that he was fundamentally unattainable and that there was an inherently 'horrible' aspect to their union – found poignant expression in her diary, drawings and paintings. In many of these references she linked Rivera overtly with Siva.

In sharp contrast to Kahlo's portrayals of her consuming desire to become one with her husband, Rivera's view of Kahlo and of their relationship from the same period reveals a very different attitude. In a large mural titled *Dream of Sunday Afternoon at Alameda Park* (1947), Rivera included portraits of himself and Kahlo. He portrays himself as a child of about twelve, standing among political, historical and folkloric figures that represent Mexican culture. An adult Kahlo appears one step behind him and his other companions. The child Rivera does not acknowledge Kahlo's presence at all. She, however, places her right hand protectively – like a mother – upon his shoulder.[16] She is decidedly separate from him and is conceived as a maternal figure rather than a spouse or lover. Kahlo's portrait is based on a photograph taken in 1938 by Nickolas Muray that accentuates her indigenous Mexican hairdo, garb and crimson *rebozo*. But the *mexicanista* Kahlo holds another attribute in her

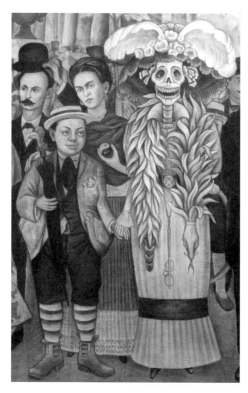

Diego Rivera, *Dream of Sunday Afternoon at Alameda Park*, 1947, detail from mural.

hand – a distinct black and white yin-yang circle that emphasizes her deep engagement with Eastern thought.

While Rivera was working on this mural, Kahlo produced two drawings that ultimately became the basis for a monumental painting titled *The Love Embrace of the Universe, the Earth (Mexico), Me, Diego and Mr Xolotl*, in which she also depicts herself and Rivera as mother and child, but in a very different manner. *The Love Embrace*, completed in 1949, blends biographical references with overt Christian, Hindu and pre-Columbian symbols. It presents a hybrid cosmology that reflects not only Kahlo's relationship with Rivera, but also her deep spiritual and existential beliefs. Composed as a

series of interconnected embraces, the painting is structured in the form of a yin-yang diagram. Like the Taoist emblem that inspired it, *The Love Embrace* harmonizes coexisting complementary elements, such as day and night, male and female, light and dark, earth and sky, life and death.

The Mother and Child format clearly evokes Christian iconography (specific images of the *Virgin and Child with St Anne* come to mind). The Mexican earth goddess, with the plethora of cacti that

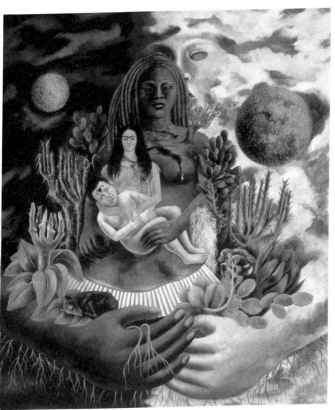

Frida Kahlo, *The Love Embrace of the Universe, the Earth (Mexico), Me, Diego and Mr Xolotl*, 1949, oil on masonite.

form an integral part of her body, and the dog Xolotl – the Aztec deity who guards the underworld, Xibalba – link the work with the Aztec world. Kahlo depicts Rivera as a peculiar-looking man-child with effeminate breasts and a huge third eye on his forehead. This visual portrait echoes a text that Kahlo published the year she painted *The Love Embrace*, in which she describes Diego as possessing 'Oriental' features, an 'Asiatic head', a 'Buddha-like mouth' and a prominent 'third eye'.[17] In the painting, Rivera holds an additional Hindu attribute near his loins, a small flaming fire that identifies him as Siva. Fire is the emblem of Siva's lingam (phallus), which was first revealed as a flame.[18] According to Hindu belief, Siva gave light to the world, since his three eyes are the sun, the moon and fire.[19] Appropriately, in *The Love Embrace* the three-eyed Rivera-Siva is positioned between the sun and the moon, with fire in his hands. Kahlo's self-portrayal in this painting is both individual and archetypal. We recognize her distinct features and

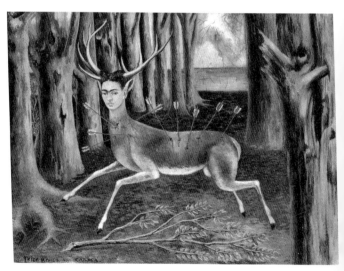

Frida Kahlo, *The Little Deer*, 1946, oil on masonite.

persona, but also the parallels she draws between herself and the universal maternal being, the Great Goddess, the Mexican earth, the Christian Virgin Mary and the oriental Parvati.

By the mid-1940s Kahlo's imagery displayed a broader spiritual quest to merge with other beings, a tendency that went beyond her psychological desire to unite with her loved ones, especially at times of loneliness and illness. Her paintings show her merging with animals and plants, while her so-called Carma Drawings and numerous diary entries portray her integrated into a massive, undifferentiated web of Being.

Kahlo's most striking depiction of herself merging with an animal appears in *The Little Deer* (1946). In a poem she composed for her friends Lina and Arcady Boytler when she presented them with the painting in May 1946, she explained the manifest meaning of the image:

Lonely wandered the Deer
Very sad and sorely wounded
Until with Arcady and Lina
She found warmth and shelter.
When the Deer returns
Strong, joyful and healed
The wounds she now bears
Will all be effaced.
Thank you children of my life
Thank you for so much consolation
In the forest of the Deer
The sky is beginning to clear.

Elsewhere she wrote with less optimism: 'Sadness is depicted in every part of my picture but that is my condition: I have no remedy.'[20]

The meaning conveyed by Kahlo's visual imagery is much more rich, profound and complex than her poetry, as she herself knew

well. The arrows that penetrate the deer's body clearly allude to images of St Sebastian. Kahlo's choice to identify herself with a deer can be traced to a variety of Aztec sources and rituals. At the bottom of the composition, alongside her signature and the date, Kahlo wrote the word 'CARMA', alluding to the Eastern concept of reincarnation according to the law of Karma and the cycle of suffering that life on earth entails. Beyond the realm of suffering, symbolized by the withering trees, broken branches, arrows and blood, Kahlo painted water and lightning. Water is an Eastern symbol for the divine essence; lightning symbolizes the possibility of reaching Nirvana-enlightenment. Kahlo amalgamates Christian, Hindu and Aztec symbols to express her desire to overcome suffering and reach spiritual release.[21]

Kahlo's hybrid interfaith cosmologies – among them *Moses*, *The Love Embrace* and *The Little Deer* – are but one type of manifestation of the artist's tenacious investigations and articulations of hybridity. Even a cursory glance at Kahlo's œuvre reveals that it is replete with numerous modes of hybridity: she imaged herself as the offspring of miscegenation; she identified as an androgynous creature; she portrayed herself as part human, part animal, part plant; or as merging with an undifferentiated web of interconnected beings.

All forms of hybridization – whether they are mythical amalgamations of animal and human beings, offspring of intermarriage or interpenetrating multicultural configurations – imply a form of trespass, an act of transgression. They often involve the rupturing of boundaries and the breaking of taboos. Moreover, hybrids (from satyrs to androgynes to vampires) have always been viewed as outsiders. Their very being embodies the threat of chaos, since they challenge the contours that define normative and so-called pure states of being.

Kahlo's systematic and bold espousal of the hybrid condition may be understood as an unequivocal rejection of notions of purity

and order that were highly valued during her lifetime. As noted in earlier chapters, in 1931 Kahlo painted the hybrid portrait of the botanist and inventor Luther Burbank, who was attacked by religious groups for his 'sacrilegious' creation of hybrid plants. By positioning herself as an advocate of Burbank, Kahlo was rejecting religious restrictions and espousing freedom of science, creativity and thought. In 1936 she was adamantly confronting Nazi laws of racial purity when she portrayed herself as the offspring of an 'impure' family tree. During the last decade of her life, by composing interfaith and inter-cultural cosmologies, Kahlo created alternative realms of inclusivity, imagination, cross-fertilization and radical freedom.[22]

Kahlo's imaginative configurations of alternative selves and hybrid cosmologies transcend the genre of self-portraiture. They conjure up bold political, spiritual and ontological queries and open up radically new discursive realms.

9

'I am the Disintegration':
The Waning of Life

'I think about death very often', Kahlo told a friend in 1950, 'too much'.[1] A little later she wrote in her diary: 'I am the disintegration.' An intense preoccupation with death is reflected in her art, which contains copious references to mortality. Examples abound: *My Birth* conflates birth and death; *My Nurse and I* shows Frida being suckled by a woman who dons an Aztec funerary mask; Kahlo's self-images as a little girl picture her wearing a skull mask; and her self-portraits as an adult woman show her sleeping and dining with skeletal companions. One of Kahlo's most famous self-portraits – explicitly titled *Thinking of Death* – displays the artist against a backdrop of poisonous, thorny leaves with a skull lodged within a gaping hole that pierces her forehead.

Kahlo's body of work reflects an understanding of death that is both ontological and personal. Beyond a general philosophical awareness of human mortality, Kahlo was also deeply engaged with a specifically Mexican contemplation of the omnipresence of death. She immersed herself in a vivid array of popular customs, folk art and acerbic cultural traditions – celebrating the Day of the Dead, collecting sugar skulls named 'Frida', and decorating her home with papier mâché *calaveras*, Posada prints and pre-Columbian skulls.

But it was Kahlo's formative encounters with the threat of her own early death that explain more fully why death was obsessively

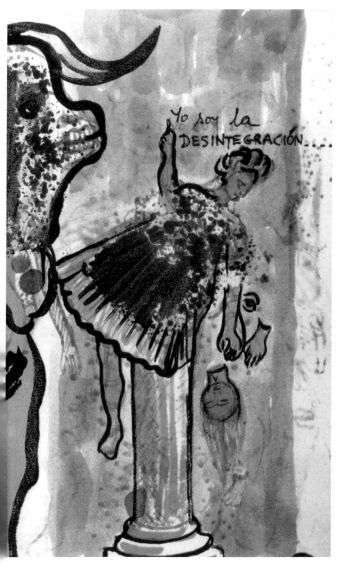

Frida Kahlo, diary entry, 'I am the Disintegration', *c.* 1950.

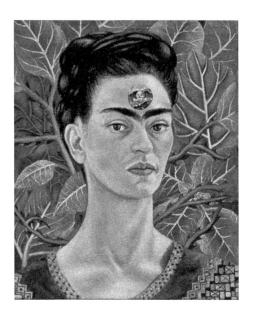

Frida Kahlo, *Thinking of Death*, 1943, oil on canvas mounted on masonite.

'on her mind'. She continuously suffered from recurring and painful medical conditions that caused her to relive her initial brushes with death, re-experiencing the traumas repeatedly.

As is the case with many aspects of the Kahlo story, even the basic facts about her medical condition are contested. Until 2010 the main sources of information were Kahlo's letters and a hand-written document titled 'family medical history' compiled by the artist for Dr Henriette Begun in 1946. Very few details about Dr Begun are known beyond Salomon Grimberg's statement that she was a German obstetrician-gynaecologist living in Mexico.[2] In a publication of 2010, Mauricio Ortiz reported the finding of 'two unsigned, typewritten medical records' in a previously locked section of La Casa Azul. He described them thus: 'One of them is dated 1944, while the other – bearing the handwritten date 1948 – actually covers four years, from 1946 to 1950 . . . although they were written in the third person and in the style of genuine medical

records, the evidence suggests it was Frida herself who penned them.'³ In addition, an undated letter, handwritten by Dr Leo Eloesser describing Kahlo's medical condition was also found among Kahlo's papers.

The recently uncovered information does not shed new light on Kahlo's physical condition and many queries regarding her medical state persist. Today it seems impossible to determine: did Kahlo have a congenital spinal problem, spina bifida, polio or all three? Did she suffer from anorexia, lack of appetite, or were there other reasons for her weight loss? Did she really have syphilis and tuberculosis or was she just tested for these ailments? Was hers a drug addiction or a legitimate pain-management regimen? To what

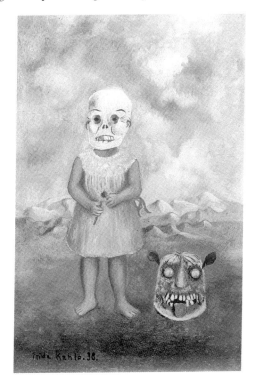

Frida Kahlo, *Girl with Death Mask (She plays Alone)*, 1938, oil on tin.

extent did her physical condition exacerbate her psychological distress and what bearing did her mental state have on her physical illness?

It is known with certainty that Kahlo consulted a staggering number of doctors, had more than 30 surgical procedures, endless medical tests, and standard and alternative treatments, and wore a variety of medical contraptions. Gómez Arias dubbed the entire post-accident phase of Kahlo's existence the 'new industry to cure Frida'.[4] Sadly, this 'industry' was unsuccessful. Kahlo's corsets appear in some paintings and, conversely, she also painted on her plaster body casts, transforming them into part of her art, part of her body, part of her self.

Kahlo's relationship with the medical profession and her care givers was very complicated. As noted earlier, she had intended to become a doctor herself and was fascinated by and knowledgeable about medicine. She also seems to have been emotionally attached to many of the physicians who treated her, and she thanks several doctors explicitly in her diary.

In 1951 Kahlo painted herself seated in a wheelchair next to an overpowering iconic portrait of Dr Juan Farill on her easel. The doctor's visage looms large and he is depicted as a deity or father figure.[5] Kahlo cradles a heart-cum-palette in her lap and holds blood-tipped paintbrushes in her right hand, suggesting that she transmitted her pain and emotions in unmediated fashion from her heart onto the 'heart' of the canvas. In a diary entry, penned while she was composing this work, Kahlo wrote:

> 1950–1951 – I have been sick for a year. Seven operations on my spinal column. Dr Farill saved me. He gave me back my 'joy of life'. I am still in a wheelchair, and do not know whether or not I will be walking again soon. . . . I began to paint. A small painting that I am going to offer to Dr Farill and that I am making for him with all my love.[6]

But Kahlo's growing dependency on her physicians and their ultimate failure to cure her also made her, to use her own words, 'feel like getting even with the doctors, and all their progenitors'.[7]

Hayden Herrera has suggested that Kahlo may have had unnecessary medical procedures because she suffered from Munchausen Syndrome, a disorder stemming from a deep need for attention that causes a patient to push for risky operations and invent symptoms in order to outwit doctors or to gain sympathy and care.[8] Salomon Grimberg posited that it was Kahlo's early experience with polio, which resulted in her father's tender care, that led her to use her illnesses in a manipulative manner, especially to solicit Rivera's attention and compassion.[9]

Reading through Kahlo's medical records and heart-rending letters; witnessing the tangible reality of the wheelchair, corsets, crutches and prosthetic leg, which remained in her home even after her death; peering at countless photographs that show Kahlo in traction with acute mute pain in her eyes; and deciphering the

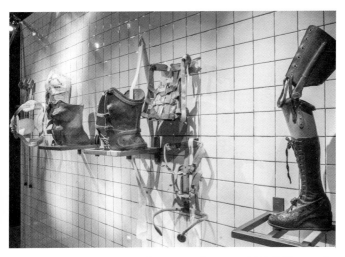

View of exhibition *Appearances can be Deceiving: The Dresses of Frida Kahlo*, opened at La Casa Azul in November 2012. Photograph: Miguel Tovar.

raw imagery of her paintings – I find the scholarly debates regarding the objective condition of her body somewhat troubling and misguided. Pain is always experienced subjectively, as Elaine Scarry reminds us.[10] For Kahlo, her pain and her illnesses were palpably real and extreme, even if outside observers have doubts and cannot agree on their cause.

There is no doubt that Kahlo had grave medical problems throughout her life and that acute secondary conditions developed in response to her physical deterioration and to the psychological toll of living with chronic pain and with a constant sense of fragility and physical inadequacy. If she did solicit 'too many' medical opinions or opted for treatments and procedures that seem unnecessary in hindsight, it is most likely that she did so out of a desperate desire to be healed, to live and to overcome her unbearable suffering.

Kahlo suffered from three main medical conditions. First, she had problems with her polio-stricken limb that remained atrophied and further deteriorated throughout her life; from the 1930s her right leg became infected with tumours, ulcers and, ultimately,

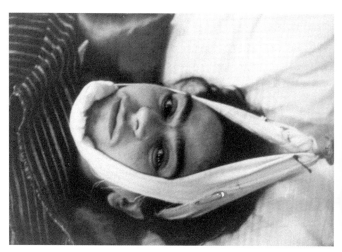

Nickolas Muray, Frida Kahlo in traction, 1940.

gangrene, which necessitated numerous medical treatments and surgical operations until in July 1953 the leg was amputated below the knee.[11] Second, she was plagued by acute and debilitating pain caused by serious deformities in her spinal column. Third, she experienced gynaecological ailments.

Many writers, prominent among them Hayden Herrera and Carlos Fuentes, have observed Kahlo's unique capacity to sublimate her pain into art. Significantly, however, her paintings are never mere illustrations of one-time events. Rather, they also simultaneously refer to layered experiences of early traumata and to the essential fragility of the human body.[12] The painting titled *Tree of Hope*, for instance, triggered by the spinal fusion operation performed in New York by Dr Phillip Wilson in June 1946, also echoes Kahlo's primary responses both to polio and to her accident. As she was recovering from this operation – just as when she was recuperating from polio – Kahlo literally created a second self as an 'imaginary friend'. This 'double' – whole, undamaged and strong – is an alterego, who, like Kahlo's childhood companion, allows the broken artist to alleviate her loneliness, her pain and her fears. *Tree of Hope* also relates to Kahlo's *Accident Drawing* of 1926. Both works visualize her defensive 'splitting', the psychological mechanism that enabled her to cope with her traumas. The sick Kahlo in *Tree of Hope* lies on a hospital stretcher partially covered by white hospital sheets that evoke a shroud.[13] Kahlo's thinking and conscious self separates from the wounded body. By distancing herself from the suffering body, much as she did following the accident and miscarriage, she finds the strength to survive.

There are conflicting reports regarding the outcome of Kahlo's operation in 1946.[14] What seems clear is that her physical condition deteriorated rapidly. On the final page of one of the newly discovered medical records, Kahlo writes about her condition in the third person, strangely distancing herself (as if 'splitting') from her own bodily experience: 'From 1946 to 1950 the patient's

condition has undoubtedly worsened. She experiences constant pain in her column as well as weight loss (from 54 k. to 42). Terrible general condition. Not self-sufficient. Nervous depression.'[15] For the rest of her life Kahlo was in and out of hospitals. Her nurse, Judith Ferreto, described her final year as a journey burdened by excruciating pain and intense loneliness. The emotional upheavals of her life also took their toll. In her diary, Kahlo expressed a death wish several times.[16] She visualized her disintegration most poignantly in *The Circle* (*c*. 1950), a small round painting that depicts her ravaged and headless body. Blood spurts from her breast as her entire body seems to be consumed by flames, eaten by sulphuric acids, in the process of complete disintegration. The circular format of the painting becomes an integral part of its meaning. An archetypal symbol of unity, harmony and wholeness, the circular shape amplifies the disharmonious process of Kahlo's physical dissolution.[17]

Frida Kahlo died on 13 July 1954. To this day there is speculation as to the cause of her death. The death certificate proclaims 'FRIDA KALO DE RIVERA [*sic*] died at age 43 [she was actually 47] of non-traumatic pulmonary embolism and phlebitis of the interior right membrane.'[18] The *New York Times* obituary erroneously reported that she was 44 years old and 'had been suffering from cancer for several years'. Judith Ferreto stated that after Kahlo's leg was amputated in 1953, she lost her will to live.[19] Others, pointing to the artist's self-destructive behaviour towards the end of her life, consider that her death was a suicide.[20] The possibility that she took an unintended overdose of painkillers has also been raised. In 2005 Kahlo's beloved niece, Isolda, published what she called her family's 'best kept secret'. She revealed that Diego Rivera gave Kahlo an intentionally lethal dose of drugs in order to bring an end to her suffering. She vividly recalled Rivera's confession of euthanasia, whispered in confidence at the foot of Kahlo's coffin: 'I could no longer bear this slow death, day after day, this cruel and senseless torture, especially the senseless aspect of it'.[21]

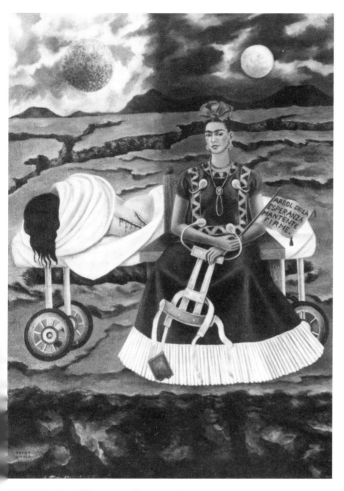

Frida Kahlo, *Tree of Hope*, 1946, oil on masonite.

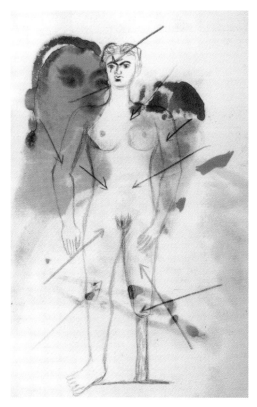

Frida Kahlo, diary entry, 1954. This is Kahlo's last self-portrait, done after the amputation of her leg and shortly before her death.

For several hours Kahlo's coffin lay in state at the Palacio de Bellas Artas in Mexico City. The grey casket was covered with a huge red communist banner, with the hammer and sickle upon it, causing great controversy and drama.[22] On 14 July 1954, a week after her forty-seventh birthday, Kahlo's body was cremated at the Pantéon Civil de Dolores crematorium. Here too a wide variety of opinions as to why she was cremated have surfaced and remain unresolved: was the body disposed of so that there would not be an autopsy? Was it Kahlo's wish to be cremated in accordance with her Hindu beliefs? As they bid her farewell, Kahlo's friends

sang the *Internationale*, the Mexican national anthem, and her favourite Mexican *corridos* (folk songs), reflecting her staunch and lifelong affiliation with communism, Mexican nationalism and popular culture.[23]

Most of the major studies of Kahlo's life end with one of her last finished paintings, a still life of watermelons. Herrera concludes her monumental biography *Frida* with an exuberant description of the painting and an uplifting interpretation that suggests that Kahlo hung on to life until the very end:

> Set against a brilliant blue sky . . . are watermelons, the most loved of Mexican fruit . . . It is as if Frida had gathered and focused what was left of her vitality in order to paint this final statement of *alegría* . . . Eight days before she died, when her hours were darkened by calamity, Frida Kahlo dipped her brush in blood-red paint and inscribed her name plus the date and the place of execution, Coyoacán, Mexico, across the crimson pulp of the foremost slice. Then, in large capital letters, she wrote her final salute to life: VIVA LA VIDA.[24]

As always, however, Kahlo's public pronouncement – captured with precision by Herrera – masks a different aspect of her tale. A few days later she sketched a tormented self-portrait and wrote her last words in her journal. Rather than saluting life, she embraced death in her final farewell: 'I joyfully await the exit – and hope never to return. FRIDA'.[25]

10

Of her Time; Ahead of her Time

Kahlo's life spanned 47 years, from July 1907 to July 1954. Throughout, she was emphatically 'of her time', deeply immersed in the pertinent political, social, scientific and cultural issues that dominated the first half of the twentieth century. Since her schooldays at the National Preparatory School, her circle of friends had included the cultural elite of Mexico and beyond. Yet Kahlo was also decidedly 'ahead of her time'. Many of the themes with which she engaged through her paintings were considered marginal during her lifetime, yet they are central concerns in the twenty-first century, decades after her death. Indeed, before feminist thinkers formulated the slogan 'the personal is political' and long before identity politics and post-colonial hybridities were theorized in academic circles, Frida Kahlo produced a body of work that addressed these issues brilliantly.[1] Finally, Kahlo's art also conjures up profound ontological concepts and relates to the human condition in broad terms that may be viewed as 'timeless' or universal.[2]

Nowhere is Kahlo's connection to her time more evident than in her political activism. She lived through half a century of dramatic change and turmoil. She was, as Gómez Arias phrased it, 'a child of the Mexican Revolution'.[3] She was also an avid follower of the Russian Revolution and passionately involved in left-wing politics. She lived through two world wars, the Holocaust, the atomic bombing of Hiroshima and Nagasaki – and was deeply concerned about these events. She was vehemently opposed to fascism and

Nazism, supported the anti-Franco proponents of the Spanish Civil War, and helped refugees who came to Mexico from Europe during the Second World War and its aftermath. Letters from her close friends written in the 1940s, when Kahlo was depressed and overwhelmed by personal problems including her divorce from Rivera, indicate that she was always engaged with political issues of the day. A letter from Ella Wolfe, written on stationery of the 'International Relief Association', several letters from Mary Sklar and Kahlo's own epistle to Henry Ford (recently found among Kahlo's papers in the National Museum of Women in the Arts archives) suggest that she was involved in desperate efforts to save refugees from Europe and in securing them jobs once they reached a safe haven in America.[4] Overcoming debilitating physical handicaps, Kahlo was a political activist all her life. It is crucial to remember in this context that it was not until 1954 – the year Kahlo died – that Mexican women were granted the vote. Throughout her life, then, Frida Kahlo was literally disenfranchised but self-empowered by her strong political convictions and agency.

Two photographs provide telling evidence regarding Kahlo's political commitment and illustrate the fact that her activism spanned her entire adult life. The first – dated 1929 – shows a youthful, slim Frida next to the large-bodied Rivera marching energetically at a demonstration of the 'Syndicate of Technical Workers, Painters and Sculptors' (p. 69).[5] With her hair tightly pulled back, wearing a severe button-down shirt and a skirt that ends just below the knees, this austere Kahlo has not yet become the flamboyant, colourful character into which she evolved the following year. The second photograph was taken on 2 July 1954, just eleven days before Kahlo's death. Once again, both Kahlo and Rivera are seen leading a political demonstration. This time, it is a rally protesting against the CIA's involvement in the ousting of the Guatemalan president Jacobo Árbenz Guzmán. Both Kahlo and Rivera look old and tired. Neither is striding with energy as they

Frida Kahlo, Diego Rivera and Juan O'Gorman at a demonstration, July 1954 (unknown photographer).

had done 25 years earlier. Kahlo is barely holding up her right fist in a gesture of defiance. In her left hand she holds a sign with an image of a dove and a caption proclaiming '*Por la Paz*' (for peace). A close look at the photograph reveals that someone standing behind Kahlo is helping her support the sign. To her right is her lifelong friend Juan O'Gorman kneeling protectively next to her. Behind, a weary Rivera gently places his hand on her right shoulder. In this photograph, too, Kahlo's attire and demeanour are different from the characteristic photographic images taken over the years. Dark fabric hides her colourful native costume. A scarf haphazardly covers her head, replacing her usual distinctive coiffure of beribboned braids. She had been hospitalized in April, perhaps after a

suicide attempt, and was hospitalized again in June with bronchial pneumonia. Ignoring her doctors' advice, she nevertheless chose to participate in the political demonstration.[6]

Politically, Kahlo identified as a communist. Yet her communist views are difficult to pin down and they do not reflect simple adherence to the party line. As noted earlier, she joined the Mexican Communist Party as a teenager, shortly after being introduced to the tenets of socialist ideology by Tina Modotti. Gómez Arias stressed that her political activism pre-dated her involvement with Rivera and that she was fiercely independent, describing Kahlo as 'a Marxist-Leninist and of her own mind'.[7]

Kahlo made her deep dedication to communism explicit in a diary entry dated 4 November 1952:

> I am a communist being . . . I have read the history of my country and of almost all nations. I know about their class struggles and their economic conflicts. I understand very clearly the material dialectics of Marx, Engels, Lenin, Stalin and Mao Tse. I love them as the pillars of the new communist world.

Dozens of books devoted to socialism and communism graced the shelves of Kahlo's library at La Casa Azul, testimony to the depth and breadth of her political interests and knowledge. Framed photographs of the communist leaders whom she declared as the 'pillars' of the new world hung in her bedroom. Even today, these photographs remain in La Casa Azul, overlooking Frida's long-empty bed.

But Kahlo's affiliation with communism in general and with the Mexican Communist Party in particular was not without contra-dictions. Obvious problems were Rivera's frequent disagreements and ultimate expulsion from the party in September 1929, which positioned the newly wed Kahlo in a conflict of loyalties. Though she never ceased to identify as a communist, she resigned from the

party following Rivera's expulsion, but was readmitted as a member some time in the 1940s (after Trotsky's assassination). Rivera was allowed to rejoin the party only after Kahlo's death in 1954. Another obvious point of contention with the party was Kahlo's relationship with Trotsky. A dozen years after the fact, Kahlo wrote in her diary that granting asylum to the exiled leader in Mexico was a mistake and that she went along with it only because of her immense love for Rivera.[8]

Kahlo appears to have been a devout Stalinist at the end of her life. In this context, one must remember that information about Stalin's regime of terror and purges became available only after her death, when Nikita Khrushchev denounced Stalin's crimes in a speech of February 1956 to the 20th Congress of the Communist Party of the Soviet Union. Kahlo's diary is replete with references to Stalin, and on 4 March 1953 she wrote: 'The world, Mexico, the entire universe lost its equilibrium with the death of Stalin.' She seems to have been upset by the fact that she could not place her art at the service of the Communist Party: 'I am a worker and an unconditional ally of the revolutionary communist party. For the first time in my life my painting is trying to help according to the line set by the party.' Three unfinished paintings that remained in Kahlo's studio at the time of her death reflect her desire to paint straightforward political images: two self-portraits with communist leaders and a portrait of Stalin, which remained unfinished on her easel when she died. The evidence suggests that Kahlo's communism was underlain by a strong commitment to social justice and avid humanist convictions and that it was her inner moral compass rather than party doxa that determined her actions and positions.

In another departure from orthodox communist ideology, which promotes international unity and solidarity among all the workers of the world, precluding and replacing national boundaries and loyalties, Kahlo, like most Mexican communists, was firmly committed to Mexican nationalism. As has been seen, she

constructed her identity as a paradigmatic Mexican woman in deliberate ways. Her collection of native costumes and indigenous accessories, hairdos and jewellery has been thoroughly documented. Simultaneously hiding her ailing limb and revealing her unique persona, she composed her body as a predominantly Mexican site and sight.[9]

An ongoing exhibition curated by Circe Henestrosa, entitled *Appearances Can Be Deceiving: The Dresses of Frida Kahlo*, opened in November 2012 at La Casa Azul. It displays a rotating selection from some 300 items – dresses, shirts, shawls, accessories and other pieces belonging to Kahlo – that had been locked up in La Casa Azul for more than half a century, since the artist's death. Based on several years of intensive research conducted at the London College of Fashion, Henestrosa presents a 'curatorial thesis [that] defines Kahlo's construction of identity through disability and ethnicity'.[10] The stunning display, which occupies five small

Kahlo's studio with Stalin's unfinished portrait on the easel, La Casa Azul.

rooms of the museum, focuses on three distinct types of objects. The most highly anticipated exhibits are the well-known articles of clothing and accessories with which Kahlo composed her persona and articulated her distinct fashion statement. Here the viewers are able to see the components of the facade that the artist constructed with great verve and creativity. A second part of the exhibit offers a shocking look behind the facade: Kahlo's corsets, crutches, artificial leg and other medical apparatuses that palpably conjure up the artist's broken body are displayed in a cage-like structure against a wall of white tiles. This unusual design forcefully evokes the oppressive nature of Kahlo's medical contraptions, as well as the intimate bathroom setting where they were found. In the third section of the show, Henestrosa presents work by contemporary designers that illustrates how 'Kahlo in particular has remained a source of inspiration for international fashion designers and artists, such as Jean Paul Gautier, Riccardo Tisci, Rei Kawakubo and Dai Rees.'

The exhibition reaffirms previous scholarly assessments that Kahlo used the costumes to hide her crippled body, but also deliberately to transform herself, with the aid of a carefully fashioned sartorial style, into a unique and unforgettable persona, La Mexicana. Henestrosa also offers an in-depth analysis of Kahlo's particular predilection for costumes from the Isthmus of Tehuantepec, known for its matriarchal society of strong and beautiful women. The depth and breadth of this exhibition and the unprecedented and vivid display of such original items from Kahlo's wardrobe make an immense contribution to the field.

Kahlo's home was likewise crafted as a prominent manifestation of *mexicanidad*. Gómez Arias, who had visited the Coyoacán home frequently when he and Frida were teenagers, recalled the dramatic transformation of her parents' house, with its dull grey walls, French furniture, thick carpeting and 'European bourgeois china and crystals', to an expression of Frida's distinct taste and love for

View of the kitchen, La Casa Azul, Coyoacán.

the indigenous and popular heritage of her native land. Some time after marrying Rivera, she painted the exterior of the house blue, with vivacious reddish trim, reinventing it as La Casa Azul – literally, the Blue House. The bright yellow furniture, Mexican-style kitchen, local pottery – both ancient and contemporary – and an eclectic assortment of native crafts converted Kahlo's childhood home into a unique realm that embodied post-revolutionary Mexican identity.[11]

The patio with its lush vegetation, popular crafts, pre-Columbian items, pyramid and many indigenous pets (parrots, monkeys, dogs and even a little deer) transfigured La Casa Azul into a virtual microcosm of Mexico. Since Kahlo was housebound or even bed-ridden for much of her adult life, La Casa Azul may be viewed as a compensating realm that attempted to recreate the outside world within her interior space.[12]

Kahlo's art – even her most individualistic self-portraits – displays a broader identification with the Mexican nation. National identity, whether conceptualized as primordial or imagined, is usually

understood to be anchored in three main components: the land designated as the homeland, the native language and the shared history of the people. In a deliberate effort to create a national Mexican art movement, Kahlo, Rivera and many of their compatriots inserted images related to these three ingredients into their art. Hence Kahlo frequently painted the distinct local landscape of her native place, the stony terrain of the *pedregal*, as well as the country's typical flora and fauna (for example, a variety of cacti, birds-of-paradise, hairless Aztec dogs and assorted tropical fruits).[13] She emulated the use of language in popular Mexican genres by including written captions and scrolls in her compositions. She also incorporated indigenous Nahuatl words in the titles, for example *Xochitl* ('flower'), *Izquintli* ('dog') and *Xolotl* (guardian of the underworld).[14] Finally, Kahlo mined Mexico's past and painted archaeological remnants, many of them from the extensive Kahlo-Rivera collection: jade and coral necklaces and beads, Nayarit figurines, sculptures of hairless Izquintli dogs, an Aztec funerary mask and many other artefacts. Identifying them reveals that she used specific objects hand picked from many different pre-Columbian cultures and epochs. Unlike Rivera and the other muralists, who painted a monolithic hegemonic national narrative, Kahlo visually articulated a multidimensional Mexican past. As Steven Volk argues convincingly, by offering a multiplicity of narratives and cultural layers, Kahlo subverted the unified nationalist story and dismantled the chauvinistic and exclusive tendencies of nationalism.[15]

Kahlo also identified personally, not only nationally, with the archaeological remnants she incorporated into her work. Her choice of particular artefacts from many strata of Mexico's rich histories displays a deep interest in their artistic and iconographical import. For example, a pregnant Nayarit idol used as a model in the painting *The Square is Theirs* of 1938 is modified so that her broken feet make her Kahlo's alter ego. A figure from Colima with a crooked

spine and a dwindled leg also appears as a counterpart of the wounded artist in a *Self-portrait* of 1945. In *The Wounded Table*, Kahlo's image replaces the female figure in a statue of a couple, indicating that hers is a personal identification with specific sculptures, not merely a generic affinity with Mexico's national treasures.[16] For Kahlo, then, Mexico was by no means a monolithic or unified entity. Her insistent visualizations of a broad array of Mexican cultures and a spectrum of manifestations of Mexican-ness parallels her construction of multiple 'selves'.

The affinity between Kahlo and Mexico is by no means new. It was suggested in 1938 by André Breton and Walter Pach, and in 1943 by Rivera, who dubbed his wife's art 'individual-collective'.[17] After her death, the idea was further developed by major scholars.[18]

Indeed, reading Octavio Paz's magisterial portrait of Mexico, *The Labyrinth of Solitude* (1950), alongside Kahlo's imagery reveals the deep links between the artist and her native land, particularly a shared obsession with origins, miscegenation and masking strategies. The explosive contrasts that typify Kahlo and her images of self are also essential to Mexico, a country born of 'collisions and fusions'.[19]

Kahlo was 'of her time' in many ways, beyond political con-sciousness and national identity. Her knowledge in the sciences, humanities and arts was deep and up to date. An analysis of the books in her library and information gleaned from her voluminous correspondence reveal her erudition in art, literature, medicine, botany, psychology, philosophy, archaeology, history and linguis-tics. She was also personally acquainted with many of the artists, poets, musicians and intellectuals of her day. Her list of friends reads like a 'who's who' list of twentieth-century culture. When André Breton, Marc Chagall and Sergei Eisenstein came to Mexico, they were enchanted by Kahlo.[20] As noted earlier, in New York she was embraced by a host of prominent figures, among them O'Keeffe, Stieglitz and Pach. In Paris, she captivated Duchamp, Picasso and Miró. Latin America's luminaries, among them Nobel

laureates, were Kahlo's friends: the Mexican composer Carlos Chávez, the Chilean poets Pablo Neruda and Gabriela Mistral, and the Mexican author Octavio Paz. Kahlo's taste in music was eclectic. She preferred Mexican folk songs to classical music and more than once nearly fell asleep in fancy concert halls. Kahlo herself loved to strum the guitar and sing in a raspy voice that delighted Rivera and her friends, among them the Mexican singers Concha Michele and Chabella Villaseñor.

Finally, Kahlo's keen interest in photography, though not surprising given the legacy of her father, is worth exploring in greater depth. She began posing for the camera as a toddler and continued to strike a pose for an international cadre of the finest photographers of her time, with whom she had particularly close friendships. She knowingly used photography as a sophisticated tool to construct her persona and to perform her identities. Collaborating with the photographers, she expertly composed the mythical 'Frida' with the aid of carefully selected costumes, props, settings, body language and facial expressions.[21]

Kahlo's own recently discovered photographs confirm Gómez Arias's testimony that she had mastered the art of photography and could have become an excellent photographer in her own right had she chosen to do so. Her father's letters to her from the early 1930s, replete with technical details concerning his photographic practice, also reflect her professional understanding of the field. Rather than become a photographer, Kahlo used photographs (her own and those of others) as visual aids or models for paintings. It is fascinating to trace her creative process by comparing the photographs she incorporated into her compositions with the paintings themselves. Compelling examples include photographic portraits of individuals (for example, her grandparents, parents, Luther Burbank, Alberto Misrachi), animals and various artefacts.[22]

Not only during her lifetime but also decades after her death, Kahlo continues to inspire photographers. Her impact may be found

in fashion photography, where superficial aspects of her 'look' are variously appropriated, and in original art inspired by her legacy. Graciela Itubide's recent series of photographs published by La Casa Azul offers sensitive and poetic insights into the world that Frida Kahlo left behind.[23]

Kahlo's involvement and interest in photography was not limited to stills. An enthusiastic film buff since adolescence, she was an eyewitness to the transition of Mexican films from silent movies to 'talkies'. Her letters and the recollections of her fellow movie-goers convey the fact that she delighted in films, so much so that when she was hospitalized special arrangements were made to screen movies in her hospital room. Even during the last year of her life, when she could barely leave the house, her nurse Judith Ferreto would take her out to the cinema.[24] The director Arcady Boytler, the film star Emilio (El Indio) Fernández and the producer Jacques Gelman were loyal friends and collectors of her work. In the USA Edward G. Robinson purchased four of her paintings.[25] Mexican film legends Jorge Negrete and Pedro Infante were also part of her social circle.[26]

In 1943 both Kahlo and Rivera painted portraits of Natasha Gelman, Jacques' wife. A vivacious and beautiful refugee from Europe, Natasha met the film producer in 1939 in Mexico City and they were married two years later. Both became Mexican citizens and part of the fabric of Mexican culture. Jacques was very successful in the lucrative Mexican film industry and they amassed an unparalleled art collection. When I visited Natasha in Mexico in 1989, she described sitting for her portrait in La Casa Azul, remembering Kahlo's focus and acute gaze, and her precise movements as she painted with delicate sable brushes, which were kept meticulously clean and organized in a 'strict order'. Kahlo painted alone in her studio, whereas Rivera liked to have an audience. Both, she said, were geniuses. Gelman also recalled the frequent social events that she and Jacques hosted in the 1940s. Kahlo was often the life of the

party and was always buoyant and beautiful. 'We had lots of fun. I never saw Frida when she wasn't well or well-composed.'[27] It seems clear from the wide spectrum of memories of Kahlo that the artist maintained her facade in some social circles, sharing her inner turmoil only with close friends and revealing it in her paintings.

Kahlo's links with the film industry were not only social. One may detect cinematic influences in her paintings. The braid cutting scene in the popular film *Adios Nadador* of 1937 seems to have informed her *Self-portrait with Cropped Hair* (1940) and her image of the *Suicide of Dorothy Hale* echoes the effect of a 'motion picture'. Kahlo was also a protagonist and the subject of films. Several rare fragments of original footage exist. The Hoover Institute of Peace Archives in California possesses a short colour film of Frida Kahlo and Diego Rivera in the patio of La Casa Azul. Previously rare and difficult to view, this brief segment is today easily accessible on YouTube. In it Kahlo is seen stroking Rivera's hand and laying her cheek upon it tenderly. She laces flowers in her hair and interacts with her husband gracefully. There are several additional documentary snippets: one from 1937, in which Kahlo is seen boarding the ship that brought Trotsky to Mexico; another is a two-minute black-and-white sequence of Trotsky with Rivera and Kahlo in La Casa Azul; yet another shows Kahlo towards the end of her life, lying in bed and leafing through her diary. A minute or two of poetic black-and-white footage, intended to be developed into a longer art film, was shot by Lola Alvarez Bravo towards the end of Kahlo's life. In it, Kahlo is standing in a doorway ambiguously engaging with a very young, wide-eyed woman. Alvarez Bravo, a photographer and a close friend of Kahlo's, explained in an interview:

> We began some tests with a daughter of Don Alberto Misrachi who is a dancer, and it looked very beautiful. There was a moment when Frida had to open a door and close it because the dancer was the representation of death. I filmed it in 16 mm

to see if Frida could tolerate posing and we were surprised how well it turned out.[28]

The first major posthumous project devoted to Kahlo was a remarkable documentary film. In 1966, more than a decade before the first book on Kahlo was published in Mexico and long before the artist became famous abroad, Karen and David Crommie produced *The Life and Death of Frida Kahlo*. A pioneering project that began shortly after Kahlo's death, the film weaves together three types of primary sources in a thoughtful and illuminating manner: black-and-white photographs of Kahlo's life, colour images of her paintings and a voiceover of the testimonies of Kahlo's close friends and companions. The documentary and the unedited interviews that the filmmakers conducted were produced early on, when memories were fresh and before external narratives of Kahlo interfered with unmediated personal recollections. The Crommie film remains to this day an unsurpassable source of knowledge and understanding about the artist. Many additional documentaries of varying quality have been produced since, and two major feature films. The first was produced in Mexico and directed by Paul Leduc in 1984. Much more famous is the 2002 Miramax production featuring Salma Hayek as Frida. Directed by Julie Taymor and based on Herrera's monumental biography, the film was instrumental in making Frida Kahlo a household name.

Taymor framed her film as a riveting and melodramatic love story between 'Diego and Frida' and has been criticized for offering a very reductive view of Kahlo's life and art.[29] The film also, however, includes exceptional artistic vignettes inspired by Kahlo's art, which illustrate how art begets art. Taymor's brilliant cinematic recreation of Kahlo's accident is a powerful example of how the art of film – with its use of motion, images, sounds, visual allusions and symbols – can palpably convey what words cannot. The chilling and devastating psychophysical experience of the fateful crash, imaginatively

conceived in the film, invades the minds and bodies of the audience, transcending the narrative line. The aftermath of the accident is expressed in a surreal manner with skeletal puppets commissioned from the Brothers Quai. The *calavera* puppets operate on Kahlo's spinal cord with jerky movements in a harsh glaring light, as they mechanically recite the list of her injuries, spewing blood, to harrowing effect. Taymor's numerous allusions to Kahlo's world – to her artistic imagery, to photographs of her life, to the colours and textures of her milieu, to the music and popular Mexican culture in which she was immersed – lift certain scenes in the film above the limits of the Hollywood biopic.

During her lifetime, Kahlo was also portrayed in several murals by Rivera and her students, and she inspired a now-lost work by Joseph Cornell. As noted in chapter Four, John Weatherwax drafted a play and short story about the bewitching 'Queen Frieda' as she was developing her colourful persona in San Francisco in 1930–31; a few years later, she reportedly informed the work of the fashion designer Elsa Schiaparelli (though the two probably never met), who was impressed by her unique sense of style and originality.

But it was only decades after her death that Kahlo became a cultural icon, a cult figure and one of the most critically acclaimed and influential artists worldwide. Frida Kahlo was clearly ahead of her time.

Today, it is virtually impossible to keep up with the countless novels, plays, comic books, musical compositions and variety of visual art forms that are produced daily across the globe inspired by Kahlo's life, art, myths and legacies. Responses to Kahlo range from cult-like adoration or 'Fridamania' to erudite scholarly enquiry; from glib appropriations of exotic 'Fridaesque' accessories and exploitative commercial ventures, to original works of art that provide insights about Kahlo's paintings and their underlying themes. This broad range of dialogues with Kahlo is clearly exemplified in the field of music. The performances of the

Mexican-born musician Lila Downs, her choice of songs, costumes and the emotional tenor of her voice, invoke Kahlo's spirit. So much so, that Down's music was integrated into the soundtrack of Taymor's film and she herself was invited to perform in one of the scenes. More obliquely, the James Newton Ensemble released 'Suite for Frida Kahlo' in 1994 and the Dutch pop musician Petra Berger's single 'Portrait of Love (Frida Kahlo)' was issued in 2006. Finally, a more tenuous link may be found in the case of the British band Coldplay, who titled their 2008 album *Viva la Vida*. As *Rolling Stone* reported:

> Singer Chris Martin chose [the title] after seeing the phrase, which means 'long live life', on a painting by Mexican artist Frida Kahlo, who endured polio, a broken spine, and chronic pain for decades. 'She went through a lot of shit, of course, and then she started a big painting in her house that said "Viva la Vida" says Martin. 'I just loved the boldness of it.'[30]

Sadly, though perhaps inevitably, there are also reports of a growing industry of Kahlo forgeries, financial feuds and lawsuits that trail the canonization and commodification of 'Frida'.[31]

Kahlo's posthumous acclaim began when distinct groups outside Mexico 'discovered' her and hailed her as a role model for different, though sometimes converging, reasons. Chicano and Chicana artists organized the exhibition *Homage to Frida Kahlo: Day of the Dead* at Galería la Raza in San Francisco on 2 November 1978.[32] The works on display honoured Kahlo's life and art, stressing her staunch Mexican identity. Perhaps most famous and memorable was the 'altar' created by Amalia Mesa-Bains – a powerful amalgamation of a traditional Mexican altar and a contemporary art installation that paid tribute to Kahlo, even as it engaged with her visual vocabulary and the cultural heritage both artists share. For many Chicana artists, Kahlo was an empowering ally when they

asserted their Mexican roots vis-à-vis a discriminating hegemonic art world, and a feminist sister in their efforts to counter Mexican machismo and American patriarchal forces.

In the 1970s feminist artists also 'discovered' Kahlo. Judy Chicago and Miriam Schapiro referenced her in their art. Chicago included Kahlo's name in her *Dinner Party* project. Schapiro produced work that incorporated Kahlo's art into her own, suggesting a collaboration between them and positioning herself as Kahlo's disciple. In 1979 Ana Mendieta dressed up as Kahlo at a feminist costume party in New York. Mesa-Bains observed that whereas Chicana artists emphasized Kahlo's strength, resilience and national pride, feminists tended to identify with her 'female suffering' and her role as a victim. They also promoted her as a representative of an essentialized womanhood, dismantling her cultural specificity. Feminist responses to Kahlo have evolved since then, focusing on different interpretations of her relationship with Rivera. Whereas feminists of the 1970s often regarded Kahlo as a passive victim of her husband's marital abuse, younger feminists now emphasize her agency and strength.

Parallel to the 'discovery' of the artist by u.s. artists, the British filmmakers Peter Wollen and Laura Mulvey also 'found' Kahlo in the 1970s while seeking politically radical alternatives to Western, mainstream modernism. In an illuminating essay that retraces the journey that led them to La Casa Azul in Mexico, Wollen explains that it was Kahlo's 'otherness' – as a marginalized, non-Western, communist, bisexual, physically handicapped woman of colour – that drew them to her. Although he distinguished between political fascination with Kahlo in the 1970s and the current wave of popular 'Fridamania', Wollen also linked the two phenomena:

> The things that interested me in her work were in many ways the same things that drove the formation of the Kahlo cult. The work had an immediate relevance and a powerful impact . . .

so, in a certain sense, I should not have been surprised when, as the work became disseminated, it began to have such a powerful effect on others.[33]

Wollen and Mulvey's Mexican sojourn resulted in an exhibition in 1982, in which they juxtaposed the paintings of Frida Kahlo with the photographs of Tina Modotti. The show opened at the Whitechapel Gallery in London, then toured Europe and the U.S. The exhibition almost coincided with the publication of Hayden Herrera's biography *Frida* (1983). Both were highly influential and played a crucial role in promoting further scholarship about the artist and also helped disseminate the story of Frida Kahlo to wider audiences.

Kahlo was never forgotten in Mexico. In 1955 Rivera bequeathed La Casa Azul to the Mexican people, and one year after his death, on 12 July 1958, the house reopened as the Frida Kahlo Museum.[34] Exactly four years after Frida Kahlo's death, her friend Carlos Pellicer, the museum's first director, transformed the home of her childhood, her convalescence, her marriage and her death into a public museum that still maintained her spirit. Although his original scheme has been altered and the museum has undergone massive renovations several times, the place still houses many of Kahlo's objects, as well as her ashes and death mask. For Kahlo fans who look for 'Frida' and for tourists who seek an 'authentic Mexican experience', La Casa Azul has become a pilgrimage destination.

After waning for a while, interest in Kahlo resurged in Mexico at the end of the 1970s. The first monographs about the artist were published in Mexico by Teresa del Conde, Raquel Tibol and Martha Zamora alongside a variety of influential essays. At the same time Mexican artists created work that was clearly informed by Kahlo and her art. Perhaps best known is the work of Nahum Zenil, who incorporates Kahlo's portraits into his compositions but also adopts her mode of self-reflection, her visual vocabulary and her thematic focus on the body as a locus of identity and sexuality.

His explorations of his homosexuality, marginality and loneliness also expose a deep affinity with Kahlo.[35]

The Mexican artist Yosi Anaya's ongoing artistic dialogue with Kahlo is profound and unique. An international authority on Mexican textiles and indigenous costumes and a world-class feminist ethnographer and art historian, Anaya is also a brilliant artist. A few of her performances, installations and video pieces relate to the traditional Mexican *huipil* (embroidered blouse) that Kahlo chose to wear, as seen in her photographs and paintings. Anaya's work illuminates Kahlo's art by expanding our understanding of the 'life' of these garments that were sewn, embroidered, embellished and worn as a 'second skin' by Kahlo and other indigenous women. If superficial appropriations of Kahloesque fashions dismantle the significance of Kahlo's sartorial choices and disempower their polit-ical implications, Anaya's artistic practices reconstitute the efficacy and meaning of Kahlo's identification as a native Mexican woman.

Anaya was granted special access to La Casa Azul to observe and assist when one of Kahlo's hidden closets, locked since the artist's death, was finally opened in December 2003. The ritualistic process of exhuming its contents – lifeless dresses, shawls and intimate undergarments – was documented by Anaya as an anti-climactic act of violation and trespass. The vigilant supervision of male custodians and the overpowering cloud of dust that drifted through La Casa Azul exuded an oppressive and surreal ambience. Anaya framed and made sense of this ritual with the aid of three different genres: a documentary film, a detailed written report included in her doctoral dissertation and a powerful video art piece that artistically recreated the alienation and emptiness that accompanied the separation of Kahlo's personal garments from their absent owner.[36]

Unlike Anaya, who possesses a deep cultural, emotional and professional understanding of Kahlo's rich inventory of native costumes and textiles, popular magazines outside Mexico have

appropriated superficial aspects of the Kahlo 'look' as inspiration for exoticized fashionable and marketable trends. Cultural critics have pointed out the cynicism and tastelessness of certain aspects of this phenomenon. Oriana Baddeley has observed that 'there is poignant irony in the way clothing, which on one level served to hide Kahlo's broken body, falls or is lifted by the model to reveal a luxuriantly perfect physique'.[37]

Straddling the line between fashion and culture, the pop icon Madonna identified Kahlo's deliberate masquerading strategies as a source of inspiration. In an article in the *New York Times*, Madonna was quoted as saying: 'I love the way she dressed . . . She wanted to establish her identity, and she could do it with clothes . . . I love the contrast between her wearing a man's suit and her traditional Mexican costumes. Both were out of sync with what other people were doing.' The article links Kahlo's costumes with Madonna's hit tune 'Vogue', which urges women to 'strike a pose', and with the singer's own use of clothes to perform her identities.[38]

Perhaps one of the most well-known contemporary artists to appropriate Kahlo's imagery is the Japanese artist Yasumasa Morimura. His extensive series *Self-portraits: An Inner Dialogue with Frida Kahlo*, exhibited in 2001 at Luhring Augustine Gallery in New York, is composed of photographs in which Morimura 'masquerades' as Frida Kahlo within staged reconstructions of her best-known paintings. The gallery's press release asserts that it took Morimura ten years to complete this series and that he pays homage to Kahlo as he 'recreates, relives and indulges in the painter's artistic process, vividly depicting the glamorous yet agonizing life of this remarkable woman . . . Morimura becomes Frida Kahlo in this exhibition'.[39] Scholars have argued that Morimura appropriates the image of Kahlo as a mediated commodity, thus addressing the Kahlo cult which he both participates in and critiques. He oscillates between sincere identification as Kahlo and garish masquerade; between serious interrogations of

Yasumasa Morimura, *An Inner Dialogue with Frida Kahlo (Hand Shaped Earring)*, 2001, photograph.

cultural and gender hybridizations and reflections on the fluidity of identity and ambiguous or ironic self-presentations as a Japanese male posing as a Mexican *mestiza* female.[40]

Morimura's equivocation is echoed by younger artists, who address Kahlo's cult status head on. The Mexican artist Boris Viskin created a series of works that juxtapose Van Gogh's crows, famed as foreboding symbols of death, with Kahlo's trademark

uni-brow. Using a striking visual pun – the crows and the uni-brow appear as an identical V-shaped black signifier – Viskin links the two famous suffering artists together. Viskin's art humorously invokes the critical issues raised by scholars such as Lynne Cooke and Oriana Baddeley, whose writings explored the '(con)fusion of life and art' that characterizes both iconic self-portraitists.

Maya Escobar's Web art reveals this young Latina artist's obsession with Kahlo. In one video, Escobar masquerades as Kahlo against a backdrop that mimics the leafy setting of Kahlo's *Thinking of Death*. The bilingual Escobar aggressively reiterates in Spanish and English: 'He is Frida Kahlo, I am Frida Kahlo, I am Frida Kahlo', over and over again. As she attempts to assert Kahlo's identity, she spirals out of control. Her hairdo unravels and her agitation and frustration come to a crescendo, reflecting a disintegration, rather than an affirmation of identity. Escobar's mixed Jewish-Latin American genealogy and her avid interest in Kahlo since a very young age contributed to her obsessive desire to merge with Kahlo, which she simultaneously professes and critiques.[41]

While some scholars have studied the work of artists who were influenced by or paid tribute to Kahlo and others have examined 'Fridamania' as a phenomenon, Victor Zamudio-Taylor suggested a different method of enquiry that might further our understanding of Kahlo's legacy. He introduced what he called 'The Frida Effect', an examination of prominent contemporary artists through the prism of Kahlo's work. Robert Gober's fragmented body parts and Cindy Sherman's performances of mediated and gendered identities were among the compelling examples he explored.[42]

Zamudio-Taylor's conceptualization of 'The Frida Effect' provides illuminating insights regarding the many ways in which Kahlo's art paved the way for postmodern culture. On the centennial of Kahlo's birth – in 2007 – the pioneering feminist art historians Linda Nochlin and Maura Reilly opened an exhibition titled *Global Feminisms: New Directions in Contemporary Art*.[43] Though certainly

not the intention of the curators, the exhibition (and the exhibition catalogue) provide a serendipitous venue for testing 'The Frida Effect'. Many of the artists in the show, all born after Kahlo's tragic death, continue her legacy. The themes they explore – identity, hybridity, sexuality, pain, spirituality, political agency, marginality – and their embodied and performative ways of making their art visceral and powerful, unveil Frida Kahlo as their spiritual mother.

Examples abound. Margi Geerlinks from Holland and Catherine Opie from the u.s. revision the nursing Virgin and Child motif in a way that echoes Kahlo's *My Nurse and I*. Latifa Echakhch from Morocco and Mary Coble from the u.s. explore their gender transformations in ways that build on Kahlo's *Self-portrait with Cropped Hair*. Ingrid Mwangi from Kenya and Milica Tomic from Serbia imprint the wounds and scars of political violence and national identities upon their own bodies.[44]

Such deep and multi-pronged links with Kahlo's oeuvre may also be found the video *Barbed Hula* by Sigalit Landau from Israel. Linking the experience of a little girl at play with the pain of the

Sigalit Landau, *Barbed Hula*, 2000, still from video.

Tory Fair, *Walking*, 2009, resin, glitter, steel and foam.

adult woman, Landau's self-presentation relates to Kahlo's
Childhood Series. The barbed hula evokes a displaced crown
of thorns, reminiscent of Kahlo's *Imitatio Christi* self-portraits.

Although the artists noted above use photography, video and
media that are formally distinct from Kahlo's more traditional
painting techniques, the ways in which they image their own bodies

as vehicles for self expression and their affinity with Kahlo's themes and visual vocabulary are striking and often conscious.[45]

What is extraordinary, moreover, is that Kahlo's art has inspired an incredibly broad array of art, empowering very different artists from across the globe to articulate their unique vision. Kahlo's paintings of herself merged with plant forms – for example, *Roots* of 1943 – are relevant antecedents for Tory Fair's sculptures of her own body united with flora. Fair's *Walking* displays an upside down, life-sized cast of the artist, with Echinacea flowers sprouting from her body. Like Kahlo before her, the specific type of plant that she uses is significant. Fair links herself with perennial medicinal blossoms, symbolically fortifying herself with their healing powers. The surreal scene of Fair's floating hybridized Self and the palpable sense of a literal and metaphoric 'flowering of the imagination' also echo Kahlo's imagery. However, Fair's oeuvre presents a body that is decidedly able and whole immersed in nature and reverie and their magical embrace.[46]

In 1927, while convalescing from her accident, Kahlo wrote to Alejandro Gómez Arias, who was travelling in Europe at the time: 'According to what you tell me, the Mediterranean is marvelously blue. Will I know it someday? I think not . . . my greatest desire for a long time has been to travel – the only thing that will remain for me is the melancholy of those who read travel books.'[47]

As we have seen, although she never saw the Mediterranean, Kahlo did go on to see both the Pacific and the Atlantic oceans, and travel to the u.s. and Paris. Her art and her legacy travelled even further. Indeed, though she was decidedly of her time and place – strongly linked to Mexico and the first half of the twentieth century – she was also clearly ahead of her time. Her legacy reverberates globally with a critical impact that is still unfolding.

Postscript: Frida Kahlo's Art, Life and Legacy

The genre of self-portraiture often seduces viewers to blur the boundaries between art and life. In the case of Frida Kahlo, this temptation seems to be virtually irresistible. We see the artist's image before our eyes. She gazes at us, imploringly. We are drawn to and engage with her unblinking eyes. There is a sense of immediacy and a bond. We feel that the painting is minted with an imprint of the artist's spirit. We assume she is telling us a profound truth about her life. For the duration of this encounter we seem to share her emotions, her time and her space. She is alive and we are there – right there – with her.

In this respect, Kahlo's paintings are analogous to Leon Battista Alberti's metaphorical windows through which we peer through a frame to find reality, to find the 'real Frida'. This brings us back full circle to the '(con)fusion' between Kahlo's art and life discussed in the opening pages of this book. Salomon Grimberg, who has traced the ownership of Kahlo's art through the years, demonstrated how the original owners of Kahlo's portraits invariably felt that owning the painting was synonymous to possessing a part of Frida: 'they loved her work *because they loved her*', he concluded.[1] As many Kahlo aficionados know well, however, in seeking Frida Kahlo, viewers frequently discover themselves. Oriana Baddeley has suggested that Kahlo's self-portraits serve as mirrors in which viewers find a reflection of 'what it is they are looking for'. The 'politics of identification', as Baddeley dubs the 'desire of the audience to "see"

and "be" Frida', is not without problems. Baddeley notes that it reduces the artist to 'a fairground of identity'.[2]

Kahlo's paintings are not only windows and mirrors, as the traditional metaphors would posit. Her paintings may also be conceived as liminal spaces of creativity, imagination and unbridled freedom. To be sure, within the space of art, Kahlo inserted pieces of reality and biographical allusions. But she also included ancient and modern symbols, theological and scientific traditions, quotes from diverse visual and literary sources, traces of thoughts and emotions, and much more. Hence, her paintings are often depositories of human experiences, containing genealogies of knowledge. In temporal terms, Kahlo's paintings are Janus-faced: they possess layered elements from the past; they relate to the specific historical, social and cultural contexts in which they were created; but they also continue to resonate and exert meanings to be deciphered long after the artist's death.

Conceptualizing Kahlo's paintings as liminal spaces rather than windows or mirrors, and certainly distinguishing them from verbal narratives of the artist's life, explains the rich multiplicity of readings they inspire and the varied, sometimes contradictory responses they evoke. Within the space of her art, Kahlo was not limited to a single language, nor was she shackled by linear or univocal narratives. Rather, she could assimilate words, medical illustrations, popular visual vernaculars and religious imagery, as well as more conventional fine-art tropes. In a letter from 1940 Kahlo stressed that it was only through her paintings that she could articulate what she 'was unable to say in any other form'.[3] Visuality, not words, was the essential language for Kahlo's self-expression – so much so, that she told a friend that if she had to stop painting she would 'wilt like a flower'.[4]

Kahlo produced a body of work that contains numerous strata of meaning, which allow each generation – perhaps each and every viewer – to uncover new layers of richness that are embedded within

them. We are – in a way – Kahlo archaeologists as we carefully dig in, explore, expose, analyse and try to piece together the intersecting and overlapping iconographies that Kahlo inserted into her art.

Since Kahlo was both of her time and ahead of her time, the full profundity of her legacy seems to unfold gradually as we – her archaeologists – become ready to unearth and decipher its meaning layer after layer. Indeed, as noted earlier, it is no coincidence that Kahlo was first embraced by the Chicano community who emphasized her overt Mexican symbolism. It is also understandable why she gained international prominence only after feminist revisions of art history formulated the personal as political. During the last decades, additional aspects of Kahlo's œuvre have been unveiled: prominent among them her gender ambiguities, her bold visualizations of the body, her modes of dealing with the ethics and aesthetics of hybridity, and her poignant contributions to our understanding of identity as a composite, dynamic and constructed configuration.

Kahlo had only three major exhibitions during her life, all in galleries: her debut in November 1938 at the Julien Levy gallery in New York; an exhibition at the Pierre et Colle gallery in Paris, which displayed her paintings alongside photographs and artefacts from Mexico in March 1939; and her final farewell show at the Galería de Arte Contemporáneo in Mexico City, just one year before her death. In order to attend the opening on 13 April 1953, Kahlo was carried into the gallery in her canopied bed. Isolda Kahlo told me that her aunt had to be heavily drugged with painkillers that evening. Although she made a huge effort to enjoy the event, her glazed eyes revealed to her loving niece the full extent of her deterioration.

A beautiful photograph of Kahlo at the opening captures the artist with well-wishers, among them the painter Dr Atl and the singer Concha Michel. But the *punctum* of the photograph is in the background, hanging on the gallery wall and looming above the artist and her guests: Kahlo's poignant self-portrait titled *Thinking of Death*.

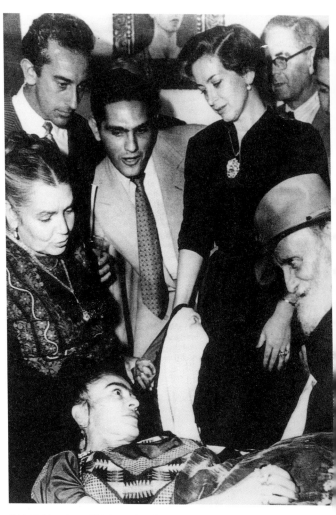

Frida Kahlo at her exhibition with well-wishers, 1953; *Thinking of Death* in the background (unknown photographer).

Kahlo's first major posthumous exhibition (the show that paired her paintings with Tina Modotti's photographs) opened almost three decades later, in 1982 at the Whitechapel Gallery in London, subsequently touring to several venues in Europe and the United States. Since then, Kahlo's paintings have been displayed in Australia and Japan as well. Her centennial decade was celebrated with four major museum exhibitions, all blockbuster events: at Tate Modern in London (2005), the Institute of Fine Arts in Mexico City (2007), a triple-venue u.s. exhibition that toured from Minneapolis to Philadelphia and San Francisco (2007–8), and a smaller exhibition in Vienna and Berlin (2010).

Kahlo's life was full of contradictions. Her afterlife also contains quite a few ironic twists. During her life she was in Rivera's shadow. She was framed as the 'Wife of the Master Mural Painter [who] Gleefully Dabbles in Works of Art', as the patronizing headline of the *Detroit News* proclaimed in February 1933. Today, Rivera is known as Frida's husband. Although her work was appreciated by her friends and several collectors, she was never able to support herself by selling art, and $400 was the highest price that was paid for her painting during her lifetime. Today, her paintings are sought after and purchased for millions of dollars, and even souvenirs associated with Kahlo fetch record prices at auctions.[5]

Finally, on 4 April 1949 Rivera appeared on the cover of *Time* magazine. In the feature story, he is quoted as saying that he 'always wanted to paint for the millions'.[6] He did. His murals dominated Mexican art in the twentieth century and to this day cover thousands of square metres of public buildings. In contrast, Kahlo painted about two hundred paintings, most of them intimate and diminutive in scale. She herself assessed her art as 'small and unimportant, with the same personal subjects that only appeal to myself and nobody else'.[7] In the annals of Mexican culture '*los tres grandes*' – the three great muralists, Orozco, Siqueiros and Rivera – were

inscribed as the most important artists of their time. Kahlo was viewed as eccentric and marginal.

Since the end of the twentieth century it is Frida Kahlo, not Rivera, who 'paints for the millions'. A Google search of her name yields more than three million hits in a tenth of a second. Websites are devoted to her life and art; her fame has resulted in brilliant exhibitions and scholarly insights, but also cynical commercial ventures, tasteless merchandise, postage stamps and diverse commodities imprinted with her image. Oriana Baddeley cogently summarized the phenomenon and its dangers when she wrote: 'This wild, hybrid Frida, a mixture of tragic bohemian, Virgin of Guadalupe, revolutionary heroine and Salma Hayek, has taken such great hold on the public imagination that it tends to obscure the historically retrievable Kahlo.'[8]

This book reflects an effort to retrieve aspects of the historical Kahlo, even as it demonstrates the limitations of such an undertaking and exposes Kahlo's biography as a composite of fissured tales, riddled with gaps and contradictions. As has been seen, long before her popular appeal distorted her image, Kahlo fabulously composed her multiple narratives and constructed her many selves. This is clearly reflected in the self-assigned names that she used as markers of her identities: the Germanized 'Frieda', the Mexicanized 'Carmen Rivera', the code names 'Xochitl', 'Mara' and 'Malinche'. But perhaps the most telling nickname of all was the one she frequently used, particularly in her letters to Rivera. Kahlo called herself '*La Gran Ocultadora*' – the Great Concealer.[9]

Frida Kahlo's life stories are instructive and fascinating. They illuminate her persona and her ways of being in the world. The legacy of her art offers insights that transcend her biography. Her paintings – metaphoric windows, mirrors and liminal spaces – extend our range of vision and expand our ways of knowing and understanding.

Frida Kahlo, self-portrait drawing, *c.* 1937–8, pencil and coloured pencils on paper.

References

Throughout this book I have used my own copies of primary sources (letters, diaries, medical records, interview transcripts and so on), collected since 1989 from dozens of private and public archives. Wherever possible, I have included references to published material and English translations of the original documents.

Introduction

1 The epigraph is taken from Raquel Tibol, ed., *Frida by Frida*, trans. Gregory Dechant (Mexico City, 2006), p. 374.

2 Olga Campos, notes from an interview with Frida Kahlo, 27 October 1950, presented verbatim in Salomon Grimberg, *Frida Kahlo: Song of Herself* (London and New York, 2008), p. 107.

3 Frida Kahlo, letter to Diego Rivera, 11 June 1940, in Tibol, ed., *Frida by Frida* (Mexico City, 2006), p. 237.

4 Lynne Cooke, 'Picturing Herself: Frida Kahlo', *New York Times Book Review* (17 November 1991), p. 13. The comparison between Kahlo and Van Gogh appears in the work of numerous scholars, prominent among them Oriana Baddeley, Joan Borsa and Peter Wollen, as well as visual artists, as in an ongoing series by the Mexican artist Boris Viskin.

5 A copy of the marriage certificate, obtained through CENIDIAP archives, Mexico City, is in the author's private archive.

6 Helen Appleton Read, 'Mexican Renaissance in Art: Diego Rivera Heads Group of Painters Who Are Rewriting Mexican History from the Revolutionary Stanpoint', *Boston Evening Transcript* (22 October 1930), p. 45.

7 Ibid.

8 The photograph from *Vanity Fair* is by Peter Juley and is referenced in the text: 'Rivera is shown here with Frieda Kahlo, his third wife': F. C., 'Señor and Señora Diego Rivera', *Vanity Fair*, September 1931.

9 Edward Weston, *The Daybooks of Edward Weston*, vol. II (New York, 1973), pp. 198–9.

10 Frida Kahlo, letter to Matilde Calderón, 21 November 1930, p. 3. The Nelleke Nix and Marianne Huber Collection: The Frida Kahlo Papers. Special Collections, Library and Reseach Center, National Museum of Women in the Arts, Washington, DC (NMWA archives). I thank Heather Slania, Jennifer Page and Julia Viets for their generous help when I conducted my research at the NMWA. For a more detailed analysis of the Kahlo papers in this archival collection, see Gannit Ankori and Lori Cole, '*Self-portrait on the Borderline between the United States and Mexico*: Frida Kahlo's Correspondence' (in preparation). My sincere gratitude to Eduardo Berinstein for helping me decipher illegible handwritten documents and with translations.

11 Frida Kahlo, letter to Lucienne Bloch, 14 February 1938, copy in author's private archive. See also Tibol, ed., *Frida by Frida*, p. 183. I am immensely thankful to have had the pleasure and privilege of conducting numerous conversations with Lucienne Bloch and learning directly about her friendship with Rivera and Kahlo.

12 Tibol, ed., *Frida by Frida*, p. 192. For an analysis of Breton's insightful though patronizing text, see Gannit Ankori, *Imaging her Selves: Frida Kahlo's Poetics of Identity and Fragmentation* (Westport, CT, and London, 2002), pp. 1–2.

13 Bertram D. Wolfe, 'The Rise of Another Rivera', *Vogue* (1 November 1938), p. 64.

14 Ibid., p. 131. Kahlo loved Wolfe's write-up in *Vogue*, which is clearly based on her own words that are either quoted verbatim or paraphrased. In her previously cited letter to Gómez Arias (Tibol, ed., *Frida by Frida*, p. 192) the artist wrote enthusiastically: 'Did you see *Vogue*? There are three reproductions, one in color – the one that seems swellest [*sic*] to me'.

15 Julien Levy Gallery, Press Release, 28 October 1938; Museum of Modern Art Library, New York (copy in author's private archive).

16 Wolfe, 'The Rise of Another Rivera', p. 64.

17 Ibid.

18 For a detailed analysis of Kahlo's painting, see Ankori, 'Re-visioning the Female Bather', in *Imaging her Selves*, pp. 123–34.

19 'Bomb Beribboned', *Time* (14 November 1938), p. 29.

20 Frida Kahlo, 'Transcription of notes taken during conversations with Frieda Kahlo de Rivera and Diego Rivera by Parker Lesley', 27 May 1939; unpublished transcript, copy in author's archive. Everett Parker Lesley, Jr, known as Parker Lesley, was born in Baltimore, Maryland, on 31 August 1913. He attended Stanford University and graduated with a BA degree in classical literature (Greek) in 1934. From 1935 to 1938 he was a scholar in art and archaeology at Princeton University. In 1937 he earned a MA (art and archaeology) from Princeton University. Lesley was Curator of European Art at the Detroit Institute of Arts in 1938. From 1939 to 1942 he was Assistant Professor of Art and Architecture at the University of Minnesota. He served in the U.S. Army from 1942 to 1946. To the best of my knowledge, he never published or made use of his illuminating interview with Kahlo.

21 MacKinley Helm, *Modern Mexican Painters* (New York, 1941; reprinted 1968), p. 167.

22 Ibid., pp. 167–8.

23 Ibid., p. 168.

24 A comparable approach, again based on interviews with Kahlo, who carefully crafted her own narrative, may be found in Virginia Stewart, *45 Contemporary Mexican Artists: A Twentieth Century Renaissance* (Stanford, CA, 1951), pp. 120–21, and in the impressive three-page spread titled 'Homage to Frida Kahlo' published in the Mexican newspaper *Novedades* (10 June 1951), pp. 1–3. The first page includes an essay by Mario Monteforte Toledo on Kahlo's 'landscape' of herself and nine photographs of Kahlo by Gisèle Freund, who also wrote a text beginning with the oft-quoted statement by the artist: 'I have suffered two grave accidents in my life – one when I was 16 when a streetcar knocked me down . . . The other accident is Diego.' The second page includes two photographs of Kahlo, one of her painting *Portrait of my Father* and four photographs of other paintings. Articles by Ceferino Palencia, '*La realidad ensonada de la pintura Frida Cahlo* [*sic*]', and Raul Flores Guerrero, '*Frida Kalho* [*sic*]: *su ser y su arte*', also point to a merging of her life with her art. The third and final page of this 'Homage'

includes a large photograph of Kahlo in her home above the fold and reproductions of five of her paintings. An article by Paul Westheim on Kahlo's art and a text titled 'Memory' by Kahlo also appear on this page.

25 'Mexican Autobiography', *Time* (27 April 1953), p. 90. For a similar review, see Susana Gamboa, 'Portrait of the Artist', *Art News*, v/4 (21 March 1953), p. 1. The exhibition was organized by Lola Alvarez Bravo and took place in the Galería de Arte Contemporáneo, Mexico City, on 13–27 April 1953.

26 José Moreno Villa, '*La realidad y el deseo en Frida Kahlo*', *Novedades* (26 April 1953), p. 5; translated and quoted in Hayden Herrera, *Frida* (New York, 1983), pp. 410–11. A similar sentiment was more recently expressed by the prominent Kahlo scholar Salomon Grimberg in a book review: 'It is often nearly impossible to differentiate the art from the life', in 'Thinking of Death', *Woman's Art Journal*, xiv/2 (Fall 1993–Winter 1994), p. 46.

27 Herrera, *Frida*, p. xii.

28 Grimberg, 'Thinking of Death', p. 46.

29 Christopher Busa, 'Hayden: Life Study', *Provincetown Arts* (2003), p. 35.

30 Martha Zamora, *The Brush of Anguish* (San Francisco, 1990), p. 8. Moving well beyond the self-aware empathy that both Herrera and Zamora have expressed towards their subject, the writer Elena Poniatowska opted to merge her voice totally with that of Kahlo. Her 'Memoir' is written as a first-person narrative; see Elena Poniatowska, 'Diego, I Am Not Alone: Frida Kahlo', in *Frida Kahlo: The Camera Seduced* (San Francisco, 1992), pp. 15–21.

31 Alejandro Gómez Arias, 'Un testimonio Sobre Frida Kahlo', in *Frida Kahlo: Exposición Nacional de Homenaje* (Mexico City, September–November 1977), no page.

32 Some of the more recent material that has surfaced is apparently fake, further complicating efforts to disentangle the Kahlo myth from historically sound research. Kahlo scholar James Oles responded to the publication of an allegedly forged 'Kahlo trove' with frustration: 'This is a perversion of Frida Kahlo . . . It's just like the "Hitler diaries" that threaten to change history. And it's pernicious because she was complex and there were all these fictions that circulated around her. Scholars are trying to get behind all these scrims, and a book like this muddies the waters' (Jason Edward Kaufman, 'Forthcoming Frida

Kahlo Book Denounced as Fake', *Art Newspaper*, 20 August 2009, www.theartnewspaper.com, accessed October 2009). See also Elizabeth Malkin, 'Kahlo Trove: Fact or Fakery?', *New York Times* (29 September 2009), pp. C1, C5.

33 Isolda P. Kahlo, *Intimate Frida* [2005] (Bogotá, 2006); Grimberg, *Song of Herself*; Carlos Phillips Olmedo et al., *Self Portrait in a Velvet Dress: Frida's Wardrobe: Fashion from the Museo Frida Kahlo* (San Francisco, 2007); Pablo Ortiz Monasterio, ed., *Frida Kahlo: Her Photos* (Mexico City, 2010). Whereas these books collate new primary sources from Kahlo's intimate interior spaces and her domestic sphere, other scholarly genres position the artist and her œuvre within the public domain, contextualizing her art and life historically, politically, culturally and socially. Two particularly innovative and noteworthy examples are Tanya Barson's brilliant 'Glossary' published in conjunction with the Frida Kahlo retrospective exhibition at Tate Modern in London ('All Art is at Once Surface and Symbol': A Frida Kahlo Glossary', in *Frida Kahlo*, ed. Emma Dexter and Tanya Barson, London, 2005, pp. 55–79), and the remarkably comprehensive and eye-opening 'Timeline' compiled by Fernando Feliu-Moggi, Nancy Meyer and Victor Zamudio-Taylor for the Kahlo exhibition at the Walker Art Gallery ('Timeline, 1907–1954', in *Frida Kahlo*, exh. cat., Walker Art Center, Minneapolis, 2007, pp. 81–127).

34 Grimberg, *Song of Herself*, p. 91.

1 Family Tree

1 Salomon Grimberg, *Frida Kahlo: Song of Herself* (London and New York, 2008), p. 57.

2 A copy of Kahlo's birth certificate (document no. 11507), obtained from the CENIDIAP archives in Mexico City, is in the author's archive.

3 See Ilona Katzew, *Casta Paintings: Images of Race in Eighteenth-century Mexico* (New Haven, CT, 2005).

4 Hayden Herrera, *Frida* (New York, 1983), p. 4.

5 Kahlo claimed to have been born at 1 a.m. on 7 July, rather than 8.30 a.m. on 6 July (her parents and sisters consistently sent her birthday greetings on 7 July); and at 127 Londres Street (the address of her

home, La Casa Azul) and not on '1 Londres Avenue', as is specified in the registrar's document. Today, more than a century after the fact, we may speculate, but will probably never know for sure, if the exact time and place of Kahlo's birth were inadvertently misreported by her grandmother, or erroneously entered by a clerk at the municipal registry, or if the details in the document are correct but were later modified by Kahlo or by a family member, for some unknown reason. Martha Zamora was the first to notice that the address that appears on the birth certificate contradicts Frida's statements that she was born in La Casa Azul; see Martha Zamora, *The Brush of Anguish* (San Francisco, 1990), p. 15.

6 Isolda P. Kahlo recalled: 'My aunts Maria Luisa and Margarita Kahlo, were born from [my grandfather's] first union. Maria Luisa never married and Margarita became a nun. They both lived to an old age and were very affectionate with us. My daughter Mara . . . had a chance to meet them.' Isolda P. Kahlo, *Intimate Frida* [2005] (Bogotà, 2006), p. 55.

7 Ibid., pp. 56, 224–5.

8 An unpublished letter from Maria Margarita Kahlo, addressed to '*Friduchita linda*', dated 26 October 1932, attests to the ongoing family ties (The Nelleke Nix and Marianne Huber Collection: The Frida Kahlo Papers. Special Collections, Library and Reseach Center, National Museum of Women in the Arts, Washington, DC [NMWA archives]).

9 Basing herself on the psychoanalytical premise that one's formative childhood experiences shape one's identity, Kahlo painted what I have called her 'Childhood Series', a group of nine paintings that investigate her early years. The series began in 1932 with *My Birth* (discussed below) and ended in 1938. See Gannit Ankori, *Imaging her Selves: Frida Kahlo's Poetics of Identity and Fragmentation* (Westport, CT, and London, 2002), pp. 61–92.

10 Frida Kahlo, 'Transcription of notes taken during conversations with Frieda Kahlo de Rivera and Diego Rivera by Parker Lesley', 27 May 1939; unpublished transcript, copy in author's archive, p. 2.

11 All Kahlo's biographers – Raquel Tibol, Martha Zamora and Hayden Herrera – stress this point, but it is Salomon Grimberg's psychoanalytical studies of Kahlo's œuvre, and of this painting in particular, that offer the most comprehensive interpretation of Kahlo's strained relationship with

her mother. For a full discussion of this issue and the related research literature, including citations of Grimberg's thesis, see Ankori, 'The Matrix', in *Imaging her Selves*, pp. 27–36. Kahlo's *My Nurse and I* (1937) also presents a maternal body fragment with the mother's head covered and is related to the issues discussed in this section. For an expanded 63–77.

12 Juan O'Gorman, interview with Hayden Herrera, 1977 (author's archive). Alejandro Gómez Arias, interview with Gannit Ankori, 1989 (author's archive). See also Raquel Tibol's interviews of 1953 with Kahlo herself, extensively quoted in her publications. The following information, unless otherwise indicated, is based on Kahlo's unpublished papers from the NMWA archives.

13 Kahlo told Olga Campos that she chose not to view her mother's body after Matilde Calderón had died, but that she did want to see her father's body after his death in 1941: 'I saw him dead; I did not want to see her dead', Grimberg, *Song of Herself*, p. 85. Even at death, her different relationship with each parent manifested itself distinctly.

14 Kahlo, *Intimate Frida*, p. 56. For an interpretation that views the Virgin Mary as a surrogate mother, see Ankori, 'The Matrix', in *Imaging her Selves*, pp. 27–36.

15 Kahlo's youthful letters reflect her immersion in the Catholic practices of her mother, but also her growing scepticism. A newly uncovered photograph of Frida's First Communion attests to her Catholic upbringing: see Pablo Ortiz Monasterio, ed., *Frida Kahlo: Her Photos* (Mexico City, 2010), p. 61. On the back Kahlo scribbled: 'Friduchita in 1920 when she received her First Communion at age 10' (the date and the age have been revised) and below that in capital letters, she wrote: 'IDIOT!'

16 Kahlo began to paint on metal using the *retablo* format in 1932. She amassed a substantial collection of authentic *retablos* that are still on display at La Casa Azul.

17 For a full discussion of this painting, including comparative material, the meaning of its colour scheme and use of perspective, see Ankori, *Imaging her Selves*, pp. 27–33, 40–41, 128–9, 65–6.

18 It was Diego Rivera who first compared *My Birth* with the Aztec sculpture of the goddess of birth, in his attempt to link Kahlo with indigenous Mexican culture (Diego Rivera, '*Frida Kahlo y el arte*

mexicano', *Boletin del seminario de cultura mexicano*, ɪɪ, October 1943, pp. 89–102). The comparison was picked up and developed by many scholars.

19 Newly discovered photographs of Matilde Calderón – specifically those showing her and other family members dressed up in native Mexican costumes from Tehuantepec of the type that Frida favoured – make Kahlo's deliberate choice even more meaningful (Monasterio, ed., *Frida Kahlo: Her Photos*, pp. 42–3).

20 The photograph that includes the camera was found in La Casa Azul, and first published in 2010 (ibid., p. 81). Other newly revealed photographs by Wilhelm Kahlo – for example, nude self-portraits – display a bold and creative side of his personality. Apparently, Frida's artistic affinity with her father was even deeper than previously imagined. For more details, see Ankori, 'The Paternal Contribution', in *Imaging her Selves*, pp. 37–42.

21 NMWA archives.

22 There are no accounts that attest to Wilhelm Kahlo's political activism. There are, on the contrary, several anecdotes that allude to his being apolitical and even telling Trotsky that he should keep away from politics.

23 Herrera, *Frida*, pp. 19–20 and note on p. 451.

24 On her deathbed, Kahlo repeated this positive view of her father, writing in barely legible script: 'My childhood was wonderful because even though my father was sick . . . he was the best example for me of tenderness and workmanship (also a photographer and painter) but above all of understanding all my problems which since I was four years old were of a social nature.' *The Diary of Frida Kahlo* (New York, 1995), p. 282. It is striking to read Isolda Kahlo's testimony about her grandfather's ability to cope with suffering, since her language seems to echo the metaphors usually reserved for Frida: 'as is the case with all good trees, he knew how to bear his torment in silence, with dignity, and without the slightest complaint' (Kahlo, *Intimate Frida*, p. 54).

25 Raquel Tibol, *Una vida abierta* (Mexico City, 1983), p. 35.

26 Kahlo painted *Portrait of my Father* at a time of great physical and emotional hardship. For a full discussion of the context in which the work was created, her emotional regression to childhood and consequent portrayal of other 'father figures' (for example Dr Farill

and Stalin), see Gannit Ankori, 'The Fractured Self: Identity and Fragmentation in the Art of Frida Kahlo', PhD thesis, Hebrew University of Jerusalem, 1994, pp. 56–60, 465–7.

27 All quotes by Alejandro Gómez Arias, unless otherwise noted, are from interviews conducted by the author in 1989. Porfirio Díaz (1830–1915) was a most controversial leader who ruled Mexico as a dictator for 30 years until the Mexican Revolution broke out in 1910. Guillermo Kahlo's commissions and his professional success were based on his association with Porfirio's government and its supporters. After the Revolution, he fell out of favour and the family suffered a financial downturn.

28 In the course of my interview with Gómez Arias, he recounted vividly how Frida learned the various 'stages of photography, as they were practised in those days' from her father, but that she did not enjoy the fastidiousness of his technique: 'Frida could never conform to or "fit" the classical forms of art, that nurtured the concept of a "perfect" composition', he explained, adding that 'nevertheless, she could and did produce excellent photographs'. For newly discovered examples of photographs taken by Frida, see Monasterio, ed., *Frida Kahlo: Her Photos.* The unpublished correspondence between Frida and her father is in the NMWA archives.

29 Juan O'Gorman (Herrera interview, 1977, author's archive), p. 2. Juan O'Gorman met Kahlo when they were both teenagers. He remained a close friend throughout her life. He was an artist and architect, who designed Rivera's studio and house in San Ángel. When Rivera and Kahlo were in the United States, O'Gorman worked on the house and Wilhelm Kahlo photographed it, suggesting that the two were in touch at that time as well.

30 Kahlo, *Intimate Frida*, pp. 53–67, especially pp. 54, 57, 66. Isolda's memories of her grandfather and the family history are an extremely valuable resource. I am grateful to have had the opportunity to meet and interview Isolda in her home in Mexico in March 1989.

31 Ankori, *Imaging her Selves*, p. 37.

32 Monasterio, ed., *Frida Kahlo: Her Photos*, pp. 40, 41, 82, 83. The captions on these photographs, inscribed by Frida herself, along with additional testimonies and publications that pre-date Wilhelm Kahlo's death in 1941 and stress both his Hungarian and Jewish ancestry, dispel the claims

of Gaby Franger and Rainer Huhle that his Hungarian Jewish roots were 'invented' by scholars after Frida's death. Their assertion that Wilhelm Kahlo's forefathers were German Lutherans is difficult to substantiate since Judaism is a matrilineal religion and tracing the matrilineal genealogy of the Kaufmann family is virtually impossible. This type of research is, of course, very difficult given the destruction of Jewish communities and their archives throughout Europe during the Nazi era. Both Frida and her niece Isolda strongly asserted the family's Hungarian Jewish roots.

33 For more information on how this painting relates to the immigrant experience, see Ankori, *Imaging her Selves*, pp. 44–55.

34 Francis H. Ramsbotham, *The Principles and Practice of Obstetric Medicine and Surgery in Reference to the Process of Parturition*, ed. William V. Keating (Philadelphia, 1865), pl. 53, fig. 2; reproduced in Gannit Ankori, 'The Hidden Frida: Covert Jewish Elements in the Art of Frida Kahlo', *Jewish Art*, xix–xx (1993–4), p. 233, fig. 5.

35 In addition to the genealogical charts, the painting is based on diverse sources, among them family photographs, medical illustrations, imagery derived from books of poems in Kahlo's library and Henri Rousseau's *The Present and the Past*. See Jewish Museum, New York, website devoted to this painting and its sources: www.thejewishmuseum.org/kahlo. This visual genealogy echoes the family history compiled and published by Frida's niece, Isolda, half a century after the artist's death (Kahlo, *Intimate Frida*, pp. 53–4). 'How far back in time do we have to go in order to identify our family origins? . . . According to what I have read, for the majority of people, it is considered adequate to go back to their grandparents. It certainly is enough for me. Guillermo Kahlo Kaufmann, my grandfather, was a wonderful character, exquisite in his manners, full of social graces, zealous in his work, sensitive without sentimentality, uncannily honest, discreet in his talk, sometimes distant, but always respectful of others. He could be a little mysterious in his thoughts and emotions, but invariably upright and always averse to provoking any trouble with other people.

His parents (Frida's grandparents were Jacob Heinrich Kahlo and Henriette Kaufmann) were both Hungarian Jews from Arad (now Romania).

They both had immigrated to Germany. My great grandfather Jacob had two professions – jewelry and photography.

... My Grandmother, Matilde Calderón y González, who was Frida's mother, was born in Oaxaca in 1876 ... She was the daughter of Isabel González and Antonio Calderón. Like my grandfather, he was a photographer from Michoacán.

As [Frida] shows in her painting "My Grandparents, My Parents and I", she was endowed with my paternal grandmother's eyebrows. That detail had great meaning for Guillermo.'

36 Grimberg, *Song of Herself*, pp. 82, 105.
37 Traces of the complex relationship with Cristina may be found in Kahlo's paintings, for example *My Nurse and I* (1937); see Ankori, *Imaging her Selves*, pp. 63–77.
38 Grimberg, *Song of Herself*, p. 57, and Tibol, *Una vida abierta*, p. 39.
39 Guillermo Kahlo, letter to Frida, 4 September 1932 (NMWA archives).
40 For a detailed analysis of the unfinished family tree, see Ankori, *Imaging her Selves*, pp. 55–6.

2 Childhood Traumas

1 Raquel Tibol, *Una vida abierta* (Mexico City, 1983), pp. 36–7; Salomon Grimberg, *Frida Kahlo: Song of Herself* (London and New York, 2008), p. 65.
2 Issy Pilowsky, 'Psychodynamic Aspects of the Pain Experience', in *The Psychology of Pain*, ed. Richard A. Sternbach (New York, 1986), pp. 181–95. See also Richard Serjeant, *The Spectrum of Pain* (London, 1969); Ronald Melzack, *The Puzzle of Pain* (Harmondsworth, 1973).
3 Tibol, *Una vida abierta*, p. 36.
4 Hayden Herrera, *Frida* (New York, 1983), pp. 15–16.
5 For detailed discussions of relevant images, see Gannit Ankori, *Imaging her Selves: Frida Kahlo's Poetics of Identity and Fragmentation* (Westport, CT, and London, 2002), pp. 80, 82, 86–7, 97, 111–13, 118, 126, 203–6. I have also suggested that Kahlo's entire œuvre, characterized by compositions that deal obsessively with a quest for symmetry and balance, is connected in a profound way to

her body image following her bout with polio. Kahlo's desire to balance her asymmetrical body is accomplished time and again in her art.

6 Ibid., pp. 96–7. *The Diary of Frida Kahlo* (New York, 1995), pp. 82–5. I have used my own translation (Gannit Ankori, 'The Fractured Self: Identity and Fragmentation in the Art of Frida Kahlo', PhD thesis, Hebrew University of Jerusalem, 1994, p. 151).

7 Humberto Nagera, 'The Imaginary Companion: Its Significance for Ego Development and Conflict Solution', in *The Psychoanalytic Study of the Child*, vol. XXIV (New Haven, CT, 1969), pp. 165–96.

8 *The Diary of Frida Kahlo*, p. 213.

9 For a detailed analysis of Kahlo's use of the circle to express abstract concepts and emotions, see Ankori, 'The Fractured Self', p. 194. Salomon Grimberg interpreted the circle as a symbolic birth canal in his unpublished manuscript 'Frida Kahlo's Loneliness' (author's archive), pp. 13–17.

10 Herrera, *Frida*, pp. 47–61, especially p. 49.

11 Two copies – one handwritten, the other typed – of Kahlo's medical records, compiled by the artist for Dr Henriette Begun, are in the CENIDIAP archives, Mexico City.

12 Martha Zamora located newspaper clippings that claimed Kahlo was killed in the accident. She also learned that emergency medics at the scene of the accident originally left Kahlo for dead (or too seriously injured to be treated), but that Gómez Arias forced them to give her medical attention (Ankori telephone interview with Martha Zamora, 1992).

13 Quoted in Herrera, *Frida*, p. 62. In her exhaustive reconstruction of the accident and its aftermath, Herrera arrived at a similar conclusion: ibid., pp. 47–77.

14 Tibol, *Una vida abierta*, p. 40.

15 Herrera, *Frida*, pp. 66–7.

16 Grimberg, *Song of Herself*, p. 71.

17 Tibol, *Una vida abierta*, p. 40. Kahlo was also referring to the doctors, whom she thought were not offering her the best medical care, perhaps because her parents were not well off.

18 Raquel Tibol, ed., *Frida by Frida*, trans. Gregory Dechant (Mexico City, 2006), p. 315.

19 Gómez Arias (Ankori interview, 1989).
20 Ibid.
21 Tibol, *Una vida abierta*, p. 39.
22 On 'splitting', see Sigmund Freud, 'Splitting of the Ego in the Process of Defence', in *The Standard Edition of the Complete Psychological Works of Sigmund Freud* (London, 1964), vol. XXIII, pp. 273–8.
23 For a broader discussion on the creation of a 'Second Self' or 'Double' vis-à-vis Kahlo's œuvre, see Ankori, *Imaging her Selves*, pp. 119–21.
24 Quoted by Herrera, *Frida*, p. 74.
25 Gómez Arias (Ankori interview, 1989).
26 Carlos Fuentes, 'Introduction', in *The Diary of Frida Kahlo*, pp. 7–25.
27 Elaine Scarry, *The Body in Pain: The Making and Unmaking of the World* (Oxford, 1985), pp. 4–5.
28 Ibid.

3 On the Cusp of Womanhood

1 Frida Kahlo, letter to Alejandro Gómez Arias, 29 September 1927, quoted in Hayden Herrera, *Frida* (New York, 1983), p. 75. The letter, in different translation, may be found in Raquel Tibol, ed., *Frida by Frida*, trans. Gregory Dechant (Mexico City, 2006), p. 58.
2 Gómez Arias (Ankori interview, 1989).
3 Salomon Grimberg, *Frida Kahlo: Song of Herself* (London and New York, 2008), pp. 58, 68–9.
4 Reproduced in Martha Zamora, *Frida Kahlo: The Brush of Anguish* (San Francisco, 1990), p. 22.
5 For a full analysis of this painting, see Gannit Ankori, *Imaging her Selves: Frida Kahlo's Poetics of Identity and Fragmentation* (Westport, CT, and London, 2002), especially pp. 84–90, 128–9.
6 Gómez Arias (Ankori interview). It is instructive to compare Kahlo's milieu and her engagement with the cutting-age ideas of her time with Rubén Gallo's formulations of Mexican modernity in his book *Mexican Modernity: The Avant-Garde and the Technological Revolution* (Cambridge, MA, and London, 2005).
7 Herrera, *Frida*, p. 226.

8 For information regarding the analysis of Kahlo's library and its methodological underpinnings, see Ankori, *Imaging Her Selves*, especially pp. 6–10, 51–5, 58–60, 254–5.

9 Gómez Arias recalled that Kahlo liked Oscar Wilde (Ankori interview, 1989); Wilde is also mentioned in the artist's letters from the 1920s. Kahlo's nurse, Judith Ferreto, recalled that she would read Whitman to her when she was in bed towards the end of her life. Kahlo gave a copy of Whitman's *Leaves of Grass* to José Bartolí at the height of their amorous relationship. He treasured it until his death (Salomon Grimberg, 'Any Friend of Frida's is a Friend of Mine; or, Who Collects Frida Kahlo's Art', in *Frida Kahlo Retrospective*, Munich, 2010, p. 33). Frida Kahlo, 'Memory', in *El universal ilustrado* (30 November 1922), p. 61; reproduced in Tibol, ed., *Frida by Frida*, p. 13. See also her verses composed in 1946 for Lina and Arcady Boytler (ibid., pp. 296–7) and the corrido she wrote for Mariana Morillo Safa, also in 1946 (ibid., pp. 311–14).

10 Unpublished letters from Mary Channing Wister to Frida Kahlo, 1932 (The Nelleke Nix and Marianne Huber Collection: The Frida Kahlo Papers. Special Collections, Library and Reseach Center, National Museum of Women in the Arts, Washington, DC [NMWA archives]).

11 Unpublished and undated note from Margaret Sanger to Diego Rivera (NMWA archives).

12 *The Diary of Frida Kahlo* (New York, 1995).

13 The *Cachuchas* – literally 'caps' or 'berets' – were named after the head-gear they sometimes wore. They were: Miguel N. Lira, José Gómez Robleda, Agustín Lira, Jesús Ríos Ibúñez y Valles, Alfonso Villa, Manuel González Ramirez, Alejandro Gómez Arias and Frida Kahlo. Kahlo said there was a 'satellite' group: Carmen Jaime, Ernestina Martin, Agustin Olmedo, Angel Salas, Renato Leduc and Fernando Campo (Grimberg, *Song of Herself*, p. 69). For an excellent study of Kahlo and the Preparatoria, see Herrera, *Frida*, pp. 22–44. For an analysis of Kahlo's paintings that relate to her social group (for example *Adelita*, 1927), see Ankori, *Imaging her Selves*, pp. 104–11, 117, 138–40. See also the more recent article by James Oles, 'At the Café de los Cachuchas: Frida Kahlo in the 1920s', *Hispanic Research Journal*, VIII/5 (December 2007), pp. 467–589.

14 Grimberg, *Song of Herself*, pp. 69–71.

15 Ibid., pp. 68–9.
16 The letter is dated 28 September 1926: Tibol, ed., *Frida by Frida*, p. 58.
 The portrait remained hanging in Gómez Arias's sitting room until his
 death. When I interviewed him in his home in the spring of 1989, 'his
 Botticelli' was eyeing us with her intense gaze.
17 Kahlo letter to Gómez Arias, 25 December 1924; quoted in Herrera,
 Frida, p. 40.
18 Kahlo letter to Gómez Arias, 17 March 1926; quoted ibid., p. 60.
19 Kahlo letter to Gómez Arias, 12 April 1926; quoted ibid.
20 Kahlo letter to Gómez Arias, 20 October 1925; quoted ibid., p. 53.
21 Ibid., p. 43.
22 Kahlo letter to Gómez Arias, 19 December 1925; quoted ibid., pp. 58–9.
23 On Nahui Olin and her relationship with Rivera, see Bertram D. Wolfe,
 The Fabulous Life of Diego Rivera [1963] (New York, 1984), p. 242; Diego
 Rivera, with Gladys March, *My Art, my Life: An Autobiography* (New
 York, 1960), p. 128; Herrera, *Frida*, pp. 312. See also Adriana Malvido,
 Nahui Olin, la mujer del sol (Mexico, 1999).
24 The Crommie interviews were conducted in the 1960s. Herrera inter-
 viewed many of Kahlo's friends in the late 1970s. Also see Adelina
 Zendajas's statement in the Louise Lo film of 1988. (All interview
 transcripts are in the author's archive.)
25 Raquel Tibol (Ankori interview, 1989).

4 Coming of Age

1 Bertram D. Wolfe, *The Fabulous Life of Diego Rivera* [1963] (New York,
 1984), p. 6. See also Andrea Kettenmann, *Rivera* (Cologne, 2007), p. 7,
 and the cover story on Rivera in *Time* (4 April 1949).
2 Hayden Herrera, *Frida* (New York, 1983), pp. 31–3; Wolfe, *The Fabulous
 Life of Diego Rivera*, pp. 240–42; Diego Rivera (with Gladys March), *My
 Art, My Life: An Autobiography* (New York, 1960), pp. 128–9.
3 *Diego Rivera: A Retrospective*, exh. cat., Detroit Institute of Arts, Detroit
 (1986), pp. 66, 70.
4 Herrera, *Frida*, p. 80. For a path-breaking study of Kahlo and Modotti,
 see Laura Mulvey and Peter Wollen, *Frida Kahlo and Tina Modotti*, exh.
 cat., Whitechapel Gallery, London (1982). Some accounts claim that

Modotti was Rivera's lover before he met Kahlo. See photograph of Kahlo and Modotti in Pablo Ortiz Monasterio, ed., *Frida Kahlo: Her Photos* (Mexico City, 2010), pp. 282–3.

5 Rivera, *My Art*, pp. 169–72; Wolfe, *The Fabulous Life of Diego Rivera*, pp. 243–4.

6 Wolfe, *The Fabulous Life of Diego Rivera*, p. 245.

7 Ibid., p. 244.

8 Ibid.

9 See Gannit Ankori, *Imaging her Selves: Frida Kahlo's Poetics of Identity and Fragmentation* (Westport, CT, and London, 2002), pp. 140–41; Herrera, *Frida*, pp. 98, 106, 109.

10 For example, the photograph on p. 73 and a photograph by Imogen Cunningham (1930), reproduced in Elena Poniatowska and Carla Stellweg, *Frida Kahlo: The Camera Seduced* (San Francisco, 1992), p. 25.

11 Janice Helland, 'Aztec Imagery in Frida Kahlo's Paintings: Indigenity and Political Commitment', *Woman's Art Journal*, XI/2 (Fall 1990–Winter 1991), p. 9.

12 Cesar Macazaga Ordoño, *Diccionario de la lengua Nahuatl* (Mexico, 1979), p. 64.

13 Herrera, *Frida*, p. 80.

14 The following information is based on Rivera's autobiography and on the chronological notes compiled by Laurance P. Hurlburt, 'Diego Rivera (1886–1957): A Chronology of his Art, Life and Times', in *Diego Rivera: A Retrospective*, pp. 22–115.

15 Wolfe, *The Fabulous Life of Diego Rivera*, p. 407.

16 Herrera, *Frida*, p. 99.

17 The passenger list and brochure detailing the voyage are among the documents of The Nelleke Nix and Marianne Huber Collection: The Frida Kahlo Papers. Special Collections, Library and Reseach Center, National Museum of Women in the Arts, Washington, DC (NMWA archives).

18 Rivera, *My Art*, pp. 287–8.

19 The ups and downs of Kahlo's relationship with Guadalupe (Lupe) Marín are difficult to trace. There are unsubstantiated stories about Marín's jealous rage and insulting remarks at a party immediately after Kahlo's wedding to Rivera. There are also tales that the two became friends and that Marín taught Kahlo to cook Rivera's favourite

dishes. From Kahlo's letters, however, it seems clear that she disliked Marín intensely. On 24 October 1940 Kahlo wrote to Emmy Lou Packard: 'She is absolutely a son of a bitch. She is furious because I will marry Diego again, but everything she does is so low and dirty that sometimes I feel like going back to Mexcio and kill her. I don't care if I pass my last days in prison' (Raquel Tibol, ed., *Frida by Frida*, trans. Gregory Dechant, Mexico City, 2006, pp. 239–40). On 11 June 1940 Kahlo wrote to Rivera: 'You know better than anyone what an abject bitch Guadalupe is, as if Mussolini himself had given birth to her' (ibid., pp. 235–6).

20 Unless otherwise noted, the reconstruction of Kahlo's San Francisco sojourn is based on unpublished sources from the NMWA archives.

21 Galka Scheyer was a German-born artist and art dealer, who introduced Kandinsky, Klee and other prominent avant-garde European artists to US audiences and collectors (see information about her in the Norton Simon Museum collections). Scheyer's humorous and intimate letters to Kahlo, whom she gave a playful nickname that merges German and Spanish and alludes to 'farts', reveal an intense friendship based on mutual love for each other and for the arts (the letters are deposited in the NMWA archives).

22 NMWA archives.

23 Letter of 14 November 1930 (NMWA archives).

24 Among Kahlo's friends from San Francisco with whom she kept in touch were Albert Bender, William Gerstle, Elise Haas, Clifford and Jean Wight, and Christina and Jack Hastings (NMWA archives).

25 Frida Kahlo, letter to her mother, 10 November 1930 (NMWA archives).

26 For an excellent analysis of the portrait, see Lucretia Hoover Giese, 'A Rare Crossing: Frida Kahlo and Luther Burbank', *American Art*, XV/1 (spring 2001), pp. 52–73. For a fascinating recent study of Burbank and his times, including a discussion and photographs of Kahlo, see Jane S. Smith, *The Garden of Invention: Luther Burbank and the Business of Breeding Plants* (London, 2009). See Gannit Ankori, 'Frida Kahlo's Ethics and Aesthetics of Hybridity', paper delivered at Tate Modern, London, in conjunction with the *Frida Kahlo Restrospective*, 2005 (the entire symposium is available online: www.tate.org.uk).

27 Kahlo mentions both the visit and the photograph in a letter to her mother dated 21 November 1930 (NMWA archives).

28 Dan Barker, 'The Forgotten Story of Luther Burbank': www.ffrf.org (accessed 2004).

29 The material below is from the John Weatherwax papers relating to Frida Kahlo and Diego Rivera, 1928–88, bulk 1931–3, in the Archives of American Art, Smithsonian Institution, Washington, DC. A letter from Weatherwax to Selma Hechtlinger dated 31 August 1973 offers a detailed account of his close relationship with Rivera and Kahlo in San Francisco. In addition to numerous drafts of the play and short story cited below, the archive contains a letter from Kahlo (dated 2 September 1931) to Weatherwax's sister and brother-in-law, Clara and Gerald Strang, referring to the play. The letter is signed 'Queen Frieda the 1', with a humorous illustration of Kahlo's self-portrait on a coin.

30 Fanny Rabel (Ankori interview, 1989); Judith Ferreto (Crommie interview, 1960s, author's archive); Natasha Gelman (Ankori interview, 1989).

31 Lucienne Bloch (Crommie interview, 1960s, and Ankori telephone interview, 1989).

32 Mariana Morillo Safa (Ankori interview, 1989).

33 Albert Bender's letters to Kahlo from 1935 reveal his continued fascination, affection and possible infatuation with her, even five years after her stay in San Francisco (NMWA archives).

34 A riveting study and exhibition of the original show of 1931 was mounted in 2011: see Leah Dickerman et al., *Diego Rivera: Murals for the Museum of Modern Art*, exh. cat., Museum of Modern Art, New York (2011).

35 Kahlo's letters to her mother from New York are in the NMWA archives.

36 Letter of 14 November 1931 (NMWA archives).

37 NMWA archives.

5 'The Lost Desire'

1 Bertram D. Wolfe, *The Fabulous Life of Diego Rivera* [1963] (New York, 1984), p. 242.

2 Diego Rivera (with Gladys March), *My Art, My Life: An Autobiography* (New York, 1960), p. 201.

3 The following quotes are from Kahlo's letter to Leo Eloesser of 26 May 1932; emphasis is in the original. Kahlo's letters to Eloesser are in Spanish. I have photocopies in my personal archives. Portions of the

letters have been translated and reproduced in Raquel Tibol, ed., *Frida by Frida*, trans. Gregory Dechant (Mexico City, 2006), pp. 117–21. For a detailed analysis of this text and other sources that support my conclusion that Kahlo was conflicted and ambivalent about having children, see Gannit Ankori, 'The Fractured Self: Identity and Fragmentation in the Art of Frida Kahlo', PhD thesis, Hebrew University of Jerusalem, 1994, pp. 252–9, 506–8.

4 Kahlo's understanding that Rivera did not want children is also supported by Lucienne Bloch's report on his reaction to the miscarriage. Although he was concerned about Kahlo's health, she said, he was certainly not saddened by the loss of the child (Bloch, Herrera interview transcript, 6 November 1978, author's archive).

5 Suzanne Bloch, letter to Frida Kahlo, 6 June 1932 (The Nelleke Nix and Marianne Huber Collection: The Frida Kahlo Papers. Special Collections, Library and Reseach Center, National Museum of Women in the Arts).

6 'Statement by Angelina Bellof [*sic*]', in Rivera, *My Art*, pp. 294–5.

7 Wolfe, *The Fabulous Life of Diego Rivera*, pp. 105–6.

8 'Statement by Lupe Marín', in Rivera, *My Art*, p. 297.

9 Ibid. In the chronological account of Rivera's life, the two events are listed consecutively in 1927: 'Daughter Ruth born. The definitive break in Rivera's tumultuous marriage' (*Diego Rivera: A Retrospective*, exh. cat. Detroit Institute of Arts, 10 February–27 April 1986, p. 66). Although she modelled for Rivera and other artists, Tina Modotti was first and foremost a great photographer and political activist in her own right.

10 Wolfe, *The Fabulous Life of Diego Rivera*, p. 251.

11 Herrera suggested that before Dr Eloesser's reply, in which he confirmed Dr Pratt's contention that Kahlo could have the baby by Caesarian section, reached Kahlo, she had already made up her mind not to abort: Herrera, *Frida*, p. 140.

12 Bloch (Crommie interview transcript, 1960s, author's archive).

13 Frida Kahlo, letter to Leo Eloesser, 29 July 1932, p. 2; Tibol, ed., *Frida by Frida*, pp. 121–3.

14 Ibid.

15 Ella Wolfe quoted in Herrera, *Frida*, p. 147, telegram in NMWA archives

16 Kahlo's medical records, compiled by the artist for Dr Henriette Begun CENIDIAP archives, Mexico City.

17 For a detailed analysis, see Gannit Ankori, 'The Maternal Self', in
 Imaging her Selves: Frida Kahlo's Poetics of Identity and Fragmentation
 (Westport, CT, and London, 2002), pp. 149–64. I wish to acknowledge
 the inspiring and meticulous scholarship of David Lomas concerning
 the use of medical imagery in the work of Kahlo and Rivera. See David
 Lomas and Rosemary Howell, 'Medical Imagery in the Art of Frida
 Kahlo', *British Medical Journal*, CCXCIX/6715 (23 December 1989),
 pp. 1584–7.

18 One of Kahlo's favorite songs was 'La Llorona', which she loved to
 hear and sing. She reportedly composed extra stanzas to the song
 in reference to her own life, indicating her identification with the
 Weeping Woman of Mexican lore. There has been speculation that
 the line written across the top of her *Self-portrait with Cropped Hair*
 (1940) was one that she added to the song. One of the most moving
 scenes of Julie Taymor's *Frida* (2002) includes a rendition of the song
 by Kahlo's friend Chavela Varga.

19 For a detailed analysis of the lithograph, see Ankori, *Imaging her Selves*,
 pp. 158–9.

20 For a comparison of Kahlo's lithograph with 'Flap Anatomies', see Gannit
 Ankori, 'Frida Kahlo: The Fabric of Her Art', in *Frida Kahlo*, ed. Emma
 Dexter and Tanya Barson (London, 2005), pp. 36–8, figs 28 and 29.

6 'Double Sorrow'

1 Frida called her older sister, Matilde Kahlo, 'Mati', and the sisters had
 various nicknames for each other. The letters in the National Museum
 of Women in the Arts archives, Washington, DC, reveal that Cristina
 was called 'Kitty', Adriana 'Adri', and Frida 'Fridi', 'Frieducha' and
 other endearments. The Nelleke Nix and Marianne Huber Collection:
 The Frida Kahlo Papers. Special Collections, Library and Reseach
 Center, National Museum of Women in the Arts, Washington, DC
 (NMWA archives).

2 The paragraphs below are based on the unpublished letters in the
 NMWA archives, especially Matilde Kahlo, telegram to Frida Kahlo,
 6 July 1932; Guillermo Kahlo, letter to Frida Kahlo, 4 September 1932;
 Frida Kahlo, letter to Diego Rivera, 10 September 1932.

3 Lucienne Block (Herrera interview, 1978, author's archive), and Hayden Herrera, *Frida* (New York, 1983), pp. 140, 147.

4 Bloch (Herrera interview).

5 Bloch (Herrera and Ankori interviews). See also, Carlos Fuentes, 'Introduction', *The Diary of Frida Kahlo* (New York, 1995), p. 22.

6 Raquel Tibol, ed., *Frida by Frida*, trans. Gregory Dechant (Mexico City, 2006), p. 117.

7 Bloch (Herrera interview). As noted in chapter One, Kahlo claimed that her father was of Jewish descent. Rivera claimed to be the descendent of Ynez Acosta, a Mexican from a Portuguese Jewish family, Bertram Wolfe *Diego Rivera: His Life and Times* (New York and London, 1939), p. 5.

8 Unpublished postcards and letters from Lucienne Bloch to Frida Kahlo (NMWA archives). There are two postcards from the spring of 1932; the letter is from 25 April 1936.

9 Frida Kahlo, letter to Georgia O'Keeffe, 1 March 1933 (New Haven, Yale University, Beinecke Library). I thank Nancy Scott and the archivists at the Beinecke Library for helping me track down and photograph this unpublished letter. The letter refers to the fact that O'Keeffe was in the Doctor's Hospital in New York in February 1933, suffering from 'psychoneurosis'. She later recuperated in Bermuda (March–April), but was back in New York during Kahlo's stay there. In 1938 Stieglitz and O'Keeffe attended Kahlo's exhibition at the Julien Levy Gallery, as evidenced by a photograph of the couple found at La Casa Azul. That Kahlo and O'Keeffe spent time together in 1931 may also be deduced from a letter to Kahlo from Mary Channing Wister (NMWA archives). Apparently, in 1951 Georgia O'Keeffe visited Mexico City, and saw Rivera and Kahlo, who was in hospital for most of that year.

10 For a comprehensive analysis and compilation of primary sources on the Rockefeller Center debacle, see Irene Herner de Larrea et al., *Diego Rivera: Paradise Lost at Rockefeller Center* (Mexico City, 1987). I thank Eduardo Berinstein for sharing this publication with me.

11 Bloch (reading from her journal, Herrera interview).

12 For a comprehensive and fully documented account of Kahlo's relationship with Nickolas Muray, see Salomon Grimberg, *I Will Never Forget You: Frida Kahlo to Nickolas Muray* (Munich, 2004). For a reference to O'Keeffe in Kahlo's letter to Clifford and Jean Wight, see Tibol, ed., *Frida by Frida*, p. 129.

13 Kahlo letter to Isabel Campos, 16 November 1933; Tibol, ed., *Frida by Frida*, p. 137.

14 Lucienne Bloch (Ankori interview). In this context, Bloch described a scene where Rivera stabbed a painting of a Mexican cactus, a symbolic act that horrified Kahlo.

15 Gannit Ankori, 'The Fractured Self: Identity and Fragmentation in the Art of Frida Kahlo', PhD thesis, Hebrew University of Jerusalem, 1994, pp. 220–22. For a comprehensive and fascinating Bakhtian analysis of this painting, see Yosi Anaya, 'The Time–Space in Kahlo's My Dress Hangs There', in *Proceedings of the Thirteenth International Mikhail Bakhtin Conference*, eds Mykola Polyuha, Clive Thomson and Anthony Wall (London, Ontario, 2012), based on her thesis: Josefina Anaya Morales, '*Mi Vestido Somos Nosotras*: Addressing *Huipil*: A Study in the History, Significance and Use of Mexican Indigenous Textiles through Makers, Wearers and Frida Kahlo', PhD in Visual Arts, Goldsmiths College, University of London, 2006. I thank Shir Aloni for helping me locate and obtain excerpts from this dissertation.

6 Frida Kahlo, letter to Leo Eloesser, 26 November 1931; Tibol, ed., *Frida by Frida*, p. 105.

7 An insightful article based on Frida Kahlo's correspondence with the Rockefellers explores this issue: Servando Ortoll and Annette B. Ramirez de Arellano, 'Frida Kahlo: Portrait of the Artist as Corporate Wife', copy in the NMWA archives.

8 Frida Kahlo, letter to Leo Eloesser, 15 March 1941; Tibol, ed., *Frida by Frida*, pp. 249–57.

9 Frida Kahlo, letter to Leo Eloesser, 14 June 1931; ibid., p. 105.

10 For a full analysis of the work, see Ankori, 'The Fractured Self', pp. 277–86, 510–11; Terry Smith, 'From the Margins: Modernity and the Case of Frida Kahlo', *Block*, VIII (1983), pp. 11–23. Also see Emma Dexter, 'The Universal Dialectics of Frida Kahlo', in *Frida Kahlo*, ed. Emma Dexter and Tanya Barson (London, 2005), pp. 11–29.

11 Kahlo, letter to Ella Wolfe, 11 July 1934; Tibol, ed., *Frida by Frida*, p. 143.

12 Kahlo, letter to Ella and Bertram Wolfe, 18 October 1934; Tibol, ed., *Frida by Frida*, p. 151.

13 Kahlo, letter to Leo Eloesser, 24 October 1934 (author's archive). See also Herrera, *Frida*, pp. 180–91; Bertram D. Wolfe, *The Fabulous Life of Diego Rivera* [1963] (New York, 1984), pp. 356–60.

24 Frida Kahlo, letter to Ella and Bertram Wolfe, 18 October 1934; Tibol, ed., *Frida by Frida*, p. 153. My thanks to Salomon Grimberg for sharing information regarding this work with me.

25 Herrera, *Frida*, pp. 179–88. See also Kathrin Hoffmann-Curtius, *John, Der Frauenmörder von George Grosz* (Hamburg, 1993), pp. 42–4, in which she compares this work with German depictions of so-called sex crimes.

26 Salomon Grimberg, *Frida Kahlo: Song of Herself* (London and New York, 2008), p. 105.

27 Salomon Grimberg quoting Emmy Lou Packard, ibid., p. 22.

28 Wolfe, *The Fabulous Life of Diego Rivera*, pp. 357–8.

29 Kahlo, letter to Leo Eloesser, 26 November 1934; Tibol, ed., *Frida by Frida*, p. 156.

30 Isolda P. Kahlo, *Intimate Frida* [2005] (Bogotà, 2006), p. 76.

31 Ibid. See Gannit Ankori, *Imaging her Selves: Frida Kahlo's Poetics of Identity and Fragmentation* (Westport, CT, and London, 2002), pp. 239–40.

32 The affair with Aguirre was documented by Raquel Tibol, who also published Kahlo's letters to him in *Frida by Frida*, pp. 159–63. On Kahlo' affair with Isamu Noguchi, see Herrera, *Frida*, pp. 199–201. See also Isamu Noguchi (Herrera interview, 30 April 1977, author's archives).

33 Isamu Noguchi, note to Frida Kahlo, n.d. (NMWA archives). His photograph is reproduced in Pablo Ortiz Monasterio, ed., *Frida Kahlo: Her Photos* (Mexico City, 2010), p. 293.

34 Work on the San Ángel home was in progress when Rivera and Kahlo were in the United States. A letter with a drawing of the house was sent to the couple by Juan O'Gorman on 3 March 1932; Guillermo Kahlo included a lengthy description and various photographs on 4 September 1932 (both letters are in the NMWA archives).

35 Jean van Heijenoort, *With Trotsky in Exile: From Prinkipo to Coyoacán* (Cambridge, MA, 1978), pp. 110–12.

36 Tibol, ed., *Frida by Frida*, p. 208.

37 Diary entry dated 1952.

38 Monasterio, ed., *Frida Kahlo: Her Photos*, p. 343. See other photograph on pp. 341–2 and the related essay by James Oles.

39 Ibid., pp. 205–221. There is evidence that Kahlo was romantically involved with the New York Gallery owner Julien Levy, who exhibited her first solo exhibition in November 1938. In an interview with

Hayden Herrara, Levy recalled Kahlo's flirtatiousness and simultaneous affairs during her stay in New York. He also photographed Kahlo topless. These photographs are currently part of the Julien Levy collection at the Philadelphia Museum of Art.

40 For a detailed analysis, see especially Ankori, *Imaging her Selves*, pp. 208–14.

41 The most comprehensive reconstruction of the Kahlo–Muray relationship is Salomon Grimberg's moving book *I Will Never Forget You*. For the tale of Arija's death and its aftermath, see ibid., pp. 38–41.

42 Diego Rivera, unpublished letter to Walter Pach, 11 October 1938; Walter Pach papers, Archives of American Art, Smithsonian Institution, Washington, DC, Reel 4218, frame 585 (in Spanish). W. P., 'Frida Rivera: Gifted Canvases by an Unselfconscious Surrealist', *Art News* (12 November 1938), p. 13. See also Rivera's letter to Kahlo encouraging her to pursue her artistic career and enjoy her success in New York and in Paris: Herrera, *Frida*, pp. 238–9.

43 Monasterio, ed., *Frida Kahlo: Her Photos*, p. 388 (Mary Reynolds photographed by Man Ray), p. 306 (Marcel Duchamp photographed by Carl van Vechten), unpublished note from Lamba to Kahlo, coordinating her visit to Mexico (NMWA archives). Salomon Grimberg has written about the Lamba–Kahlo friendship based on Lamba's papers and interviews with her in 'Jacqueline Lamba: From Darkness, with Light', *Woman's Art Journal*, 22 (2002), pp. 5–13.

44 Diego Rivera, '*Frida Kahlo y el arte mexicano*', *Boletín del seminario de cultura mexicano*, II (October 1943), pp. 89–102.

45 Frida Kahlo, letter to Ella and Bertram Wolfe, 17 March 1939; Tibol, ed., *Frida by Frida*, pp. 206, 208.

46 Frida Kahlo, letter to Nickolas Muray, 13 October 1939 (author's archive). Kahlo wrote to Muray in English.

47 On the divorce, see Diego Rivera (with Gladys March), *My Art, My Life: An Autobiography* (New York, 1960), pp. 222–6; Herrera, *Frida*, pp. 272–86.

48 Tibol, ed., *Frida by Frida*, pp. 212–14.

49 Nickolas Muray, letter to Frida Kahlo, 16 May 1939; cited in Grimberg, *I Will Never Forget You*, p. 26.

50 The following section is based on several undated and unpublished letters from Mary Sklar to Frida Kahlo (NMWA archives).

51 Kahlo, *Intimate Frida*, p. 789.

52 Frida Kahlo, letter to Sigmund Firestone, postmarked 1 November 1940 (New York; author's archive).

53 All quotes are from Frida Kahlo, letter to Diego Rivera, Coyoacán, 11 June 1940; Tibol, ed., *Frida by Frida*, pp. 229–38.

54 Monasterio, ed., *Frida Kahlo: Her Photos*, p. 205 (additional photographs from this series, photographed by Nicolas Muray, are also reproduced in the book). In her letter of 1 November 1940 to Sigmund Firestone, Kahlo wrote: 'Three months I was lying in bed with a plaster corset and an awfull [*sic*] apparatus on my chin which made me suffer like hell.'

55 Kahlo's medical records, compiled by the artist for Dr Henriette Begun, CENIDIAP archives, Mexico City. Apparently Kahlo was drinking excessively at this time.

56 Paulette Goddard was married to Charlie Chaplin at the time and Rivera reported meeting him in the 1940s.

57 Rivera, *My Art*, pp. 264–5.

58 Grimberg, *Song of Herself*, p. 105.

59 Ankori, *Imaging her Selves*, p. 193.

60 Hayden Herrera, 'Tortured Love: Frida and Diego', in *Sotheby's at Auction* (25 May–17 June 2011), pp. 36–9. In her biography of 1983, *Frida*, Herrera gave Bartolí the code name 'Frida's Spanish refugee lover'. Although his identity was known to Kahlo scholars, he remained very discreet about his relationship with Kahlo throughout his life. After his death in 1995 articles about the love affair proliferated in the press and eventually his Kahlo memorabilia and portrait were auctioned off. I am grateful to Salomon Grimberg for introducing me to José Bartolí and for providing me with information about his relationship with Kahlo.

61 Interview with Chavela Vargas, 'Special Features', in the DVD version of Julie Taymor's film *Frida* (2002).

62 Oles in Monasterio, ed., *Frida Kahlo: Her Photos*, p. 255

63 James Oles, 'Gelatin Silver Gossip', ibid., pp. 257–8.

64 Kahlo, *Intimate Frida*, and Isolda Pinedo Kahlo (Ankori interview, Mexico, 1989). Rina Lazo is quoted by Isolda Pinedo Kahlo in the book.

65 Gómez Arias (Ankori interview, 1989).

66 Juan O'Gorman, typed transcript of recorded interview with Hayden Herrera, 11 March 1977; San Ángel, Mexico, p. 7 (author's archive).

67 Grimberg, *Song of Herself*, p. 101.
68 Judith Ferreto (Crommie interview, 1960s, author's archive).

7 'Where is the "I"?'

The quotation in the chapter's title is taken from Frida Kahlo in a
conversation with Julien Levy (Julien Levy, Herrera interview, 24 April
1997, author's archive).

1 Salomon Grimberg, *Frida Kahlo: Song of Herself* (London and New York,
 2008), p. 91.
2 For a comprehensive list of Kahlo's exhibitions, see 'Selected
 Exhibition History' compiled by Maria Cristina Tavera in *Frida Kahlo*,
 exh. cat., Walker Art Center, Minneapolis (2007), pp. 302–10. Group
 shows mounted during Kahlo's lifetime are listed on pp. 304–5.
3 See Hayden Herrera, *Frida* (New York, 1983), pp. 328–43. I was very
 fortunate to meet and interview Fanny Rabel, one of Los Fridos, in
 1989 in her home in Mexico.
4 Frida Kahlo, letter to Diego Rivera, 11 June 1940; Raquel Tibol, ed.,
 Frida by Frida, trans. Gregory Dechant (Mexico City, 2006), p. 237.
5 For a comprehensive discussion, see 'The Child Self: Kahlo's Childhood
 Series', in Gannit Ankori, *Imaging her Selves: Frida Kahlo's Poetics of
 Identity and Fragmentation* (Westport, CT, and London, 2002), pp. 61–92.
6 For further analysis, ibid., pp. 159–64, 167–74.
7 For a detailed account of the various interpretations of this work, with
 full citations of sources, see 'The Androgynous Self', ibid., pp. 175–87.
 Kahlo again appears as La Llorona in a self-portrait of 1949 titled *Diego
 and I.* In this work her tear-spotted and grief-stricken face is framed by
 wild hair that sweeps around her throat as if threatening to strangle
 her. Kahlo painted Rivera's portrait upon her brow, suggesting that he
 is on her mind. Rivera has a third eye on his forehead and a red shirt
 that appears as a bleeding wound piercing Kahlo's flesh. Blood-red
 dots also spot the green background in several places. At the upper
 right-hand corner of the canvas Kahlo used the same blood-red colour
 to write a caption: 'Mexico. Frida Kahlo. 1949. Diego y yo.' The use of a
 red dot within a large area of green evokes a metaphor that she used in
 1949 in order to describe her unusual relationship with her husband:

'Within my role, difficult and obscure, of being an ally to an extraordinary being, *I have the compensation that a green point has within a great quantity of red*: the compensation of equilibrium' [emphasis added]. Complementing this verbal portrait, *Diego and I* depicts Rivera within Kahlo both as a 'portrait within a portrait' and as a red 'point' within the green expanse. It seems significant that, at the onset of their marriage, Kahlo had used a colour scheme dominated by the complementary red and green to create her marriage portrait of 1931. See Ankori, *Imaging her Selves*, pp. 220–22.

8 For a fuller discussion of La Malinche with citations of historical and cultural sources, ibid., pp. 87–9.

9 Ibid., pp. 189–93.

10 This information appears in a book from Kahlo's library: Luis G. Cabrera, *Plantas curativas de México* (Mexico City, 1936), p. 245.

11 Kahlo photographed the Judas lying on the ground and used the photograph as a model for this painting. See Pablo Ortiz Monasterio, ed., *Frida Kahlo: Her Photos* (Mexico City, 2010), pp. 410–11.

12 For a profound and nuanced understanding of La Chingada in Mexican culture, see Octavio Paz, *The Labyrinth of Solitude* (New York, 1985), pp. 74–82.

13 D. Palevitch and Z. Yaniv, *Medicinal Plants of the Holy Land* (Tel Aviv, 1991), vol. II, pp. 274–5 [in Hebrew].

14 *Roots* also relates to Kahlo's mixed cultural 'roots'. For a detailed analysis, see Ankori, *Imaging her Selves*, pp. 193–200.

15 Donald Cordry, *Mexican Masks* (Austin, TX, 1980), pp. 38, 170.

16 Ankori, 'Trapped in a Web of Deceit and Betrayal', in *Imaging her Selves*, pp. 189–200.

17 Emmanuel Pernoud, '*Une autobiographie mystique*', *Gazette des Beaux-Arts*, ser. 6, CI (January 1983), pp. 43–8.

18 Ankori, 'Ascetic Self ', in *Imaging her Selves*, pp. 203–22. Kahlo turned to the *Crowned Nun* genre in self-portraits such as *Self-portrait with Dead Hummingbird* (1940) and *Self-portrait as a Tehuana* (1943). Both contain distinct biographical references, but they also reveal a profound existential schism that was part and parcel of Kahlo's complex identity. Pernoud convincingly argues that *Self-portrait as a Tehuana* places the young Diego on Kahlo's forehead, suggesting their celibate second marriage and displaying a 'mystical marriage' between

Kahlo and her husband, which would parallel the lofty betrothal of a nun and Christ.

8 'Everything is All and One'

The quotation in the chapter's title is taken from *The Diary of Frida Kahlo* (New York, 1995), p. 77.

1 Salomon Grimberg, *Frida Kahlo: Song of Herself* (London and New York, 2008), p. 89.

2 My ongoing research and book project 'A Faith of their Own: Women Artists Re-Vision Religion', conducted at Harvard Divinity School's Women's Studies in Religion Program since 2005, has helped me understand that Kahlo's ambivalence towards religion is similar to that of other modern and contemporary artists. She rejected institutional religion, but her art displays a close affinity with certain religious energies. My gratitude to Ann Braude, Director of the WSRC.

3 Several symbols (the bleeding heart, for example) amalgamate Catholicism with pre-Columbian rituals; see Gannit Ankori, *Imaging her Selves: Frida Kahlo's Poetics of Identity and Fragmentation* (Westport, CT, and London, 2002), especially pp. 89–90, 128–9, 159–2.

4 See the 'The Ascetic Self', 'Imitatio Christi' and 'Emulating Christ's Mystical Bride', ibid., pp. 201–22. Kahlo's use of Christian iconography figures prominently in the publications of Teresa del Conde and Salomon Grimberg (see especially the latter's 'Frida Kahlo's *Memory*: The Piercing of the Heart by the Arrow of Divine Love', *Woman's Art Journal*, XI/2 [Fall 1990–Winter 1991], pp. 3–7).

5 The artist's niece, Isolda, claimed that every time Kahlo faced a medical crisis, she reverted to prayer and belief in God (Ankori interview 1989, and Isolda P. Kahlo, *Intimate Frida* [2005], Bogotà, 2006). As Lomas and Howell have cogently observed, 'It is a paradox that given her avowed rejection of Catholicism Kahlo constantly draws on its rich visual traditions; the tears, wounds, and broken hearts are those of the Mater Dolorosa, whom she repeatedly invokes to symbolize her plight'; David Lomas and Rosemary Howell, 'Medical Imagery in the Art of Frida Kahlo', *British Medical Journal*, CCXCIX/6715 (23 December 1989), p. 1597.

6 Ankori, 'Portrait of a Library', in *Imaging her Selves*, pp. 51–60.

7 Gannit Ankori, 'The Hidden Frida: Covert Jewish Elements in the Art of Frida Kahlo', *Jewish Art*, xix–xx (1993–4), pp. 224–47.

8 Pablo Ortiz Monasterio, ed., *Frida Kahlo: Her Photos* (Mexico City, 2010), pp. 492–93, 494–5.

9 Sigmund Freud, *Moses and Monotheism* [1939], trans. Katherine Jones (New York, 1967). After she had completed the work in 1945, Kahlo explained the circumstances that led to the painting: 'More or less two years ago, José Domingo told me . . . that he would like me to read "Moses" by Freud, and to paint my interpretation of the book as I wished. This canvas is the result of that small conversation between José Domingo and myself. I only read the book once, and started to paint the picture with the very first impression it left me' (Frida Kahlo, 'The Birth of Moses', quoted in *Tin-Tan*, 1/2 [September 1975], pp. 2–6).

10 For a detailed analysis of this complicated and crowded painting, see Gannit Ankori, 'Moses, Freud and Frida Kahlo', in *New Perspectives on Freud's Moses and Monotheism*, ed. Ilana Pardes and Ruth Ginsberg (Tübingen, 2006), pp. 135–48.

11 At the time she was painting *Moses*, Kahlo presented a mock family romance in her diary, where she herself appears as the androgynous Egyptian offspring called 'Neferunico, founder of Lokura [madness]'.

12 Ankori, 'Moses, Freud and Frida Kahlo'.

13 Arturo Schwartz, who was a close friend of Breton and part of the Surrealist circle, has written widely on this theme: 'For Surrealism, as in the traditions of the Cabbala, alchemy and Hinduism, love is the royal way to initiatic knowledge. This implies, in the first place, self-knowledge. If love is an instrument of knowledge, it is because to love means to understand, and therefore to understand the *other*, who is always a reflection of oneself' (Arturo Schwartz manuscript, Arturo Schwartz archives, Israel Museum, Jerusalem).

14 E. G., and Albert Beguin, 'L'Androgyne', *Minotaure*, no. 11 (15 May 1938), pp. 10–13; Maurcie Heine, 'Eritis icut Dii . . . ', ibid., pp. 30–33.

15 Kahlo's serious interest in Eastern thought deepened in the mid-1940s, but as early as 1924 she wrote to Alejandro Gómez Arias: 'I found some very nice books with lots of things about Oriental art and that's what your Friducha is reading at the moment' (letter dated 12 January 1924; Tibol, ed., *Frida by Frida*, p. 26). Among the books Kahlo owned that I

had a chance to examine were: P. Thomas, *Hindu Religion, Customs and Manners* (Bombay, n.d.: the New York Public Library catalogued their copy of the book in 1948, indicating the book must have been published before that date). Kahlo's letters to Leo Eloesser attest to the fact that she also borrowed books on the subject and read them with relish (for example, Kahlo's letter to Eloesser, 11 February 1950, author's archive). Kahlo was also influenced by the writings of Heinrich Zimmer (1890–1943), one of the leading authorities on Indian art and philosophy. Zimmer, who had fled Europe just two years before his death and delivered a widely acclaimed lecture series on Hinduism, Buddhism and Indian art at Columbia University, was in touch with some of Kahlo's closest friends. His lectures of 1942 were published posthumously, edited by Joseph Campbell: Heinrich Zimmer, *Myths and Symbols in Indian Art and Civilization* (Washington, DC, 1946). Kahlo also owned Zimmer's earlier book, *Kunstform und Yoga im Indischen Kultbild* (Berlin, 1926). I thank Prof. David Schulmann of the Hebrew University for discussing aspects of Indian philosophy with me.

16 For a full analysis, see *Diego Rivera: A Retrospective*, exh. cat. Detroit Institute of Arts, 10 February–27 April 1986, pp. 316–19; William Weber, 'The Tumultuous Life and Times of the Painter Diego Rivera', *Smithsonian*, XVI/11 (February 1986), pp. 36–51.

17 Frida Kahlo, 'Portrait of Diego' [1949], in Raquel Tibol, ed., *Frida by Frida*, trans. Gregory Dechant (Mexico City, 2006), pp. 344–57.

18 Zimmer, *Myths and Symbols*, pp. 128–9.

19 Wendy Doninger O'Flaherty, 'The Symbolism of the Third Eye of Siva in the Puranas', *Purana*, XI/1 (January 1969), p. 279. For a comprehensive analysis of this painting and related Eastern oriental imagery, see Part VII: 'Merging Self and Other', 'Uniting with Rivera, Identifying with Parvati' and 'The Ultimate Union: From *Aham* to *Atman*', in Ankori, *Imaging her Selves*, pp. 223–48.

20 Tibol, ed., *Frida by Frida*, p. 296.

21 See Ankori, 'The Animal Self', in *Imaging her Selves*, pp. 242–5, 247–8.

22 This section is based on Gannit Ankori, 'The Ethics and Aesthetics of Hybridity in the Art of Frida Kahlo', in *The Many Faces of Frida*, Tate Modern, London (2005).

9 'I am the Disintegration'

1 Salomon Grimberg, *Frida Kahlo: Song of Herself* (London and New York, 2008), p. 105.

2 I obtained a copy of Kahlo's medical records compiled for Dr Henriette Begun in 1989 from the CENIDIAP archives, Mexico City. The document was reprinted in its entirety in 2008 in Grimberg, *Song of Herself*, pp. 114–19.

3 Mauricio Ortiz, 'The Broken Body', in Pablo Ortiz Monasterio, ed., *Frida Kahlo: Her Photos* (Mexico City, 2010), p. 192 (see also entire article, pp. 189–95). Ortiz suggests that Kahlo's medical record has a literary quality. Her way of composing it seems to relate to her 'mythmaking' strategies noted in the Introduction.

4 Gómez Arias (Ankori interview, 1989).

5 On Farill as father figure, see Gannit Ankori, 'The Fractured Self: Identity and Fragmentation in the Art of Frida Kahlo', PhD thesis, Hebrew University of Jerusalem, 1994, pp. 56–60, 465–7.

6 *The Diary of Frida Kahlo* (New York, 1995), p. 82.

7 Frida Kahlo, letter to Ella Wolfe, dated 'Wednesday 13, 1938', cited in Hayden Herrera, *Frida* (New York, 1983), pp. 216–17.

8 Hayden Herrera, 'Frida Kahlo: The Palette, the Pain, and the Painter', *Artforum*, XXI (March 1983), pp. 60–67.

9 Salomon Grimberg, *Frida Kahlo*, exh. cat., Meadows Museum, Dallas (1989), pp. 40–42.

10 Elaine Scarry, *The Body in Pain: The Making and Unmaking of the World* (Oxford, 1985), p. 4.

11 Judith Ferreto gave a tearful and harrowing account of the preparations for the amputation and its aftermath. Although Ferreto understood that amputation was the correct medical decision, she felt that Kahlo 'never accepted the idea' and that it was, in a way, a death sentence (Judith Ferreto, Crommie interview transcript, 1960s, author's archive). Kahlo's letter to her mother from San Francisco reveals that as early as November 1930 there had been discussions about the possibility of amputating her toes (Frida Kahlo, unpublished letter to her mother, 10 November 1930; The Nelleke Nix and Marianne Huber Collection: The Frida Kahlo Papers. Special Collections, Library and Reseach Center, National Museum of Women in the Arts, Washington, DC

[NMWA archives]).

12 See analysis of relevant paintings and drawings in Gannit Ankori, 'The Broken Body, the Doubled Self' and 'Displaying the Wounded Body', in *Imaging her Selves: Frida Kahlo's Poetics of Identity and Fragmentation* (Westport, CT, and London, 2002), pp. 93–121.

13 A photograph of Kahlo taken by Nickolas Muray in the hospital before the operation served as a model for this image; see Monasterio, ed., *Frida Kahlo: Her Photos*, pp. 214–15.

14 Herrera, *Frida*, pp. 354–5.

15 Ortiz, 'The Broken Body', p. 194.

16 For example, *The Diary of Frida Kahlo*, pp. 131–2, 136, 139, 144, 160.

17 On the circle as an archetype of wholeness, see Carl G. Jung and M. L. von Franz, eds, *Man and his Symbols* (London, 1964), pp. 266–85. Jungian psychology also interprets the circle as a symbol of the Self. Hence, Kahlo's painting may be viewed as an expression of the internal dissolution of the Self.

18 I obtained a copy of Kahlo's death certificate from the CENIDIAP archives in 1989.

19 Judith Ferreto (Crommie interview, 1960s, author's archive).

20 Grimberg, *Frida Kahlo*, exh. cat., p. 6.

21 Isolda P. Kahlo, *Intimate Frida* [2005] (Bogotà, 2006), p. 212; see also pp. 199–215.

22 There was disagreement among Kahlo's friends if this political display would have been welcome by Kahlo or not. Some found it a distraction or even a publicity ploy by Rivera. My great-aunt and great-uncle, who attended the funeral, vividly remembered the dramatic unveiling of the communist flag that draped the coffin and the scandals that ensued.

23 Herrera provides a vivid and profusely documented account of Kahlo's funeral and cremation in *Frida*, pp. 433–40.

24 Ibid., p. 440.

25 *The Diary of Frida Kahlo*, p. 160.

10 Of her Time; Ahead of her Time

1 See Gannit Ankori, 'The Fabric of her Art', in *Frida Kahlo*, ed. Emma Dexter and Tanya Barson (London, 2005), p. 31.

2 On the occasion of her centennial exhibition at the Palace of Fine Arts in Mexico City (2007), Kahlo was hyperbolically hailed as 'Frida, Centenary and Eternal', giving her 'timeless' quality a different twist.

3 Alejandro Gómez Arias (Ankori interview, 1989).

4 Based on unpublished letters, Kahlo correspondence in The Nelleke Nix and Marianne Huber Collection: The Frida Kahlo Papers. Special Collections, Library and Reseach Center, National Museum of Women in the Arts, Washington, DC (NMWA archives). In 1982 Peter Wollen and Laura Mulvey curated a pioneering exhibition that displayed the paintings of Frida Kahlo and the photographs of Tina Modotti side by side. The exhibition and the influential catalogue essays that accompanied it espoused a decidedly political view of Kahlo's art that emphasized her position as a communist Mexican woman who created her distinct œuvre within a specific historical and political setting. This project opened new avenues of research that went beyond the dominant biographical approach to Kahlo's paintings, without ignoring the fact that Kahlo's life experiences impacted her art. I thankfully acknowledge the influence of this project on my work. This trajectory, with its emphasis on the political aspects of Kahlo's work, was further developed by various writers over the following three decades. Feminism, Marxism and Mexican nationalism were among the political issues discussed by scholars, prominent among them Oriana Baddeley, Rebecca Block, Joan Borsa, Emma Dexter, Jean Franco, Lynda Hoffman-Jeep, Margaret Lindauer, Charles Merewether, Claudia Schaeffer, Terry Smith and Steven Volk.

5 The 'Syndicate of Technical Workers, Painters and Sculptors' was established in 1922 to express the artists' solidarity with the indigenous population, the revolutionary soldiers and the peasantry. The manifesto – drafted by David Siqueiros with Orozco and Rivera – was published that year in Mexico City as a broadside. It also denounced easel painting as 'essentially aristocratic' and called for a collective artistic expression that would 'destroy bourgeois individualism'. See David Siqueiros et al., *El machete* [Barcelona], no. 7 (June 1924); English trans. in Laurence E. Schmeckebier, *Modern Mexican Art* (Minneapolis, 1939), p. 31.

6 Fernando Feliu-Moggi, Nancy Meyer and Victor Zamudio-Taylor, 'Timeline, 1907–1954', in *Frida Kahlo*, exh. cat., Walker Art Center, Minneapolis (2007), pp. 126–7.

7 Alejandro Gómez Arias (Ankori interview, 1989).

8 Diary entry dated 1952. Gómez Arias stressed this point adamantly, explaining that 'neither Rivera [who was a Trotsky supporter at a certain point], nor anyone else determined Frida's views . . . they say she was intimate with Trotsky – but she was never a Trotskyite' (Ankori interview).

9 Herrera, Baddeley and Anaya have written extensively about Kahlo's costumes. Carlos Phillips Olmedo et al., *Self Portrait in a Velvet Dress: Frida's Wardrobe: Fashion from the Museo Frida Kahlo* (San Francisco, 2007) is a valuable resource for understanding Kahlo's sartorial strategies.

10 The exhibition opened after the manuscript for this book was completed. I thank Circe Henestrosa for corresponding with me and providing images and copies of the wall texts from this remarkable exhibition, so that I could include this material in this volume. The research and curatorial work was done by Circe Henestrosa; the exhibition was designed by Judith Clark; the styling of the mannequins was by Angelo Seminara and the photography was by Miguel Tovar. I thank them all.

11 See catalogue and official guidebook published ten years after the opening of the museum: *The Frida Kahlo Museum* (Mexico City, 1968). I am indebted to Yosi Anaya's insights regarding the transformation of Kahlo's home into a public institution, which she also discusses in her doctoral dissertation: Josefina Anaya Morales, '*Mi Vestido Somos Nosotras*: Addressing *Huipil*: A Study in the History, Significance, and Use of Mexican Indigenous Textiles Through Makers, Wearers, and Frida Kahlo', PhD in Visual Arts, Goldsmiths College, University of London, 2006.

12 Bernice Kolko recalled how, whenever she went on an excursion, Kahlo would ask her to bring back a little souvenir. She wanted little tokens from the outside world, little toys or inexpensive trinkets (Bernice Kolko, Crommie interview, 1960s, author's archive). Elsewhere, I have suggested that Kahlo's books served a similar compensatory purpose. See Gannit Ankori, *Imaging her Selves: Frida Kahlo's Poetics of Identity and Fragmentation* (Westport, CT, and London, 2002), pp. 254–5.

13 On Kahlo's images of fruit, see Salomon Grimberg, 'Frida Kahlo's Still Lifes: I Paint Flowers So They Will Not Die', *Woman's Art Journal* (Fall 2004–Winter 2005), pp. 25–30; see also his *Frida Kahlo: The Still Lifes*

(London and New York, 2008). For a broader context, see Edward J. Sullivan, *The Language of Objects in the Art of the Americas* (New Haven and London, 2007).

14 Kahlo used Xochitl as a code name during her affair with Muray, as discussed above. She named one of her hairless dogs Xolotl, after the Aztec deity.

15 Steven S. Volk, 'Frida Kahlo Remaps the Nation', *Social Identities*, vi/2 (2000), pp. 165–88.

16 I have identified virtually all the dozens of objects and masks (both archeological and recent folk pieces) that Kahlo incorporated into her paintings. See, for example, the image of the Aztec funerary mask in *L'Art vivant* (15 January 1930), p. 47, also in Gannit Ankori, 'The Fractured Self: Identity and Fragmentation in the Art of Frida Kahlo', PhD thesis, Hebrew University of Jerusalem, 1994, fig. 62); the pregnant Nayarit figure, ibid., fig. 73; the Hunchback from Colima, ibid., fig. 374; and the Nayarit couple in Ankori, *Imaging her Selves*, fig. 57. Many of the items are housed today in Anahuacalli, a pyramid-like museum designed by Rivera in San Ángel. Other items are reproduced in the books in Kahlo's library.

17 In the fold-out sheet of 1938 published by the Julien Levy Gallery in conjunction with Kahlo's exhibition, André Breton wrote: 'While I was in Mexico . . . I could think of no art more perfectly situated in time and space than [Kahlo's].' Walter Pach defined Kahlo's paintings as 'the art of a woman, a Mexican and a modern . . . this painter . . . is poignantly of her time'. W. P., 'Frida Rivera: Gifted Canvases by an Unselfconscious Surrealist', *Art News* (12 November 1938), p. 13.

18 *Frida Kahlo and Tina Modotti*, exh. cat. Whitechapel Gallery, London (1982); Oriana Baddeley, 'Her Dress Hangs Here: De-Frocking the Kahlo Cult', *Oxford Art Journal*, xiv/1 (1991), pp. 10–17; Carlos Fuentes, 'Introduction', *The Frida Kahlo Diary* (New York, 1995), pp. 7–24; Seth Fein, 'Review', *American Historical Review* (October 2003), pp. 1261–3; Victor Zamudio-Taylor, 'Frida Kahlo, Mexican Modernist', in *Frida Kahlo*, exh. cat., pp. 14–34.

19 Octavio Paz, *The Labyrinth of Solitude* [1950], trans. Lysander Kemp, Yara Milos, Rachel P. Belash (New York, 1985); Michael C. Meyer and William H. Beezley, eds., *The Oxford History of Mexico* (Oxford and New York, 2000), p. 2.

20 There is very little information about Kahlo's encounters with Chagall
and Eisenstein, apart from Natasha Gelman's recollection that they were
charmed by her. A telling example regarding Kahlo's central position
within Mexican society is that when she had an issue to discuss with
the authorities, she wrote directly to the Mexican president Miguel
Alemán and he promptly responded to her 'personal and confidential'
letter on 29 October 1948 (Raquel Tibol, ed., *Frida by Frida*, trans.
Gregory Dechant, Mexico City, 2006, pp. 339–42).

21 Several excellent books on Kahlo and photography have been published
over the years: Salomon Grimberg, *Lola Alvarez Bravo: The Frida Kahlo
Photographs*, exh. cat., Society of Friends of the Mexican Culture, Dallas,
Texas (1991); *Frida Kahlo: The Camera Seduced* (San Francisco, 1992);
Margaret Hooks, *Frida Kahlo: Portrait of an Icon* (New York, 2002);
Elizabeth Carpenter, 'Photographic Memory: A Life (and Death) in
Picture', in *Frida Kahlo*, exh. cat., pp. 36–55; Salomon Grimberg, *I Will
Never Forget You: Frida Kahlo to Nickolas Muray* (Munich, 2004); and
Pablo Ortiz Monasterio, ed., *Frida Kahlo: Her Photos* (Mexico City, 2010).

22 Examples of photographs incorporated into Kahlo's compositions
abound, for example Monasterio, ed., *Frida Kahlo: Her Photos*, pp. 40,
53, 81, 82, 83, 136–7, 214–15, 343, 395, 410–11.

23 Graciela Iturbide, 'A Vision of Frida', in Phillips Olmedo et al., *Self
Portrait in a Velvet Dress*, pp. 16–25. Another remarkable series of
photographs of Kahlo's orphaned garments, medical apparatuses
and shoes were created in 2013 by the Japanese artist Ishiuchi
Miyako. I thank Circe Henestrosa for bringing this remarkable
body of work to my attention.

24 Judith Ferreto (Crommie interview, 1960s, author's archive).

25 Salomon Grimberg, 'Any Friend of Frida's Is a Friend of Mine; or, Who
Collects Frida Kahlo's Art', in *Frida Kahlo Retrospective* (Munich, 2010),
p. 31. A list of Mexican artists presented by Emilio Fernández, which
included Kahlo, was among the artist's private papers and is now in
the NMWA archives. Numerous photographs of Boytler were found
among Kahlo's papers in La Casa Azul.

26 Photographs document Kahlo with Negrete (Martha Zamora, *The Brush
of Anguish*, San Francisco, 1990, p. 100) and Infante (Isolda P. Kahlo,
Intimate Frida [2005], Bogotá, 2006, p. 222).

27 Natasha Gelman (Ankori interview, March 1989).

28 Lola Alvarez Bravo interviewed by Salomon Grimberg in *Lola Alvarez Bravo: The Frida Kahlo Photographs*, p. 8.

29 See the review of both films in Fein, 'Review', pp. 1261–3.

30 Evan Serpick, 'Coldplay's New Album Title Revealed', *Rolling Stone* (18 March 2008), www.rollingstone.com, accessed April 2008. Lila Downs's mixed genealogy and background may also explain her strong affinity with Kahlo (on her official website she writes that she was 'born in Oaxaca, Mexico, is the daughter of Mixtec singer Anita Sánchez and Allen Downs, a Scottish-American art professor and filmmaker': www.liladowns.com/us/biography).

31 For example, see Grimberg, 'Any Friend', pp. 34–5.

32 The exhibition was curated by Carmen Lomas Garza, aided by a committee that included Kate Connell, Rupert García, Amalia Mesa-Bains and María Pinedo. Reproductions of 24 works are available on the gallery's website: www.galeriadelaraza.org. I feel privileged to have had the opportunity to meet Amalia Mesa-Bains and Marisela Norte in London at the symposium at the Tate Modern on 30 September–1 October 2005. Learning from them about the impact of Kahlo on *chicanos* and *chicanas* was illuminating.

33 Peter Wollen, 'Fridamania', *New Left Review*, XXII (July–August 2003), pp. 119–30.

34 From my conversations with Isolda Kahlo, Frida's niece, it seems that ownership of the Kahlo family home in Coyoacán was transferred to Rivera at a certain point. Certain family members, who requested to remain anonymous, expressed their opinion that Frida's sisters, particularly Cristina, had been disinherited unfairly through dubious means. Isolda opined that after Frida's death her mother was deceived, dispossessed and unable to carry out Frida's wishes. See Cristina Kahlo's letter reproduced in Isolda P. Kahlo, *Intimate Frida* [2005] (Bogota, 2006), pp. 87–101.

35 'I have always felt marginalized in my life and have experienced a great sense of solitude', he explained in an interview with Edward Sullivan (Edward J. Sullivan, 'Nahum B. Zenil' Grey Gallery essay, www.nyu.edu, accessed September 2009). My understanding of Zenil's work is based on Edward Sullivan's scholarship.

36 I am grateful to Yosi Anaya for generously sharing her knowledge and her art with me.

37 Oriana Baddeley, 'Her Dress Hangs Here: De-Frocking the Kahlo Cult',
 Oxford Art Journal, xiv/1 (1991), p. 12.
38 Hayden Herrera, 'Art Review: Why Frida Kahlo Speaks to the 90s',
 New York Times (28 October 1990). See also the letter to the editor
 of the *New York Times* published on 2 December 1990. The writer
 objects to the 'romanticization' of Kahlo's tragedies, among them
 'her 25-year obsession with and marriage to a pig'. Alison Sheiffer's
 illustration published by the newspaper reflects prevailing attitudes
 that Rivera not merely overshadowed Kahlo as an artist, but also
 – quite literally – stepped all over her, using her like a proverbial
 doormat. Ironically, Rivera did use this type of imagery during his
 affair with Cristina, discussed in chapter Six.
39 Luhring Augustine Gallery, press release, September 2001:
 www.luhringaugustine.com, accessed September 2011.
40 Oriana Baddeley, 'Reflecting on Kahlo: Mirrors, Masquerade and the
 Politics of Identification', in *Frida Kahlo* (London, 2005), pp. 47–53.
 See also Nancy Princenthal, 'Yasumasa Morimura', *Art in America*
 (December 2001), pp. 110–11.
41 I thank David Sperber for introducing me to the work of Maya
 Escobar. See her website: http://mayaescobar.com, accessed
 September 2008.
42 Zamudio-Taylor presented his compelling analysis of 'The Frida Effect'
 at Tate Modern's symposium on *The Many Faces of Frida* (2005); 'Frida
 Kahlo, Mexican Modernist', ibid., p. 34, note 64.
43 Maura Reilly and Linda Nochlin, *Global Feminisms: New Directions in
 Contemporary Art* (London and New York, 2007).
44 See Nochlin and Reilly, *Global Feminisms*, pp. 204, 230, 196, 189, 228,
 256, 214.
45 My recent e-mail correspondence with Milica Tomic and Sigalit
 Landau confirmed their admiration and artistic bond with Kahlo.
46 I am grateful to Tory Fair for discussing her art with me; for more
 examples of her work and an illuminating artist statement, see
 www.toryfair.com.
47 Frida Kahlo, letter to Alejandro Gómez Arias, 2 August 1927, cited in
 Herrera, *Frida*, p. 72.

Postscript

1 Salomon Grimberg, 'Any Friend of Frida's is a Friend of Mine; or, Who Collects Frida Kahlo's Art', in *Frida Kahlo Retrospective* (Munich, 2010), p. 29.

2 Oriana Baddeley, 'Reflecting on Kahlo: Mirrors, Masquerade and the Politics of Identification', in *Frida Kahlo* (London, 2005), pp. 47–53.

3 Raquel Tibol, ed., *Frida by Frida*, trans. Gregory Dechant (Mexico City, 2006), p. 212.

4 Peggy La Salle (Hayden Herrera interview, 1978, author's archive). Although she published a poem in her youth and an essay about Rivera in conjunction with his retrospective exhibition of 1949 in Mexico City, Kahlo categorically declared that words were not her medium of choice. She opens 'Portrait of Diego' by saying: 'I must warn that this portrait of Diego will be painted in colors I am unfamiliar with: in words, and it will be the poorer for that' (Tibol, ed., *Frida by Frida*, p. 344). To Eduardo Morillo Safa she wrote a letter on 11 October 1946: 'You can see I don't possess Cervantes' tongue, nor poetic or descriptive talent of genius' (ibid., p. 307).

5 Grimberg, 'Any Friend', p. 33.

6 'Diego Rivera', *Time* magazine (4 April 1949), p. 61.

7 Frida Kahlo, letter to Lucienne Bloch, 15 February 1938; Tibol, ed., *Frida by Frida*, p. 183.

8 Baddeley, 'Reflecting on Kahlo', p. 47.

9 Kahlo's nomenclature and its relation to identity is discussed throughout Gannit Ankori, *Imaging her Selves: Frida Kahlo's Poetics of Identity and Fragmentation* (Westport, CT, and London, 2002), for example pp. 47, 50–51, 86, 102, 179, 209–13, 242, 252, and with more details in Ankori, 'The Fractured Self: Identity and Fragmentation in the Art of Frida Kahlo', PhD thesis, Hebrew University of Jerusalem, 1994.

Select Bibliography

This book is based on new published and unpublished material, as well as on my previous scholarship. For a full bibliography of items pre-dating 2002, see Gannit Ankori, 'The Fractured Self: Identity and Fragmentation in the Art of Frida Kahlo', PhD thesis, Hebrew University of Jerusalem, 1994, pp. 571–622; Ankori, *Imaging her Selves: Frida Kahlo's Poetics of Identity and Fragmentation* (Westport, CT, and London, 2002), pp. 257–72. Post-2002 sources cited in this book are given in the References.

Major unpublished sources include transcripts of interviews conducted by Karen and David Crommie in the 1960s; by Hayden Herrera in the 1970s; and by the author from 1989 to 1993. Additional primary sources include letters, drawings, photographs, official documents, medical records, ephemera and other material gleaned from private and public collections and archives in Mexico, the United States, Israel and Europe.

Countless academic and popular books, catalogues, articles, films and websites devoted to Frida Kahlo have proliferated in the last decades. This bibliography cannot possibly provide a comprehensive list of all this material. Its goal is to point those who wish to pursue further reading about Kahlo's art, life and legacy to the major sources available today.

Kahlo's own words

The Diary of Frida Kahlo (New York, 1995)
Salomon Grimberg, *Frida Kahlo: Song of Herself* (London and New York, 2008)
Raquel Tibol, ed., *Frida by Frida*, trans. Gregory Dechant (Mexico City, 2006)

Monographs

Gannit Ankori, *Imaging her Selves: Frida Kahlo's Poetics of Identity and Fragmentation* (Westport, CT, and London, 2002)

Teresa del Conde, *La vida de Frida Kahlo* (Mexico City, 1976)

Hayden Herrera, *Frida: A Biography of Frida Kahlo* (New York, 1983)

Isolda P. Kahlo, *Intimate Frida* [2005] (Bogotà, 2006)

Andrea Kettenmann, *Frida Kahlo (1907–1954): Passion and Pain* (Cologne, 2000)

Sarah M. Lowe, *Frida Kahlo* (New York, 1991)

Helga Prignitz-Poda, Salomon Grimberg and Andrea Kettenmann, eds, *Frida Kahlo: Das Gesamtwerk* (Frankfurt, 1988)

Raquel Tibol, *Frida Kahlo: An Open Life* (Albuquerque, NM, 1993)

Martha Zamora, *The Brush of Anguish* (San Francisco, CA, 1990)

Kahlo in context

Tanya Barson, '"All Art is at Once Surface and Symbol": A Frida Kahlo Glossary', in *Frida Kahlo*, eds Emma Dexter and Tanya Barson (London, 2005), pp. 55–79

Fernando Feliu-Moggi, Nancy Meyer and Victor Zamudio-Taylor, 'Timeline, 1907–1954', in *Frida Kahlo*, exh. cat., Walker Art Center, Minneapolis (2007), pp. 81–127

Kahlo and photography

Elizabeth Carpenter, 'Photographic Memory: A Life (and Death) in Picture', in *Frida Kahlo*, exh. cat., Walker Art Center, Minneapolis (2007), pp. 36–55

Salomon Grimberg, *Lola Alvarez Bravo: The Frida Kahlo Photographs*, exh. cat., Society of Friends of the Mexican Culture, Dallas, Texas (1991)

—, *I Will Never Forget You: Frida Kahlo to Nickolas Muray* (Munich, 2004)

Margaret Hooks, *Frida Kahlo: Portrait of an Icon* (New York, 2002)

Pablo Ortiz Monasterio, ed., *Frida Kahlo: Her Photos* (Mexico City, 2010)

Elena Poniatowska and Carla Stellweg, *Frida Kahlo: The Camera Seduced* (San Francisco, CA, 1992)

On the Kahlo cult and legacies

Oriana Baddeley, 'Her Dress Hangs Here: De-Frocking the Kahlo Cult',
 Oxford Art Journal, XIV/1 (1991), pp. 10–17
—, 'Reflecting on Kahlo: Mirrors, Masquerade and the Politics of
 Identification', in *Frida Kahlo* (London, 2005), pp. 47–53
Hayden Herrera, 'Art Review: Why Frida Kahlo Speaks to the 90s', *New York
 Times* (28 October 1990)
Margaret A. Lindauer, *Devouring Frida: The Art History and Popular
 Celebrity of Frida Kahlo* (Hanover, NH, 1999)
Peter Wollen, 'Fridamania', *New Left Review*, XXII (July–August 2003),
 pp. 119–30

Specialized publications

Yosi Anaya, 'The Time–Space in Kahlo's My Dress Hangs There', in
 Proceedings of the Thirteenth International Mikhail Bakhtin Conference,
 ed. Mykola Polyuha, Clive Thomson and Anthony Wall (London,
 Ontario, 2012), pp. 117–30
Gannit Ankori, 'Moses, Freud and Frida Kahlo', in *New Perspectives on
 Freud's Moses and Monotheism*, ed. Ilana Pardes and Ruth Ginsberg
 (Tübingen, 2006), pp. 135–48
Salomon Grimberg, *Frida Kahlo: The Still Lifes* (London and New York,
 2008)
Susan Gubar, 'Blessings in Disguise: Cross-dressing as Re-dressing for
 Female Modernists', *Massachusetts Review* (Fall 1981), pp. 475–508
Janice Helland, 'Aztec Imagery in Frida Kahlo's Paintings: Indigenity and
 Political Commitment', *Woman's Art Journal*, XI/2 (Fall 1990–Winter
 1991), pp. 8–13
David Lomas, 'Body Languages: Kahlo and Medical Imagery', in *The Body
 Images: The Human Form and Visual Culture since the Renaissance*, eds
 Kathleen Adler and Marica Pointon (Cambridge, 1993), pp. 5–19, 191–2
James Oles, 'Gelatin Silver Gossip', in *Frida Kahlo: Her Photos* (Mexico City,
 2010), pp. 249–58
Emmanuel Pernoud, '*Une autobiographie mystique: la peinture de Frida Kahlo*',
 Gazette des Beaux-Arts, ser. 6, CI (January 1983), pp. 43–9
Diego Rivera, '*Frida Kahlo y el arte mexicano*', *Boletin del seminario de cultura
 mexicano*, II (October 1943), pp. 89–102

Carlos Phillips Olmedo, et al., *Self-portrait in a Velvet Dress: Frida's Wardrobe: Fashion from the Museo Frida Kahlo* (San Francisco, CA, 2007)

Terry Smith, 'From the Margins: Modernity and the Case of Frida Kahlo', *Block*, VIII (1983), pp. 11–23

Robert Storr, 'Frida Kahlo: autoportrait aux Cheveux Coupés', *Art Press*, CXIII (April 1987), pp. 84–5

Edward J. Sullivan, 'Frida Kahlo in New York', *Arts*, LVII (March 1983), pp. 90–92

Steven S. Volk, 'Frida Kahlo Remaps the Nation', *Social Identities*, VI/ 2 (2000), pp. 165–88

Bertram D. Wolfe, 'The Rise of Another Rivera', *Vogue* (1 November 1938), pp. 64, 131

Victor Zamudio-Taylor, 'Frida Kahlo: Mexican Modernist', in *Frida Kahlo*, exh. cat., Walker Art Center, Minneapolis (2007), pp. 14–34

Milestone exhibition catalogues

For a comprehensive list of Kahlo's exhibitions, see 'Selected Exhibition History' compiled by Maria Cristina Tavera in *Frida Kahlo*, exh. cat., Walker Art Center, Minneapolis (2007), pp. 302–10. Group shows mounted during Kahlo's lifetime are listed on pp. 304–05

Frida Kahlo and Tina Modotti, Whitechapel Gallery, London (1982)

Frida Kahlo (1907–1954), Salas Pablo Ruiz Picasso, Madrid (1985)

Frida Kahlo, The Meadows Museum, Dallas (1989)

Frida Kahlo, Seibu Museum of Art, Tokyo (1989)

The Art of Frida Kahlo, Art Gallery of South Australia, Adelaide (1990)

Frida Kahlo, Tate Modern, London (2005)

Frida Kahlo: National Homage, 1907–2007, Museo de Palacio de Bellas Artes Mexico City (2007)

Frida Kahlo, Walker Art Center, Minneapolis (2007)

Frida Kahlo Retrospective, Martin-Gropius-Bau, Berlin (2010)

Acknowledgements

This book is small in size, but the number of people who have contributed to it along the way is huge. I am indebted to the path-breaking scholarship and unbounded generosity of Hayden Herrera and Salomon Grimberg. When I was a young student, they shared their vast knowledge and extensive archives with me with astounding kindness.

At the early stages of my academic journey Ziva Amishai-Maisels and Shuli Barzilai impacted my thinking. The trailblazing scholarship of Linda Nochlin, Whitney Chadwick, Laura Mulvey, Griselda Pollock, John Berger, Lynda Nead, Jonathan Glover and Elaine Scarry transformed my 'ways of seeing'.

I owe more than I can say to the late Dolores Olmedo, who granted me permission to conduct research at La Casa Azul in Coyoacán and gave me access to her priceless Kahlo collection.

Countless archivists assisted me throughout the years and across the globe and they are thanked individually in my 2002 book. More recently, Eileen Smith at Yale University's Beinecke Collection, and Jennifer Page, Heather Slania and Julia Viets at the National Museum of Women in the Arts facilitated my archival research. Eduardo Berinstein helped decipher handwritten documents with prodigious talent and a generous spirit. I thank them all.

My participation in a broad range of academic and curatorial projects has invigorated my scholarship and contributed ideas that have found their way into this book. I am grateful to the Israel Museum, Jerusalem, where I lectured on 'Frida Kahlo and Photography' (1993); to the Lafer Center of Women and Gender Studies at the Hebrew University of Jerusalem, where I presented 'Frida Kahlo: Anatomy, Theology and Art' (2001); to Ilana Pardes and Ruth Ginsberg, who organized the conference *New Perspectives on Freud's Moses and Monotheism*, which instigated my

paper 'Moses, Freud and Frida Kahlo', (2002); to the Jewish Museum, New York where I curated *Frida Kahlo's Intimate Family Portrait* and its online feature (2003–04); to Shula Modan, with whom I worked on a facsimile edition of Frida Kahlo's diary (2004); to Tanya Barson and Emma Dexter from Tate Modern London, who invited me to contribute a catalogue essay in conjunction with the Kahlo retrospective (2005); to Oriana Baddeley and Dominic Wilsdon who organized the Tate symposium *The Many Faces of Frida*, including my paper 'Frida Kahlo's Ethics and Aesthetics of Hybridity' (2005); to Rubén Gallo for hosting me at Princeton University where I lectured on 'Frida Kahlo's Hybrid Cosmologies' (2007); and to Mieke Bal and her brilliant students at Amsterdam University's School for Cultural Analysis, where I gave a talk on 'Visual Epistemology: The Work of Art as a Source of Knowledge' (2009).

Since 2005, I have been working on a book project titled *A Faith of Their Own: Women Artists Re-Vision Religion* under the auspices of Harvard Divinity School's propitious Women's Studies in Religion Program. I thank my colleagues at Harvard, especially WSRP director Ann Braude.

Ironically, my immersion in Kahlo's art made writing a concise book about the artist's life incredibly difficult. Carol Troen's meticulous reading of my manuscript was pivotal. I am forever thankful for her friendship and professional brilliance. My son, Lee-Or, took time to read an early draft of the text. His edits were ones I could never do myself. Edward Sullivan, Whitney Chadwick, Yosi Anaya, Nancy Scott, Ann Brash, Laura Ligouri, Kirsten Olson and Susie Harburg encouraged me along the way.

I thank my wonderful students and colleagues at Brandeis University, my academic home. Special thanks to Jennifer Stern, for significant help with the illustrations; to the Dean of Arts and Sciences and the Schusterman Center for generous support; to Anita Hill, my courageous role model, who speaks truth to power; and to Ilan Troen for his outstanding leadership.

My profound gratitude to Mimi Muray, Tory Fair, Sigalit Landau, Yasumasa Morimura, and Circe Henestrosa for generously providing images for this book. Thanks also to everyone at Reaktion Books, including Martha Jay, Simon McFadden, Delia Gaze and Maria Kilcoyne, and especially Vivian Constantinopoulos.

On a more personal note, soon after I began working on this book, one of my sons, Roi, became seriously ill. During the years of his illness and my consequent encounters with doctors, hospitals and

interminable fear – my views of Kahlo shifted. His inspiring endurance, courage, creativity and love taught me lessons that I needed to learn before I could write this book. My deepest gratitude, as always, is to Roi and his brothers, Lee-Or and Amir, and to my husband Nahum.

A few months ago my beloved father fell ill and passed away. I was with him when he exhaled his final breath, and as I write this, I sense both his presence and his absence with palpable sorrow. It is to him and to my mother that I dedicate this book. They took me to Mexico when I was a little girl and taught me to embrace life, love and art.

Photo Acknowledgements

The author and publishers wish to express their thanks to the below sources of illustrative material and/or permission to reproduce it. Some information not given in the captions for reasons of brevity is also given below. Every reasonable effort has been made to trace the copyright owners of anonymous photographs, but sometimes this has proven impossible. The publisher will be glad to receive information leading to more complete acknowledgements in future printings of the book.

© Gannit Ankori: pp. 167, 169; © Bettmann/Corbis: p. 78 top; Guillermo Davila: p. 73; © Tory Fair: p. 185; © Peter A. Juley & Son Collection, Smithsonian American Art Museum: pp. 6, 11, 83; all works by Frida Kahlo and Diego Rivera © 2013 Banco de México Diego Rivera Frida Kahlo Museums Trust, Mexico, D.F. / Artists Rights Society (ARS), New York: pp. 25, 30, 36, 42, 46, 50, 53, 59, 65, 78 bottom, 82, 94, 103, 127, 129, 132, 142, 146, 151, 152, 153, 159, 193; Guillermo Kahlo: pp. 23, 31, 37, 45, 108, 130; © Sigalit Landau: p. 184; © Nickolas Muray, © Nickolas Muray Photo Archives: p. 156; © Yasumasa Morimura, courtesy of the artist and Luhring Augustine, New York: p. 182; © Miguel Tovar: p. 155; unknown photographers: pp. 20, 39, 63, 69, 106, 111, 164, 190.